Around the World

The
GRAND TOUR
in
PHOTO ALBUMS

Barbara Levine

Kirsten M. Jensen

Princeton Architectural Press, New York

Published by

Princeton Architectural Press
37 East Seventh Street
New York, New York 10003

For a free catalog of books, call 1.800.722.6657.
Visit our web site at www.papress.com.

Editor
Jennifer N. Thompson

Design
Martin Venezky/Appetite Engineers

Photography
Dana Davis

Special thanks to
Nettie Aljian
Sara Bader
Dorothy Ball
Nicola Bednarek
Janet Behning
Becca Casbon
Penny (Yuen Pik) Chu
Russell Fernandez
Pete Fitzpatrick
Wendy Fuller
Jan Haux
Clare Jacobson
John King
Nancy Eklund Later
Linda Lee
Laurie Manfra
Katharine Myers
Lauren Nelson Packard
Arnoud Verhaeghe
Paul Wagner
Joseph Weston, and
Deb Wood of Princeton Architectural Press
—Kevin C. Lippert, publisher

Library of Congress
Cataloging-in-Publication Data

Levine, Barbara, 1960–
 Around the world : the grand tour in photo albums / Barbara Levine
and Kirsten Jensen.
 p. cm.
 ISBN-13: 978-1-56898-708-8 (alk. paper)
 ISBN-10: 1-56898-708-0 (alk. paper)
 1. Travel photography. 2. Photograph albums. I. Jensen, Kirsten M.,
1969– II. Title.
 TR790.L48 2007
 770—dc22
 2007008674

From the collection of Barbara Levine

Around the World

The
GRAND TOUR
in
PHOTO
ALBUMS

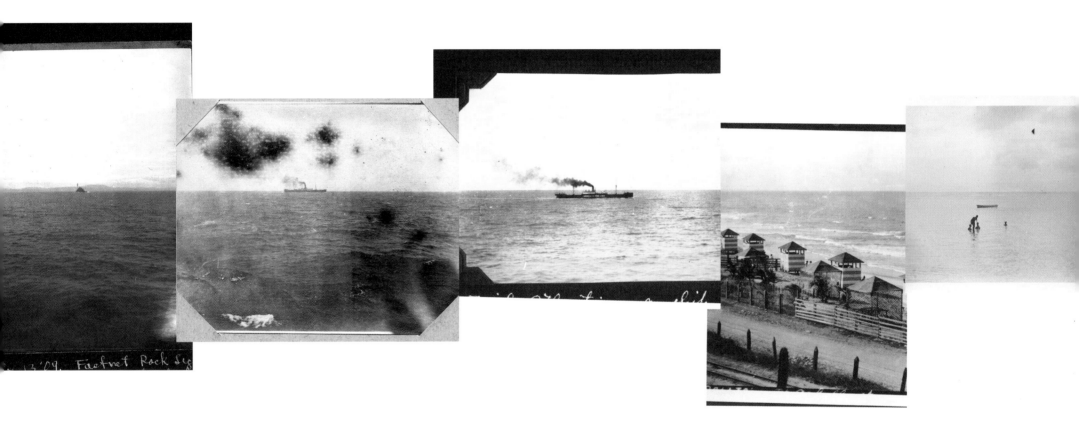

Looking at the world through a porthole.

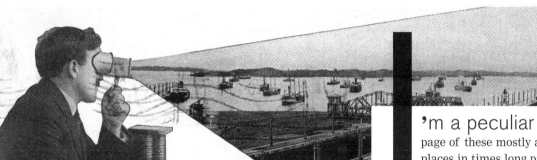

You can
talk across the
miles with your
TELEPHONE—you can

See AROUND THE WORLD with your STEREOSCOPE

AND TAKE THE FAMILY ALONG

When our Representative calls _aug_
to deliver your order about __18 – 19__ 191_6_

(COPYRIGHTED BY)
KEYSTONE VIEW COMPANY

fig. 1

Introduction

Confessions of an Armchair Traveler

Barbara Levine

'm a peculiar traveler. My preferred form of transport is vintage travel albums. In page after page of these mostly anonymous albums, I am transported by a stranger's spirit of adventure to faraway places in times long past. I board a steamship between Sri Lanka and Cairo; I cross the Alps from Italy to Switzerland by train or motor through Germany and northern Europe in an open car. I go abroad without ever leaving home. I don't need to "be there." I am happy here, in my armchair, turning the pages of an album steeped in age and history. It is this object—the album itself, what it represents and conveys to me here and now, at the beginning of the twenty-first century—that moves me.

The invention of photography in 1839 transformed travel and the means to record it. Up until that time, we depended for our picture of the world on tales from explorers, ship captains, merchants, missionaries, and archaeologists. But their descriptions of extraordinary adventures filled with wondrous sights and exotic peoples were hard to corroborate. Not many people had ventured into the unknown; we were forced to place our trust in their credibility, memories, and reporting skills. With the advent of the camera, more reliable and detailed pictures became available. Intrepid professional photographers made pilgrimages to new continents and countries, wrestling with cumbersome photographic equipment and handling messy chemicals to bring back astonishing images. Suddenly we could see for ourselves what life, people, and landscape looked like in different parts of the world: it was, in a sense, the beginning of armchair travel.

From 1860 to 1920 practically every middle and upper-class home had a stereo viewer and a drawer full of stereo cards. These stereo viewers brought the wonders of the world—the Taj Majal, Big Ben, the Eiffel Tower—right into your living room. The Keystone View Company's ads claimed that

"you can talk across the miles with your telephone—you can see around the world with your stereoscope—and take your family" (*fig. 1*). Oliver Wendell Holmes wrote, in an 1859 article titled "The Stereograph and the Stereoscope,"

> Oh, infinite volumes of poems that I treasure in this small library of glass and pasteboard! I creep over the vast features of Rameses....I scale the huge mountain-crystal that calls itself the Pyramid of Cheops.... I pace the length of the three Titanic stones of the wall of Baalbec... and then I dive into some mass of foliage...and leave my outward frame in the arm-chair at my table, while in spirit I am looking down upon Jerusalem from the Mount of Olives.

In the mid-nineteenth century, the wealthy and a newly affluent middle class began to travel abroad in increasing numbers. I imagine their desire to travel was influenced not only by these stereo cards but also by seductive advertisements (*fig. 2*), or souvenir photographs made by commercial photographers. In these early days of leisure travel, it was common for tourists to buy fancy gilded albums already full of gorgeous photographs of the most popular sites, or a leather bound diary or scrapbook in which to write descriptions of their experiences and paste in their individually purchased souvenir views.

In addition to the increasing ease of travel, the early twentieth century brought another big change—the invention of the roll-film camera. In 1888, George Eastman introduced the Kodak Camera. This small box camera came pre-loaded with a 100-exposure film roll; when the roll of film was completed all you had to do was send the entire apparatus back to Kodak in Rochester, New York, where your film would be developed, new film would be loaded and everything would be returned to you. Several other camera models, including Kodak's folding cameras, the Autographic, and the inexpensive Brownie camera, introduced in 1900, soon followed. All were easy to use and small enough to take along in a suitcase or simply carry using the camera's convenient strap. For the first time ever, leisure travelers could take their own snapshots of what they were seeing on their trips abroad. Back home, the travel album was born of the natural and inevitable desire to assemble their personal pictures and memorabilia for review and recollection. Tourists became the authors and archivists of their personal travel histories.

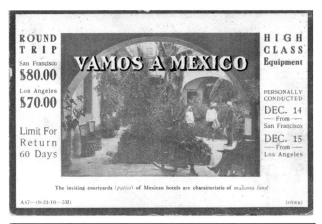

fig. 2

Travel albums are unique memory objects, serving as wondrous time-travel capsules and portals. They are in varying proportions diary, adventure story, scrapbook, and photograph album. Their makers strive for the perfect way to mix all these elements together in order to recapture, reflect, relive, and memorialize their experiences. Merely opening the album cover fires the memory and imagination, transporting the viewer (the album's creator included), again and again to a specific place and time.

Always, the album makers' expressive style—their humor and sensitivities, their opinion of the trip arrangements and the people they encountered—are revealed in the pages of their album. And revealing they are. There is a broad spectrum in what they chose to photograph and what they elected to include or exclude in compiling the album. How they juxtaposed images, what they chose to write about or explain, and how they began and ended the album are all clues as we go along with them on their travels. One person might fill every inch of every page of a blank album with layers of travel memorabilia—postcards, brochures, and receipts, accompanied by casually annotated photographs, with the effect of beckoning the senses to imagine the sights and

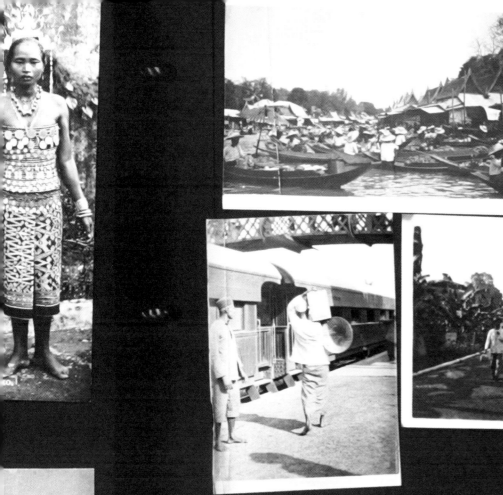

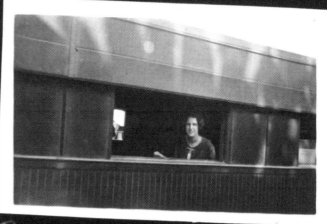

Bangkok to Penang.

bathing.

Risingsun Photo Studio

Public Execution in
Bangkok. Siam -
Priests dance themselves
into a frenzy before
chopping off head
of victims or prisoner.

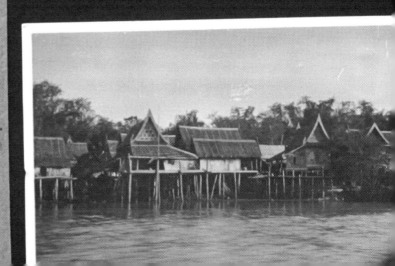

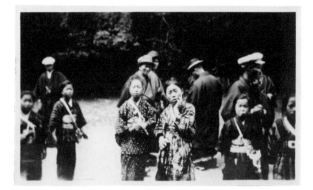

My usual audience

fig. 3

sounds of, say, Southeast Asia in the 1920s. Another might think the memory was best preserved in an elegant album filled only with artfully composed photographs and carefully scripted captions.

Some albums feature pages of snapshots with decorative borders, some include menus and tickets; you might come across a paper-cone drinking cup or baggage labels and passenger lists. The commentary ranges from the offhand to the erudite. While one traveler would comment on the weather or meals, others would be compelled to compile a repository of information and recount historical facts, taking great care to note in every detail what they were seeing, smelling, and thinking. Sometimes, with a seeming awareness that they were witnessing history in the making, album makers would devote entire pages to events such as standing outside the Vatican waiting for the announcement of a new pope, or watching the opening of King Tut's tomb and seeing its contents carried off to the Cairo Museum.

Vera Talbot, documenting her two-year trip around the world in 1924, pasted everything imaginable into her album, including the gruesome beheading of a prisoner in Bangkok. However, she sensitively took care to place these unpleasant images in an envelope and pasted the envelope onto the album page. By hiding these images she has not stripped from history the unpleasantness she saw during her travels. Another album presents on one page an image of women doing laundry in the River Nile and on the facing page two well-dressed women lounging on the deck of the boat from which they view the scene (*fig. 4*). This juxtaposition not only offers a simulated vantage-point but also emphasizes, probably inadvertently, the class differences between the women. In yet another album, a photograph taken by an American woman of Japanese people gawking at her has the seemingly self-aware caption: "My usual audience" (*fig. 3*). It is a witty and observant comment of what it must have been like for an American woman to be traveling in the Japanese countryside in 1914.

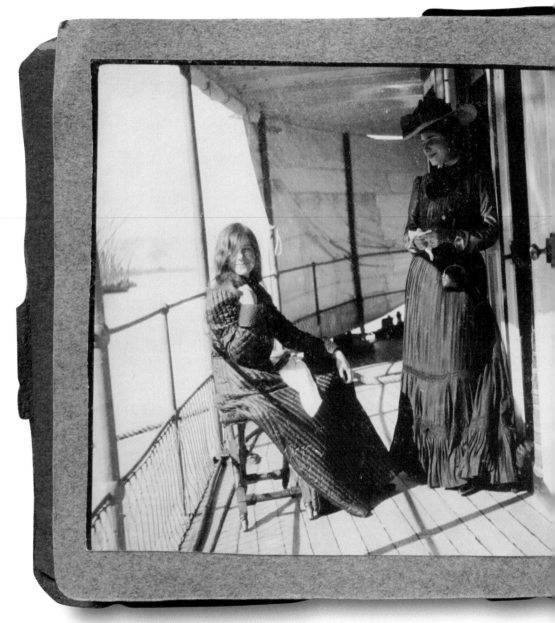

fig. 4

12

Cathedral at Mexico City

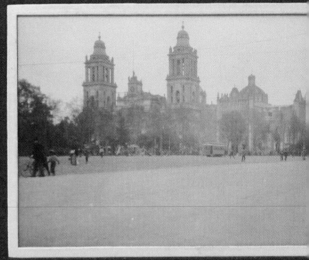

Palace of the Mexican President

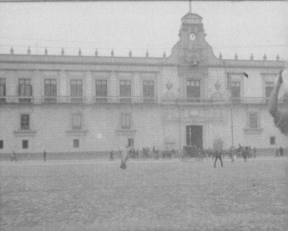

Unlike family albums depicting domestic and daily life, which may unfold over years or decades, personal travel albums cover a very specific time period—a voyage—and have a clear beginning and end. Typically, the album's first page announces the maker's name and destination, and perhaps the full itinerary of the trip. Sometimes a photograph shows the travelers or the camera used to take the pictures (*fig. 5*). We are invited to follow along with the individual or traveling party until the journey comes to an end. The album's closing page might show a passenger list signed by all their fellow travelers or a photograph of the tourist on the deck of the returning steamship or reunited at home with their beloved family pet.

Anonymous vintage travel albums allow me to share the experience of early travelers from a distance of many decades. I marvel at both the differences and similarities of our experiences, comparing what I have seen or read of the sites they visited. I am struck by the collective experience of travel and memory, as much by the vast changes of the past century as by the ways that things remain the same. For me, the appeal of opening the cover and turning the pages of personal photographic travel stories never fades. Sitting at my table, even so many years later, I look at these travelers' photographs and words on the album pages and feel transported.

I am not alone in my enjoyment of traveling on other people's coattails. Today such vicarious thrills are provided by internet companies devoted to virtual travel that take you around the world on your computer screen, and an "armchair travel" section can be found in your bookstore alongside the guides for people who are actually going someplace.

I realize I am bringing a contemporary sensibility to these albums, and I'm well aware that looking at old travel albums isn't the same as being there. In part, my fascination is simply that the albums convey the pleasure of seeing further interpreted by the camera, and they become, as a result, time capsules of a profoundly changed world. Today, for example, the journey itself is almost incidental, and getting to your destination is something to be endured rather than savored. Already, the ritual of compiling and looking at a tactile album that you hold in your hands is almost obsolete, replaced by creating on and looking at a computer or cell-phone screen.

But this is not only a lament about how much travel and places have changed. Today we face a serious dilemma with regard to recording our travel experiences. The private travel album, preserved on film and paper and ink for future generations, is fast becoming extinct. I am conscious of all the

fig. 5 15

information that will likely be lost as a result of these experiences now being digitally documented and formatted for online sharing, tenuously preserved only on hard drives, internet servers, and other technologies that will likely become obsolete in the maker's lifetime.

Around the World: The Grand Tour in Photo Albums is different from publications about nineteenth- and early-twentieth-century travel photographers and from studies focusing largely on historical, anthropological, and sociological aspects of travel—i.e., imperialism and the encounter of Western societies with the exotic "other." It is also different from scholarly investigations of tourism and amateur photography, as well as from published personal travel writing, which represents a different impulse, as these personal experiences are meant for broad consumption, unlike the private albums produced solely for the enjoyment of the makers and their friends and families. *Around the World* offers an armchair journey that aims to recapture the authentic voice and experience of early travel-album makers while showcasing the materiality of the object itself.

Vintage travel albums are singular in their expression and documentation of particular journeys beyond the realm of their creators' everyday existence. Anyone who opens an album's cover—no matter where or when—is on a voyage and can relive the experience long after the original "real" excursion was taken. We may well have been to the destination depicted in the album. Even so, we wish, in that moment, we were there.

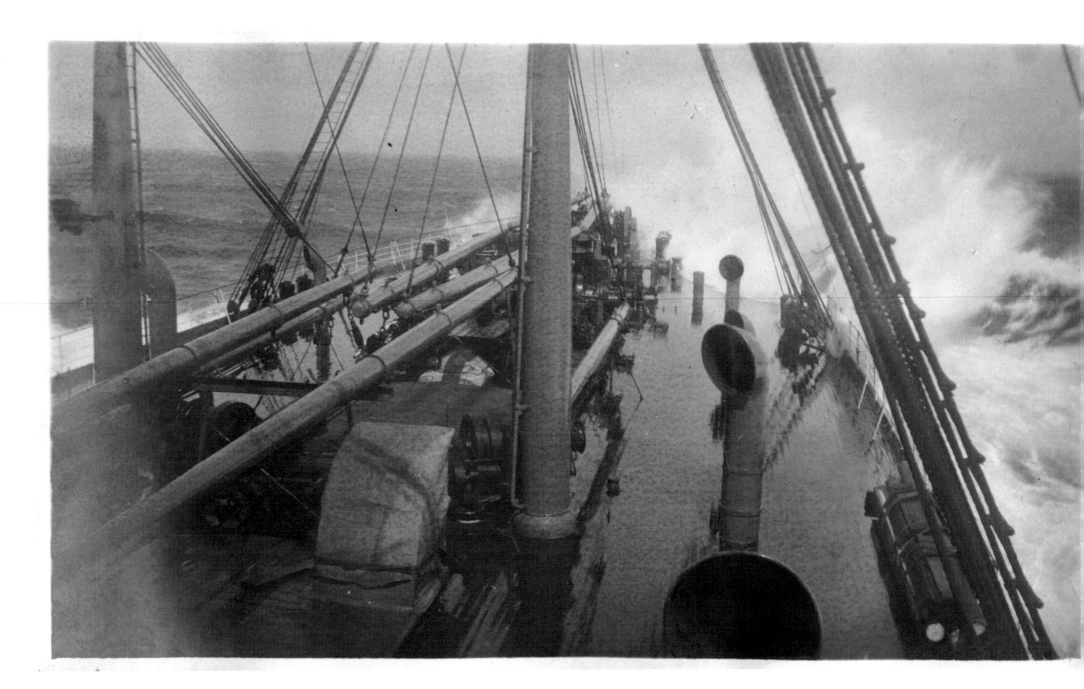

Traveler's Tales

Kirsten M. Jensen

"I have just paid sixty cents for this book with the wonder
if the notes will be worth as much. I also bought a Baedeker on Egypt.
The size and contents seem almost discouraging when I think of trying to master the subject.
It has been my custom when on visiting a country to do so as thoroughly as possible
in history, customs, geographical location, physical conditions;
also to take especial notice of the little details
that one so seldom finds in books."

So begins the travel diary of Clara Whitcomb, a young woman from Chicago, who made a voyage to Egypt and the Levant in 1898 and 1899, and intended to document her experiences in her brand-new, leather-bound journal. The opening paragraph of Clara's diary reveals that she intended both to read and record—to absorb as much as possible about what she *should* see from an "authority" on the subject, in this case a Baedeker guide, but also to provide a description of what she saw, from her own perspective.

Clara illustrated her concise and often witty descriptions of the local people, architecture, and geography with souvenir albumen photographs, hotel receipts and stationery, postcards, and even, on one page, the stamp of her own personalized silver cartouche, purchased from a stall "just outside of Pharaoh's Bed on the Island of Philae." There are no two ways about it: Clara Whitcomb was an eager, but occasionally culturally uninformed, stranger in a strange land. Her diary reflects an enthusiasm and curiosity for the places and peoples she visited, as well as her own prejudices when confronting different customs and ways of life. Visiting a market in Cairo, Clara wrote: "A woman sat...making a necklace of small red beads on gazelle work leather. Her finger nails were freshly decorated with henna that was running over her work. This added to the objection I have for touching native things. The woman had been polite, then asked for the backshish that she received."

What Clara created was a multi-layered account of her journey that reflected herself as well as the native peoples she saw or the places she visited, a personalized account which, as she indicated, could not be found in books— certainly not in a Baedeker guide, crammed with an overwhelming number of facts and detailed descriptions of sites that "must be seen." What makes it so

remarkable to us, nearly 120 years later, is that this diary was preserved, allowing us to re-experience her adventures in the present. The album, like many private travel albums, was meant to be an *aide-mémoire,* something to remind its author of her travel experiences. It has also become a time machine, allowing us to go back and visit Egypt in the nineteenth century.

Consequently, Clara's album had a larger voice than perhaps she intended, for her album tells a story.[1] In fact, it tells many stories. It is a visual memory of an individual's experience of a particular time and place, within a particular social context: a young, white, American woman, educated and presumably wealthy, making a tour of the Holy Land and Egypt. For friends and family who had remained behind in Chicago, her diary became a means through which they could partake in and relive Clara's personal experience of Egypt. Her travel album is therefore both a story of an actual trip taken and a voyage within itself. Those who read her album become voyeurs of sorts, "travelers" experiencing Clara's adventures vicariously through words and pictures. Without knowing anything else about Clara, we can create a visual image of her, and her experiences, in a sense, telling a story based on a story. In our mind's eye, we can "see" Clara giving backshish to the henna-tatooed woman in the marketplace—even though there is no visual record of her doing so.

Clara's album is also a collective, social document because it represents an act of communication, and it is a form of communication that is continually renewable.[2] Personal memories and histories change over time to reflect current beliefs, experiences, and social status; they locate our own story within the collective human experience. This suggests that authors of travel albums like Clara Whitcomb would themselves view their memories differently over time. It also suggests that our re-creation of those memories when viewing travel albums in the present is inextricably colored by our own individual experiences, beliefs, and status.[3] In a sense, we are using *her* story to tell our own.

Travel albums are incredible story-tellers, with an infinite number of tales to tell. This book tells the story of travel albums at a specific moment in time, approximately 1880–1930, a period that saw a rapid rise in tourism, changes in modes of transportation and communication, and the invention of the personal camera—new developments that made travel and the documentation of it much more immediate, visual, and personal than had been previously possible. Within that context, what follows here is a brief exploration of how the modern travel album evolved as an outgrowth of the culture of tourism, and, more specifically, the many ways in which changes in photographic technology

over time were employed by album authors—travelers, tourists—to tell stories of their journeys.

Although travel albums are created by individuals and can be highly personal documents of individual experiences, they are part of the larger tourist culture that developed during the last half of the nineteenth century. This is not to say that there was no leisure travel before 1850—quite the contrary. The ancient Greeks made tours of Egypt, and the Pyramids led by a large contingent of local guides eager to explain their history. Nor is this to say that the desire to record one's journey is not equally ancient, for graffiti scrawled on a wall of Djoser's pyramid at Giza around 1244 BCE, by a scribe named Hadnakhte, tells us he had traveled there to "make an excursion and amuse himself on the west of Memphis." But the travel album as we know it today, with its mixture of ephemera, photographs, and narrative, is largely a product of modern tourism, which had its roots in the Grand Tour of the seventeenth and eighteenth centuries but did not really come of age until it had found its avatar: Thomas Cook, the father of the modern tourist bureau.[4]

In 1841, Cook organized his first tour: an eleven-mile rail excursion from Leicester to Loughborough, near Liverpool, on the Midland Railway for 350 people. By 1872, Thomas Cook & Son offered a luxurious 212-day tour around the world—a spectacular journey that included a steamship crossing of the Atlantic, an expedition to California via stagecoach, a ride on a paddle steamer to Japan, and culminated in an overland trek to India from which the travelers departed home for England. This kind of tour was still accessible only to the very rich: it cost 200 guineas, or £190, which would equal about £11,305 today ($21,480). Thomas Cook & Son sought to make travel for pleasure, well, pleasurable. Cook's firm took the ardor out of travel—a word that had, after all, developed from the French word for work, *travail*—by coordinating timetables, purchasing bulk tickets at reasonable rates, offering currency exhanges at its branch offices, and developing a broad array of itineraries from which travelers could choose. By the turn of the century, as travel abroad became less expensive, Americans and Europeans were crossing the globe with increasing frequency, either as a part of the kind of pre-packaged tour Thomas Cook & Son provided, or on their own.

Thomas Cook & Son were by no means the only travel agent operating during this period, but they were a cultural juggernaut (one that still exists today). They not only met the needs of their clients, but also fanned the popular desire for leisure travel to Europe or exotic lands with travel talks by "experts," advertisements, and publications such as *Cook's Arrangements for Egypt and the*

1 Martha Langford argues that the sharing of an album is an act of [c] tradition. See Langford, *Suspend[] Conversations: The Afterlife of Memory in Photographic Album[]* (Montreal: McGill-Queens Univer[] Press, 2001).

2 There have been many exploratio[] of photographs and personal nar[] tives as collective acts of memor[] William Hirst and David Manier argue that memory is intrinsically a collective act, that you cannot "divorce the act of remembering from the act of communicating." [] Hirst and Manier, "Remembering Communication: A Family Recou[] its Past," *Remembering Our Pas[]* (Cambridge: Cambridge Univers[] Press, 1996), 271–90.

3 See Michael Ross and Anne Wils[] "Constructing and Appraising Pa[] Selves," *Memory, Brain, and Bel[]* ed. Daniel L. Schacter and Elaine Scarry, 231–258 (Cambridge, Mass.: Harvard University Press, 2000).

4 The history of travel and tourism [] voluminous. Piers Brendon provi[] a fairly thorough and enjoyable overview of the development of travel and popular tourism in the introduction to his book on Thom[] Cook. See Piers Brendon, *Thom[] Cook: 150 Years of Popular Tou[] ism* (London: Secker & Warburg 1991). The literature on the Gra[] Tour is equally extensive. See for example, Michael G. Brennan, ed *The Origins of the Grand Tour: The Travels of Robert Montagu[] Lord Mandeville (1649–1654), W[] liam Hammond (1655–1658), an[] Banaster Maynard (1660–1663)* (London: Hakluyt Society, 2005) Jeremy Black, *The British Abro[] The Grand Tour in the 18th Cen[]* (London: Croom Helm, 1985), a[] Edward Chaney, *The Evolution [] the Grand Tour* (London: Rout- ledge, 2000).

18

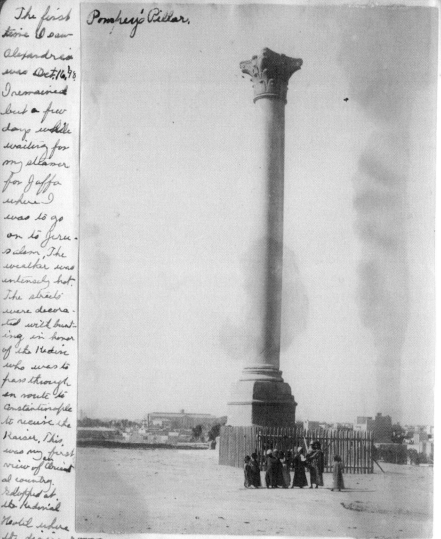

Pompey's Pillar.

The first time I saw Alexandria was Oct. 16, 78. I remained but a few days while waiting for my steamer for Jaffa where I was to go on to Jerusalem. The weather was intensely hot. The streets were decorated with bunting in honor of the Kedive who was to pass through en route to Constantinople to receive the Kaiser. This was my first view of Oriental country. I stopped at the Kedivial Hotel where the dining room was a separate building in the court surrounded by plant trees, many flowers and date palms filled with ripe fruit. Birds were trying to keep cool in the shade. Water was flowing in a grotto like fountain and the whole a beautiful restful picture while the servants in silk dresses were attentive. I took a drive seeing much that was peculiar to this country alone. The above Pompey's Pillar is of Assuan granite and the only important relic of antiquity in the city. The Corinthian capital 88 ft. The shaft is 68, nine in diameter at base & eight at top. In 302 A.D. it was surmounted by a statue of Diocletian. It was erroneously supposed to mark the tomb of Pompey the Great.

Dec. 31, '78, Saturday; Pyramids. This day marked another era of life. The first view of the Pyramids was a chance one and involuntarily I laughed as in the distance they seemed so small and insignificant after the ruins of Baalbec that are the most vast in the world, but after driving to them through a beautifully shaded avenue of large beautiful lebbek trees I changed my mind. In the party were Dr. Beiler, Mr. & Mrs. James Johnstone and myself. We drove over the great iron bridge in crossing the Nile then along the river by the Gizeh Museum, that was formerly the palace of Gizeh. There were orange trees and well laid out grounds on the right, while on the other was the Nile covered with the butterfly boats, many at rest and others in motion. Turning the corner, soon after passing the museum, we had almost a straight, broad, level road for over five miles. Gradually the Pyramids seemed to grow in size. When we reached them they had done so immeasurably, yet as they stood alone on the border of the desert with nothing definite with which to compare them they seemed huge indeed. The people climbing one looked like black and white insects crawling along the corner. The color was that of the guides who wore black and white garments. Even after hard work and as-

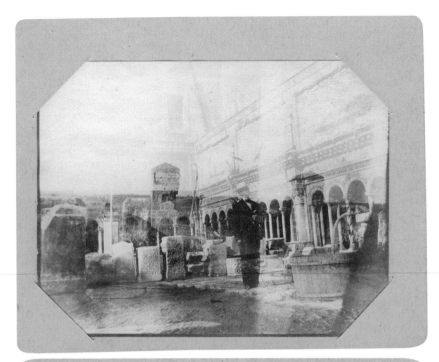

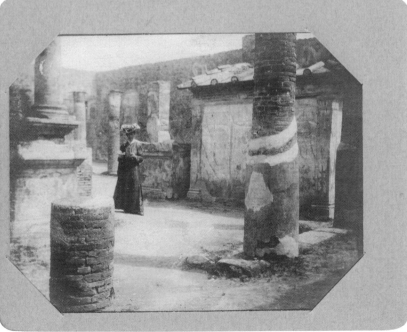

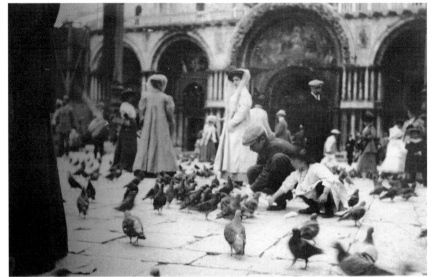

Nile (1909), which was both travel brochure and a mini-guide to Egypt. This publication was part of one of the most lasting material outgrowths of the rapidly expanding tourist culture, guidebooks: publications in which experts informed eager travelers of what they might (or should) see and experience during their journey. Samuel Johnson once remarked that "a man who has not been to Italy, is always conscious of an inferiority, from his not having seen what it is expected a man should see." His pithy remark, however, also sums up the dilemma faced by those who were able to travel to foreign lands—a question that still concerns travelers today. *What* should I see? Answer: Buy a guide.

For the nineteenth- and early-twentieth-century tourist, the must-have guides were the urbane Baedeker series. Baedeker guides provided a wealth of travel information, such as the best travel routes, where to stay, currency exhange rates, and the history of important sites and monuments. They also supplied readers with highly detailed information such as how to tip appropriately or what type of tweed best suited a jaunt in the Austrian Alps. Other popular travel guides included John Murray's *Murray's Handbook*, which, like Baedeker's, offered guidebooks by country. Cook's offered even more specific guides, such as *The Nile: Notes for Travellers in Egypt* (1902) written for the travel agency by Dr. E. A. Wallis Budge, then Keeper of the Egyptian and Assyrian Antiquities at the British Museum—a bona-fide expert. *The Nile* was available only to those travelers who made the entire Nile voyage from Cairo to Assuan and back using Cook's Tourist Steamers or Dahabeahs (a traditional Egyptian boat), and thus became at the end of the journey a souvenir in itself, a mark of one's accomplishment and social status, since such a trip required a lengthy period of time as well as a substantial outlay of cash.

The Baedeker, Murray, and Cook guides, and numerous others like them, offered more than just practical information for the traveler; they

5 Rachel Snow's recent dissertatio
gives a good overview of the de-
velopment of travel guides. Snow
larger purpose is to explore the
development of published first-pe
son narratives, illustrated with ph
tographs by the author(s) instead
standard souvenir photographs o
engravings. Among her argument
she suggests that they played a
role in the marketing of amateur
photography to the broader publi
See Rachel Snow, "Incidental To
ists: Vernacular Photo-Travel Boo
1900–1940," (Ph.D. diss., The C
University of New York, 2006).

6 Roland Barthes argues that the
critical element for a photograph
not only that it represents someth
that is—"it has been absolutely,
irrefutably present"—but that it als
depicts something that is past:
by freezing a moment in time, the
photograph's subject is "already
deferred." This duality is particula
provocative in the context of trav
albums. See Roland Barthes, *Ca
era Lucida: Reflections on Photo,
raphy* (New York: Farrar, Straus
Giroux, 1981).

offered chapters on religion, history, language, and art. The Nile, according to the company's literature, was "prepared to meet the wants of tourists who are unable to spare the time necessary for making a profound study" prior to departure, and enabled "Nile travellers to study in a concise and authentic form the principal features of the remarkable places and monuments they will visit in following our itineraries." Other guides, like the Artistical Guide to Florence and District (ca. 1916), which was "embellished with historical notes on the city and the principal monuments, views, topographical maps, catalogues of the galleries, etc.," were more specifically focused, but the intent of creating an educated and well-informed traveler was the same. The Artistical Guide was organized around the conceit of an eight-day visit, at the conclusion of which, "the visitor, if he will follow our instructions, will have seen everything in Florence that is worthy of notice."

A significant function of travel guidebooks, then, was not only to suggest what to see, but how it should be seen. The Artistical Guide to Florence stated in its introduction that only "the most perfect and interesting [works of art] from an artistic point of view" would be mentioned in the guide, implying that everything else was somehow less important, and, that if you left out what they did mention, your tour would be, well, deficient. Much of this culturally coded information was conveyed in narrative, but most guidebooks were illustrated, initially with engravings and woodcuts, and then, as the technology for photographic reproduction improved, with photogravures.5 The illustrations had a practical function, of course, so you would know what you were looking at when you saw it. But they, like the accompanying descriptions, were also loaded with cultural assumptions of what places, sites, and monuments were important, and how they should be viewed. When combined with authoritative narrative, the illustrations provided a particular, frequently exclusionary, framework to guide the traveler through a city or country. To understand this, one has only to think of Lucy Honeychurch in E. M. Forster's A Room With a View running around Florence, face buried in her Baedeker, ignoring everything else around her with the exception of what Baedeker directs her to see.

Photography, particularly, with its ability to fix on paper a specific subject that existed at a specific moment in time—to represent the truth, something that "is"—provided travelers with a visual connection to something that was real.6 Photography transformed travelers' experiences of sites and monuments as well as the ways they documented it—or told their story—in travel albums. Almost from its invention, in 1839, photography was associated with travel and tourism. By the 1860s, publishers and professional photographers such as Félix

Bonfils and Francis Frith had recognized the market for souvenir views of what were quickly becoming regular stops on the typical tourist's travel program—the major cities of ancient and modern Europe, Egypt, and the Holy Land.7

Photographs, with their ability to capture or document the "real" and fix it on paper, enabled travelers to possess the things they saw and experienced on their journey, to "take" the Pyramids of Egypt and the Gothic cathedrals of Europe home with them. Souvenir photographs made by professional photographers could be purchased singly or in expensive, gilded, leather-bound albums that sequenced the photographs of sites and monuments so as to replicate a typical tourist's experience of them. Like guidebooks, souvenir photographs were both informed by a common cultural understanding and instrumental in shaping it. What professional photographers chose to capture with their cameras was based upon certain cultural assumptions of what places, sites, and monuments were important, and how they should be viewed—"an agreed-upon and prioritized view of the world made manifest."8 Views of sites and monuments were presented from the best vantage point, and frequently devoid of any associations with people or the modern cities growing up around them; divorced from context, these photographs presented travelers with a private, perfect view, as if the site existed for them alone, but the site—and the travelers' understanding of it—existed within an established collective cultural consciousness.

Once travelers became well-versed in what to see and how to see it, through guidebooks and souvenir photographs, the question that followed was how to document their own personal experiences, to "prove" that they had had them, to tell their own stories? Travel guides can only tell you what to see, they cannot replicate the material expression of an experience one might have exploring the sites and places they describe, and souvenir photographs provide only visual complements to the narrative guidebooks. Both remain impersonal documents, coded with facts and assumptions. There is a clear distinction, as Clara Whitcomb was keen to point out in the opening pages of her travel album, between facts and the experience of them. Enter the travel album.

The modern travel album, like those reproduced later in this book, developed in conjunction with the tourist industry and its increasingly available souvenir views, commercial guidebooks, travel narratives, brochures, and publications. In many instances, travel albums reveal the influence of the tourist and travel culture in the structured approach to travel their authors take—seeing the sights one was supposed to see, how one was supposed to see them. Frequently this structure was replicated in the arrangement of the albums themselves.

ere have been numerous pub-
hed studies concerning profes-
onal photographers like Frith and
onfils, and their eerily beautiful im-
ges of exotic places—depopulated
d devoid of the modern appara-
ses of the tourist industry that are
avoidable today. See, for example,
C. Adam and J. Fabian, Masters
Early Travel Photography (New
rk: Vendome Press, 1983); Julia
n Haaften, Egypt and the Holy
nd in Historic Photographs
ew York: Dover, 1980); Paul E.
evedden, The Photographic
eritage of the Middle East (Malibu,
alif.: Undena Publications, 1981);
athleen Stewart Howe, Excursions
ong the Nile: The Photographic
scovery of Ancient Egypt (Santa
arbara, Calif.: Santa Barbara
useum of Art, 1994); Stacey Miya-
awa, England to Egypt: The Pho-
graphic Views of Francis Frith
iverside: University Art Gallery,
niversity of California, Riverside,
988); Nissan N. Perez, Focus East:
rly Photography in the Near
st, 1839–1885 (New York: Harry N.
rams, 1988); Robert Sobieszek
d Carney Gavin, Remembrances
the Near East: The Photographs
Bonfils, 1867–1907 (New York:
e International Museum of Pho-
graphy and the Harvard Semitic
useum, 1980); Thomas Ritchie,
onfils & Son, Egypt, Greece and
e Levant, 1867-1894," History of
otography 3, no.1 (January 1979),
–46.

ison Devine Nordström, "Voyages
er)Formed: Photography and
urism in the Gilded Age," (Ph.D.
ss., The Union Institute, 2001), 3.
rdström's dissertation, which de-
loped from an exhibition, explores
e use of these kind of illustrations,
ecifically, mass-produced souvenir
otographs in the creation of travel
ums by American travelers mak-
g the Grand Tour of Europe prior
1914.

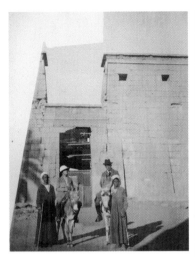 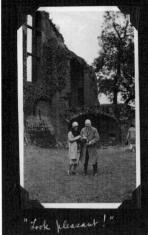 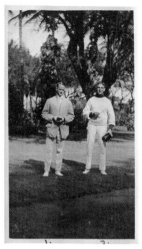 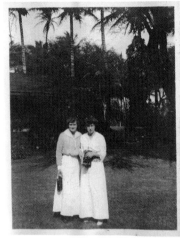

"Look pleasant!"

Others reflect a more personalized approach to travel, an approach that can be seen in elaborate, multi-layered albums with personal photographs, souvenir views, ephemera, and sections cut from travel guides pasted on the page together. Structured or unstructured, travel albums are documents grounded in the personal experiences of their authors. As leisure travel, tourism, and the technologies associated with them—particularly photography—increased, so did the impulse to personalize the experience, to document one's journeys in travel albums that preserved their creator's spirit of adventure and recounted their exploits.

Written narratives were the first mode of recording personal travel experiences, but by the late nineteenth century, photography began to transform the ways travelers told their stories. Souvenir photographs, sold unbound, singly or in sets, presented the opportunity for travelers to create a more personal approach to their journeys. These professional views appear in travel albums alongside engravings and photogravures, sometimes pasted onto the page with little description, sometimes—as in Clara Whitcomb's album—surrounded with narratives taken from Baedeker's or another guide. When using souvenir views, Clara referred to her own experience of the place or the people captured in the image, noting, for example, that the people in the photograph were "like" the ones she had seen in the markets or on the streets of Cairo, or to illustrate a monument she had seen.

Given the initial limitations of photography—the equipment was bulky and heavy, developing negatives into photographs difficult—there was relatively little opportunity for tourists to purchase photographs with themselves in the picture. Many travelers instead bought souvenir photographs and stereographs that depicted individuals taking in the scene at the same sites they had enjoyed on their trip, or perhaps even participating in some of the tourist activities associated with a particular place—such as shooting the rapids under the Old Weir Bridge in Killarney. These photographs tended to be more informal

than standard souvenir views and served two purposes. First, they reinforced how a particular site was to be experienced, with views that were carefully composed to provide the best vantage of a place or monument. Second, they introduced a human element to the picture, an element that likely personalized the place for the tourist who purchased the photograph and probably experienced the site it depicted on his or her journey. The people in these photographs function as "stand-ins," and the photograph itself is indicative of a desire to recreate one's own lived experience, and the desire, if not the ability, to push the boundaries of the available technology. Once pasted into a travel album, generic photographs like these provided a way of reconnecting visually with a lived past.

Purchased souvenir photographs, however, were tolerable only as long as technology prevented travelers from further personalizing their albums and their experiences. The end of the nineteenth century brought a new development in photographic technology—the personal camera—that transformed the experience of travel and a traveler's ability to later replicate and personalize that experience in an album.

In 1888 George Eastman introduced the first roll-film camera, the Kodak #1, pre-loaded with a hundred-exposure roll. The Kodak #1 was a small, box-like instrument that could be held easily and packed in a suitcase. When the roll was completed, the entire camera was returned to Kodak, where the film was processed, the camera re-loaded, and then both returned to the owner so the whole process could begin again—"you push the button and we'll do the rest!" Eastman's invention was revolutionary. Within a decade, the introduction of roll-film cameras such as Kodak's Brownie made it possible for tourists to fix on film their own individual experiences.[9] Equally revolutionary were the ways in which Kodak shaped the cultural conceptualization of photography through advertising and promotional materials.[10] In its many advertisements and photojournals, Kodak taught amateur photographers to see experiences and memories nostalgically and

9 Some have suggested that the introduction of the Brownie marked the "middle-classing" of photography. The history of the role of Kodak in the development and rise of popular photography was first explored by Minna Fisher Hammer in *History the Kodak and its Continuations* (New York: Pioneer Publications, 1940). It has also been the subject of several more recent studies. See for example, Brian Coe and Paul Gates, *The Snapshot Photograph: The Rise of Popular Photography 1888–1939* (London: Ash & Grant, 1977); Colin Ford, ed., *The Story of Popular Photography* (North Pomfret, Vt.: Trafalgar Square Publishing, 1989); and Daile Kaplan, *Pop Photographic: Photography Objects in Everyday Life: 1842–19* (Toronto: Art Gallery of Toronto, 2003), an exhibition catalog.

10 Some scholars call this the "Kodakification" of culture. See, for example, Christina Kochemidova, "Why We Say 'Cheese': Producing the Smile in Snapshot Photography," *Critical Studies in Media Communication* 22, no. 1 (March 2005): 2–25; James E. Paster, "Advertising Immortality by Kodak," *History of Photography* 16, no. (Summer 1992): 135–140; Nancy Martha West, *Kodak and the Lens of Nostalgia* (Charlottesville: University of Virginia Press, 2000; Philip Stokes, "The Family Photograph Album: So Great a Cloud of Witness," in ed. *The Portrait in Photography*, ed. Graham Clark, 193–205 (Seattle: University of Washington Press, 1992); Jeremy Seabrook, "Photography and Popular Consciousness: My Life In That Box," *Ten.8* no. 34 (Autumn 1989): 34–41; and Dan Meinwald, "Picture Perfect: The Selling of the Kodak Image," *Frame/Work* 1, no. 2 (1987): 15–25.

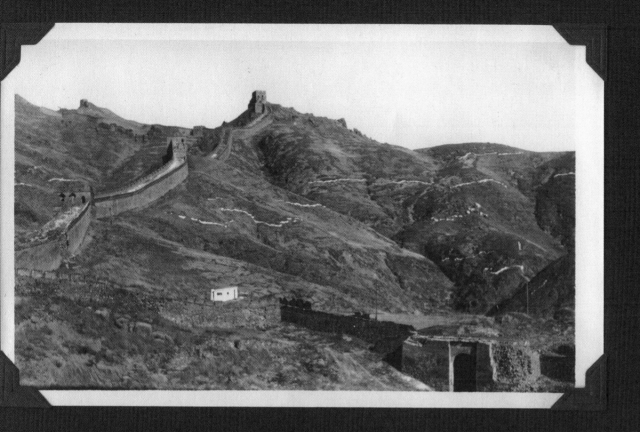

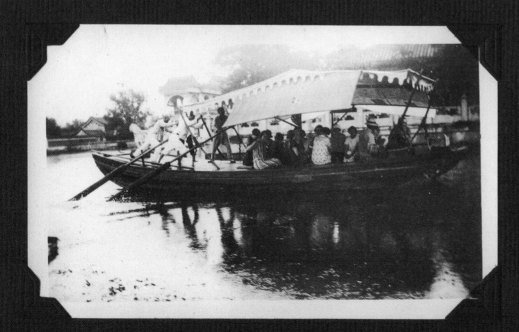

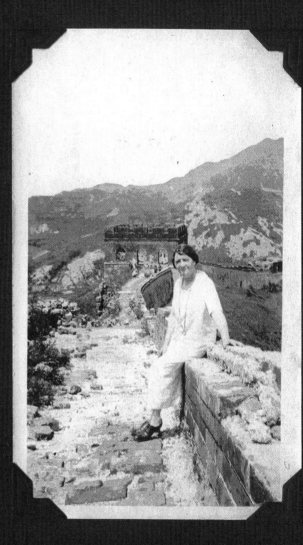

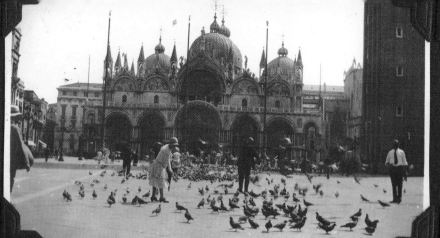

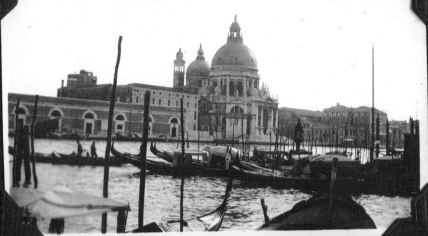

St. Mark's Square - Venice view from our hotel Miss Sax, "weezie

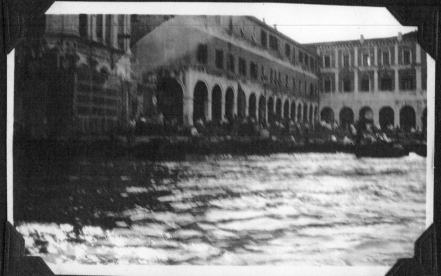

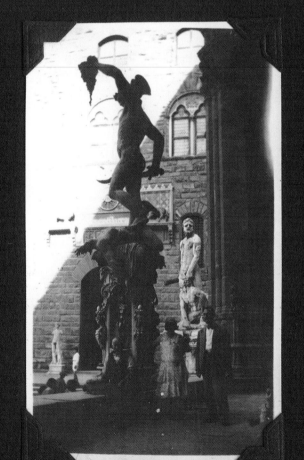

The noisy vegetable market - Venice Flore

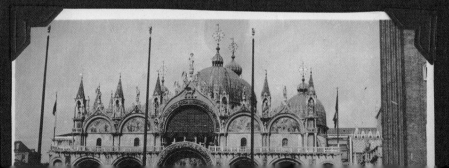

Benvenito Cellini's "Perseus" at Florence, Italy

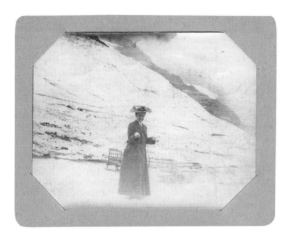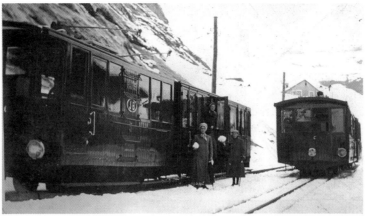

transformed the perception of how individuals could organize, present, and even remember their lives and significant events through snapshots. Photography's instantaneous character became a signifier for its value as a historical document as well as its importance as a tool for capturing memories—stilling a moment in time so that it could be re-told and re-lived later.

Increased access to photographic technology and the popular consciousness that developed around it transformed personal travel and the ways that tourists recorded their experiences. Travelers with a Brownie at their side saw and recorded things differently, in picture and in word. One of the fascinating aspects of travel albums created in this era, when the personal camera was relatively new, is the way the camera itself became a subject of interest—not just the sites and experiences it was brought along to document. In nearly all the albums reproduced in this book, there are photographs of men and women posing with cameras held at their sides or prominently in front of their bodies. It is as if they are asserting their ownership and mastery of the new technology as well as the images it produces and and the experiences they capture: these are not purchased souvenir photographs, they seem to say, but authentic images of an actual voyage taken.

Equally interesting is the willingness to include their "bad" photographs in their albums. In these albums, there are double-exposed and over-exposed photographs, there are pictures that are blurry, streaky, and some with anomalies likely caused during printing. Some authors noted their mistakes, some just put the photographs in their albums, without comment. Why were these included? Perhaps it was the only photograph of a particular place, making the information it contained more significant than the fact that it was flawed. Perhaps the flawed nature of the pictures and their creators' acknowledged lack of mastery of the camera signified in and of themselves a kind of authenticity that was not available in pristine tourist photographs. Or, perhaps, the traveler's acceptance of his own and his camera's limitations signaled his joy at just being able to take photographs, to use the camera to say "I was there" and "I stood here,

on this spot." Photographs of people with cameras, or the "bad" photographs they had taken, solidified the connections between the camera, the visual images it produced, and personal travel.

More significantly, however, the personal camera enabled tourists at last to personalize and privatize an experience of a particular place or monument. The ability to "put yourself in the picture" meant that travelers would never "see" sites and monuments the same way again. Tourists could now take a picture of whatever they wanted, rather than rely upon souvenir photographs and guides to direct their looking and recording. Instead of generic "stand-in" figures experiencing monuments and places, the traveler could have a photograph of their own experience of, say, visiting a church in Rome, standing in the center of Piazza San Marco in Venice feeding the pigeons, or playing in the snow on the slopes of the Alps.

And yet, how unique are these experiences? Not very, if we are to judge from the number of pictures in personal travel albums that show tourists smiling, eagerly feeding pigeons in San Marco or just as eagerly making snowballs in the Alps. Playing in the Alpine snow and feeding pigeons in San Marco evidently are things that tourists to the Swiss Alps and Venice *must do,* it is *de rigueur*—but who or what suggested that it was?

Every travel album contains, paradoxically, unique photographs of tourists doing the same thing. This suggests an interesting dynamic between the private moment and the collective experience of tourism and travel as recreated in the travel album. Many of these private experiences were already situated in the consciousness of their participants, perhaps visualized upon reading a published travel narrative or hearing about a similar experience from another traveler, or viewing a travel brochure or seeing a souvenir postcard or photograph. Their experiences were shaped by this collective culture, which ascribed certain feelings and behaviors to particular sites and monuments. As part of that larger culture, travel albums and the images and narratives they contain in turn shaped, and continue to shape, the experiences of future travelers.

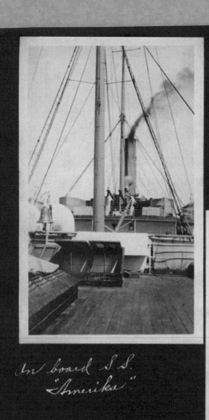

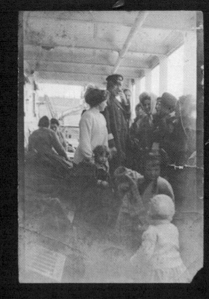

Captain
Smith,
of S.S. Amerika.

On board S.S.
"Amerika"

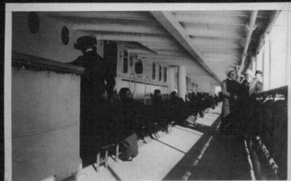

On Kaiser Deck, S.S. Kaiserin Augusta
Victoria

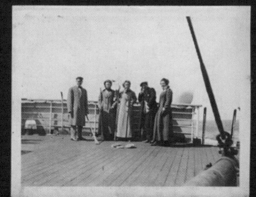

Playing Shuffel-board.

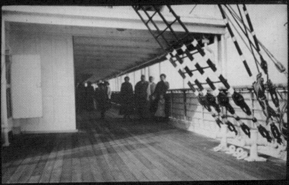

"Sun Deck."

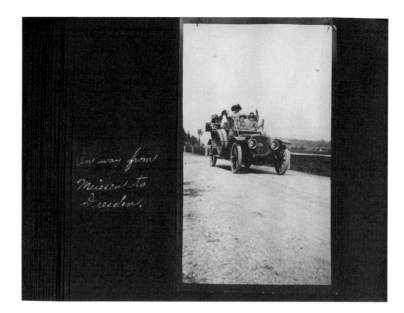

Though travel albums illustrated with personal snapshots may indeed replicate scenes from a collective cultural consciousness (Rialto Bridge, the Grand Canal, St. Peter's in Rome, Castle Pfalzgrafstein in the middle of the Rhine, the Eiffel Tower) what is remarkable about many of them is how that collective consciousness was itself altered by the ability to put one's self in the picture, and in so doing, to shape the way in which a particular place *existed* for a specific person at a particular moment in time.[11]

For example, while tourists continued to make photographs that looked exactly like souvenir views, only with the tourist or her companions in it, there appeared to be an increasing interest in the individual experience of the place, rather than the site itself. Photographs that actually document monuments and sites in a standard way—that is, taking a picture of the whole building or site from a traditional vantage point so as to provide the best view—began to disappear, replaced by something new: the private experience imposed upon the larger, cultural one. Pompeii is cropped, as is the Coliseum. St. Peter's in Rome is relegated to a columned marble hall with indefinite edges, and Cologne's cathedral is barely visible. What we see of those monuments is the tourist exploring them; if we see a column or a fresco it is only because someone is standing nearby.

Indeed, the personal camera offered travelers the ability to document the most mundane and intimate experiences of travel. These kinds of experiences were not available in standard tourist photographs, which were concerned only with the notable place or monument one was making the journey to see. Photographs of shuffleboard games, traveling companions and ship officers, leisure time spent on a deck chair, the interior of a hotel room, or the view from the window (is it a good view, or bad?) are recurring motifs across travel albums after the invention of the personal camera.

The personal camera also provided the opportunity for spontaneity: a young woman, elegantly attired, turning to catch the camera's gaze at a café along the Grand Canal; a group of boys resting their bootless feet after a jaunt in the mountains; a young woman standing on the snowy slopes of the Italian Alps, playfully weighing snowballs in her hands. Who are these individuals? Who took their pictures? Did she throw the snowballs? We have no idea, no clue. There is no doubt those back home, reliving the story with the travelers as they shared their albums, got to hear the tale.

For the viewer of travel albums, particularly so many years later, it is these pictures, the personal snapshots, that draw us in, that seduce us with their promise of a story—a story that remains a delectable and enticing mystery. We can page through the published photograph albums by Bonfils, and be interested in the images because they are "old" and because what they document may no longer exist. But they seem impersonal and distant—"unreal," even.

Travel albums are a different experience entirely—they tell stories. Their pages invite questions about personalities, relationships, and experiences. We can never satisfy these lingering questions, of course, because the people in the photographs, and the moment they documented, are gone. Still, travel albums provide a superficial sense of closeness that allows us, in a way, to connect with their creators, to project onto their experiences narratives of great intensity, imagined stories of the author's experiences, as well as stories reflective of our own. Regular snapshot albums enable us to do this as well, but while they may contain a vacation snapshot or two, they do not document the experience of travel, as the albums in this book do.

Regardless of how they were used to tell a story when they were created, the original orality of travel albums disappeared when they left the hands of their creators and their immediate family. And yet, this disconnect only adds to the story and the new experiences that are generated when we look at them decades later. The ability to project ourselves into their story, to recreate and reimagine it from the photographs and ephemera that illustrate it, is one of the things that makes travel albums so enjoyable—they can be re-activated. They become springboards for us to project our own imagined narratives upon them. As objects, travel journals and albums like those partially recreated in the pages that follow are unique expressions of a real journey, physical manifestations of a particular time and place as it was experienced by one particular individual; and yet, simultaneously, they are representations of universal and timeless expressions of adventure and discovery. We turn the page, and enter a new world.

eter Osborne has written an xcellent study of the intersection of hotography and travel, particularly e role that photography played in aping travel and how we experi- ce places. See Peter Osborne, *raveling Light: Photography, ravel, and Visual Culture* (Man- ester: Manchester University ress, 2000).

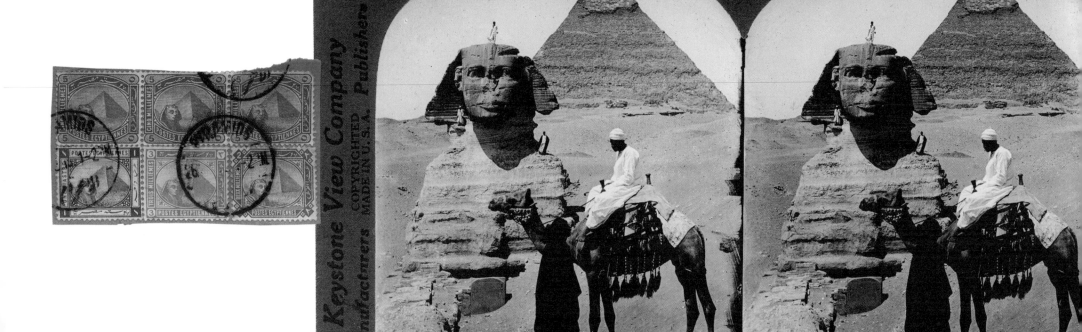

233

9781 T ***Great Sphinx of Gizeh, the Largest
Portrait ever Hewn, Egypt.

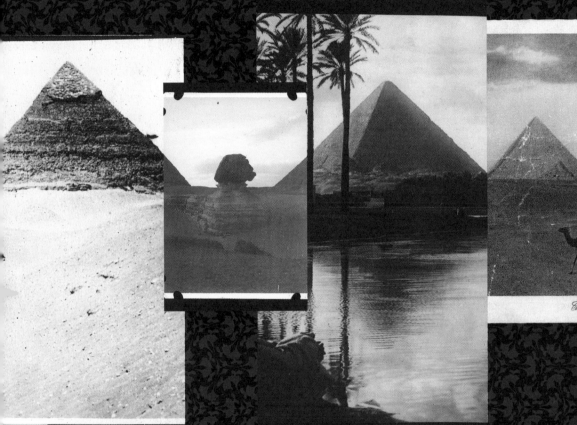

Cairo – The Pyramids of Gizeh

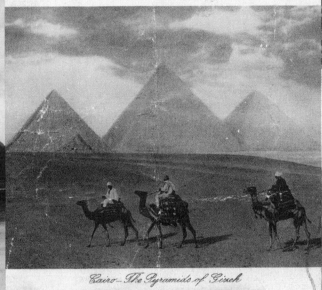

The

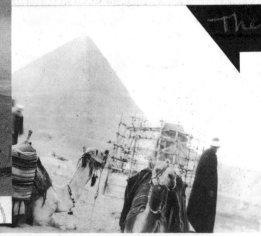

Xmas
1925.

Luxury on the White Star Line

ON JULY 19, 1883, James Duggan and his wife departed New York on the steamship Republic. After disembarking, they spent several months touring the major sights of Ireland, Scotland, and England and later made a trip to Paris before returning to Liverpool for their journey home. Because their journey predates the advent of the personal camera, their album is composed solely of purchased souvenir photographs of sites in Ireland such as Cork, Glengariff, Killarney, and Dublin, interspersed with pages of handwritten receipts for meals and lodging from all the hotels they stayed at during their trip. Lacking cameras of their own, many travelers like the Duggans used souvenir photographs in their albums to record the sites they had enjoyed along their journey.

The couple used a traditional, popular style of Victorian scrapbook to create a memorable souvenir of their trip to Europe.

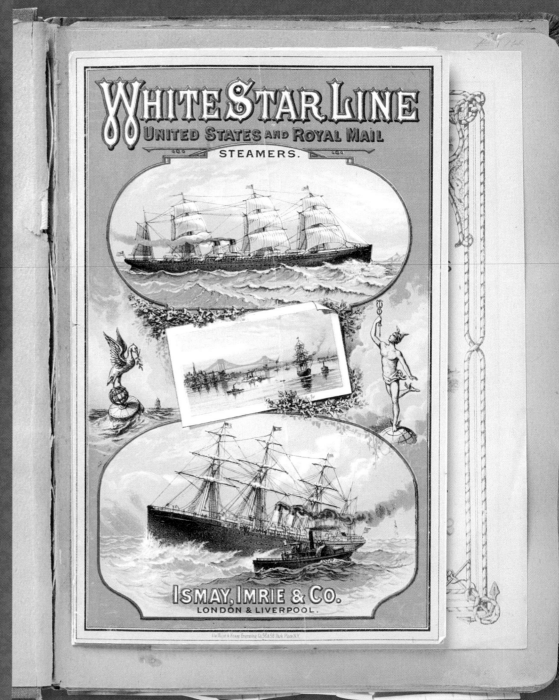

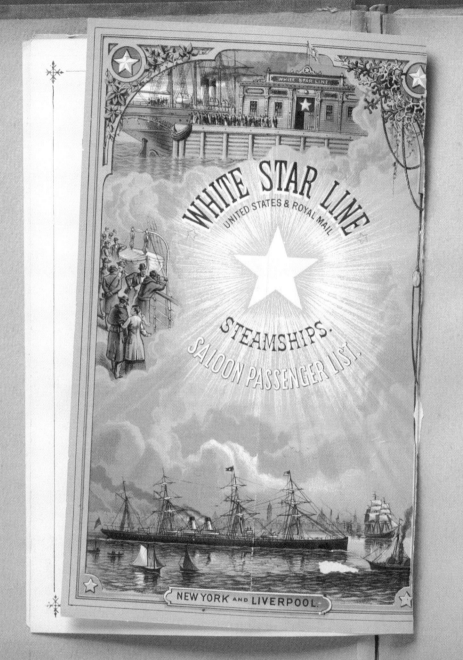

WHITE STAR LINE
UNITED STATES & ROYAL MAIL

STEAMSHIPS.
SALOON PASSENGER LIST.

NEW YORK AND LIVERPOOL.

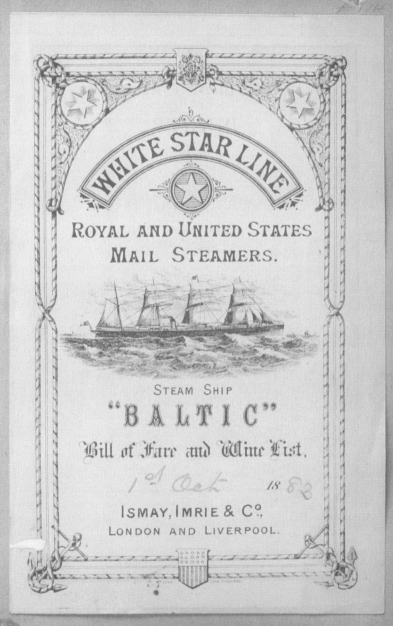

WHITE STAR LINE

ROYAL AND UNITED STATES
MAIL STEAMERS.

STEAM SHIP
"BALTIC"

Bill of Fare and Wine List.

1st Oct. 1882

ISMAY, IMRIE & Cº,
LONDON AND LIVERPOOL.

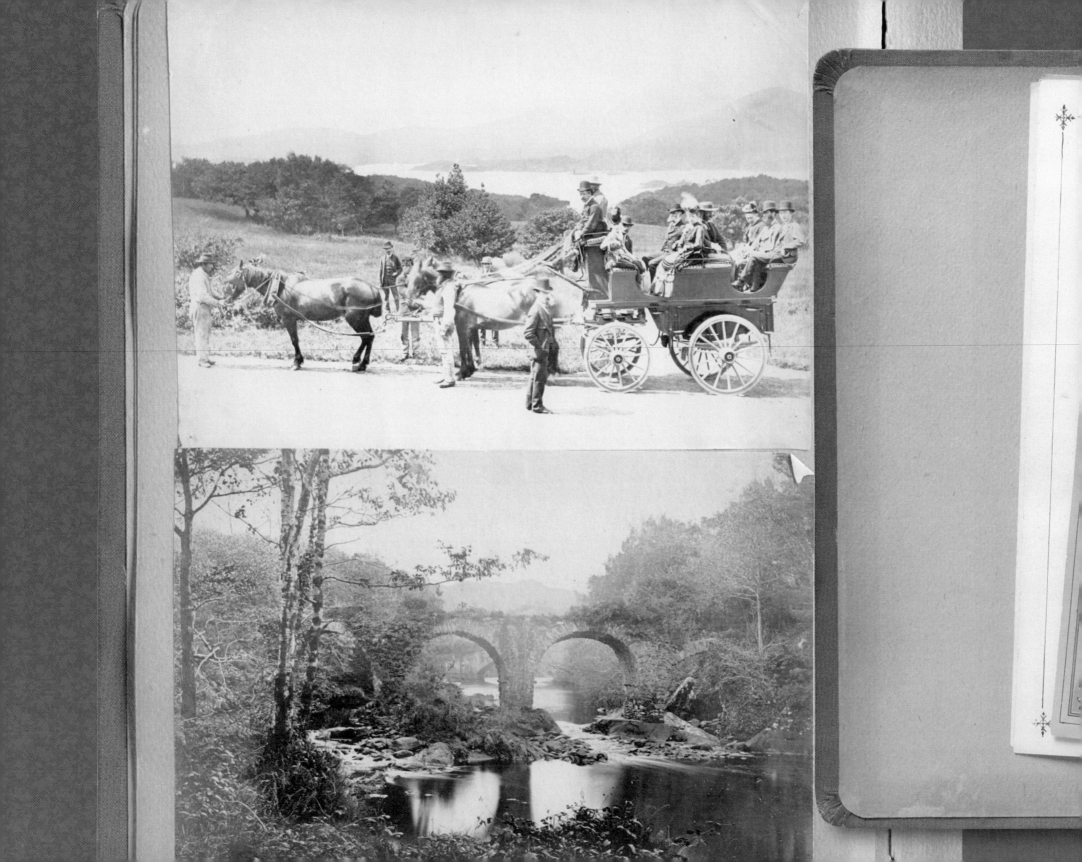

Bill of Fare.

DINNER.

SOUPS

Mock Turtle

Lamb's Head Broth

FISH

Salt Cod

& Egg Sauce

ENTREES

Jugged Hare

Mutton Cutlets aux Petit Pois

Macaroni a L'Italienne

Lobster Patties

ROAST

Ribs & Sirloin of Beef & Horse Radish

Lamb & Mint Sauce

Goose & Apple Sauce

Fillet of Veal & Ham

BOILED

Leg of Mutton a L'Anglaise

Fowl & Bacon & Parsley Sauce

Stewed Ducks & Olives

COLD.

Raised Game Pie . Ox Tongue

Round of Corned Beef

Boiled Ham

VEGETABLES

Sweet Corn . Brussels Sprouts

Mashed & Boiled Potatoes

PASTRY

Blackcap Pudding . Paris Roll

Cerealine Pudding . Brandy Snaps

White Star Cakes

King Henry VIII Shoe Strings

Custard in Glasses

CHEESE

Gorgonzola

Dunlop . Cheshire

DESSERT

Pears . Oranges

Almonds & Raisins

Prunes & Figs

Nuts Assorted

TEA & COFFEE

Mr. and Mrs. Duggan traveled to Europe in style—on the White Star Line's U.S. and Royal Mail steamships *Republic* and *Baltic*. The White Star Line's fleet was considered at the time to be the *sine qua non* of commercial passenger travel. These large, comfortable ships offered every form of luxury, with fine dining being prominent among the proffered amenities. Judging from this handwritten dinner menu, collected by the couple as they returned to New York on the *Baltic*, the dining experience was very fine indeed. On the evening of October 13, 1883, passengers could select an appetizer of Mock Turtle Soup or Lamb's Head Broth, and choose from of a variety of entrees that included Leg of Mutton à l'Anglaise, Goose in Applesauce, and Jugged Hare. The meal concluded with an assortment of pastries, cheeses, desserts, and tea and coffee. Either the Duggans enjoyed this meal particularly, or they considered it representative of the luxury they experienced on board, for they pasted the menu, with its accompanying wine list, near the front of their album, even though the meal occurred at the end of their journey.

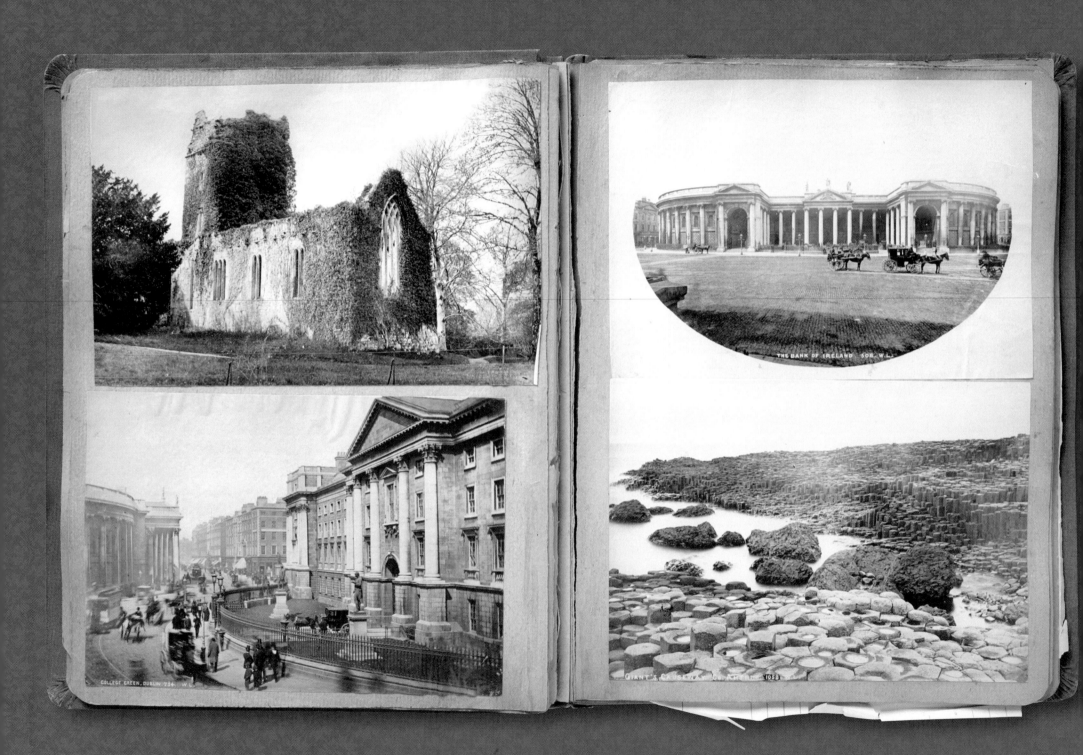

THE BANK OF IRELAND. SOB. W.L.

COLLEGE GREEN, DUBLIN. 754. W.L.

GIANT'S CAUSEWAY. CO. ANTRIM. 1058

Gazette

Lodging

In 1883, the business of catering to leisure travelers was rapidly expanding, and hoteliers increasingly met the challenge of providing services that had once been the sole province of the wealthiest travelers to those of the middle class, who wanted to experience a "little something extra" when on holiday. The Duggans stayed at a number of fashionable hotels while on tour, including the Shelbourne Hotel (built 1824) on St. Stephen's Green in Dublin; Morley's Hotel (built 1831, now the site of Africa House) in Trafalgar Square, London; the Hotel Continental in Paris; Wilson's Royal Victoria Hotel in Cork (note the two x-marks indicating their street-view rooms); and the Imperial Hotel in Belfast. The visitor's card for the Imperial Hotel provided its guests with an additional treat: an optional three-day carriage tour of the sites in Belfast and the surrounding areas, lunch included.

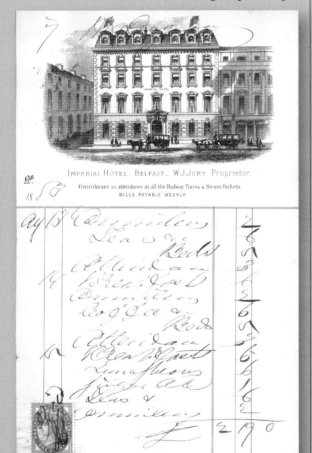

IMPERIAL HOTEL, BELFAST. W.J.JURY, Proprietor.

Omnibuses in attendance at all the Railway Trains & Steam Packets.

BILLS PAYABLE WEEKLY

MAP OF THE BRITISH ISLES.

SHETLAND ISLANDS.

CHANNEL ISLANDS.

29

Despite the amenities available to them, the Duggans appear to have been more frugal on land than they were aboard ship. Their bills from the three-night stay at Morley's Hotel in London's Trafalgar Square reveal that in addition to their room fee and breakfast, lunch, and dinner during their stay, they paid for a bath and for servants to attend to their washing and help them dress for dinner. But, there are no charges shown for such sybaritic luxuries as champagne, wine, liquor, fires in the fireplaces, or cigars. Perhaps they simply had no vices!

In addition to visiting the usual sites and monuments, the Duggans spent time going to the theater and shopping, where they indulged an apparent penchant for fine textiles and leather goods. In Liverpool they purchased a woolen shawl; in Belfast they made two trips to a linen warehouse; in Dublin they bought leather gloves; and in London they visited another purveyor of fine silks, woolens, and laces. In Edinburgh, the Duggans spent an evening at the brand-new Royal Lyceum Theatre. There is no record of what they saw, but in its early days, the theater was host to some of the most famous actors of the day, including Ellen Terry and Henry Irving.

ROYAL VICTORIA HOTEL

HOTEL, CORK.

THE GRAND HOTEL,
LONDON,
W.

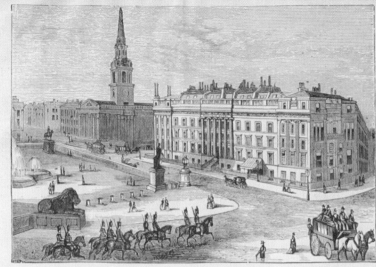

MORLEY'S HOTEL, TRAFALGAR SQUARE.

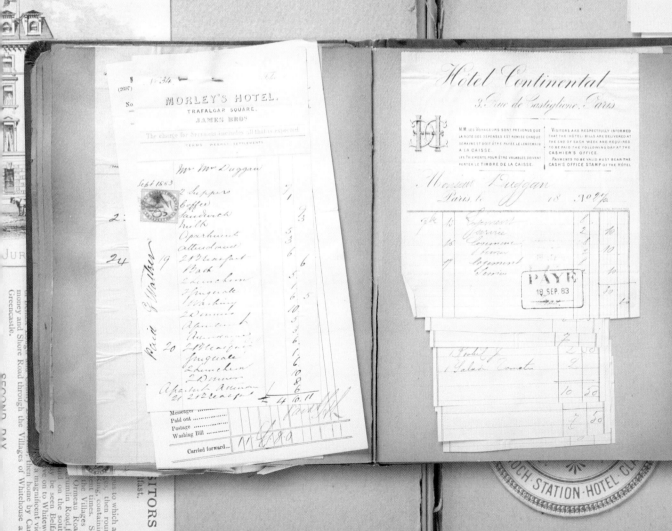

MORLEY'S HOTEL
TRAFALGAR SQUARE.
JAMES BRON

The charge for Servants includes all that is expected

TERMS WEEKLY SETTLEMENTS

Mr Mc Duggan

Sept 1883

Messenger
Paid out
Postage
Washing Bill

Carried forward...

Hotel Continental
3 Rue de Castiglione, Paris

Monsieur Duggan
Paris le 18

PAYÉ
19 SEP 83

SHELBOURNE HOTEL, DUBLIN,

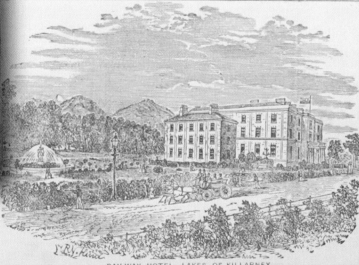

RAILWAY HOTEL, LAKES OF KILLARNEY.

As I Saw the Nile

TWO DAYS after Christmas, December 27, 1898, Clara E. Whitcomb, a young woman from Chicago, began a chronicle of her month in Egypt. Her first entry in the diary reveals that her passage to Port Said from Beirut had been difficult; she confesses to "losing her Christmas dinner" and notes that she hopes to pick up a trunk she had left a month earlier in Jaffa, Palestine, when she traveled north to Lebanon and Syria. From this bit of information, we can infer that this was but one of many journals that Clara kept during her travels in the Holy Land.

Although the diary consists mostly of lengthy narrative, Clara pasted onto its pages souvenir photographs, illustrations clipped from guidebooks and brochures, and a map with her trip down the Nile from Cairo to the Second Cataract, just beyond Abu Simbel at Wadi Halfa. The souvenir photographs in Clara Whitcomb's diary have captions that reflect both personal narrative and encyclopedic facts and figures gleaned from guidebooks she took with her or purchased along the way. She notes, under a souvenir photograph of the Step Pyramid of Sakkara, that her group ate lunch at the site before mounting donkeys and having their picture taken in front of it; another caption for a photograph of Pompey's Pillar in Alexandria records its height, the diameter of both its base and shaft, the date when it was created, and that it is made of Assuan granite. Intriguingly, although she mentions having her photograph taken in front of the Pyramids with her companions, Clara does not include it in her diary. Perhaps she wished to maintain an "authoritative" voice in her album and thought standard souvenir views lent an authority lacking in personalized photographs.

Clara selected this small, but probably expensive, leather-bound diary with its floral endpapers and pages of thick, white, coated paper to record her journey.

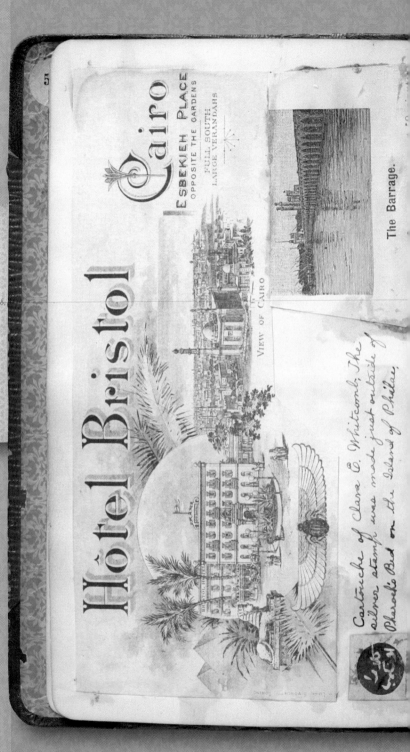

Hotel Bristol 1

Cairo, Egypt. Dec. 27, 1898, Tuesday.

I have just paid sixty cents for this book with the wonder if the notes will be worth as much. I also bought Baedeker on Egypt. The size and contents seem almost discouraging when I think of trying to master the subject. It has been my custom when on visiting a country to do so as thoroughly as possible in history, customs, geographical location, physical conditions; & to take especial notice of the little details that one so seldom finds in books. We reached here last night eleven — that is the hotel. We had direct passage from Beirut (Bayroot) & a disappointed not to stop at Sidon place I have not yet seen — also [—]ia where I expected to take on the [—]nk I left there Dec. 1 when I [wen]t North for Nazareth, Cana, Tiberias [Beir]ut, Baalbek, Damascus, and Palmyra. [Neve]r did I spend a more enjoyable busy

Although Clara mentions having her photograph taken at various sites, she doesn't include them. All the photographs in her album are purchased souvenir views, the kind that any tourist in Egypt could have bought at a hotel, print shop, or from one of her many guides. She captioned each in a neat script, weaving together facts and informative quotes from guidebooks with descriptions of her own experiences and her opinions of what the pictures depict. It is an exotic assemblage. The majority of the photographs are of native people—Bedouins, shopkeepers, veiled women carrying children or jars of water. Clara, who seems both fascinated and repulsed by what she saw, recorded every nuance of her experience, describing in detail what people looked like, how they acted. These descriptions, in conjunction with her frank opinions concerning hygiene and the behavior of the native people she encountered, make her diary as much a revelation of the clash of cultures frequently engendered by foreign travel as it is a record of her journey.

40

61

is not the case north of Kartoum. The houses consisted of mattings. On the floor inside was a circular stone about a foot in hieght covering the floor with the exception of a slight place for walking around it below. The whole house did not seem over eight or nine feet square although it was irregular and although supposed to be circular. On this floor was a covering of two layers of mattings and over it a rug. Much bedding filled up the space that was so dark I could not well see and with the universal dirt I did not care to penetrate farther. A woman sat below making a necklace of small red beads on gazelle-work leather. Her finger nails were freshly decorated with henna that was running over her work. This added to the objection I have for touching native things The woman had been polite, then asked for the bachshieh that she received The villagers on the whole did not cordially welcome us. Some told us to begone. To this we paid as little attention as they do when we say the same to them. but rode along from one house to another, notwithstanding the donkey boys always insisting that we go elsewhere. It is a singular yet unexplainable fact that these boys usually try to take you just where you don't want to go and always on a fast trot or gallop. and when they must run and keep up the same speed.

As we entered the village or encampment we saw the people covering their almost naked bodies. The children were dressed as seen in the above pictures. The hair of the girls is braided in small strips, well greased, and often the ends are fastened by pieces of Nile mud. The matting in the back ground is the outer wall of a house. Here only have I seen people with red hair. It does not improve their appearance.

kind of a game. Most of them had
at least a garment on which to kneel,
several a matting; one a large matting
with a mud coping around it on three
sides. All were facing us — looking
towards the East. Five times a day
from the minerets are the calls to pray,
rather should I say four as once the
call is at night — twelve o'clock, — if
I remember. It has never made any
impression on me, nor have I heard
any one allude to it. yet in the books
and letters I read before coming abroad
people were much moved by it. At
eight we reached Cairo and I soon
in the English Pension and in the
same room I had on first coming
to Cairo. It is a cold one as the sun never
reaches it. In the sunny rooms one
baths in the most delightful sunshine.
Cairo seems to have a most enjoyable
climate a summer one to be sure, yet
neither too cool nor warm. The seasons
seem all wrong in this land of perpet-
ual summer. It is hard to realize
that while we are in summer wear and
no fires, and no chimneys that there
can be snow, ice, and freezing winds
in other sections of the world.

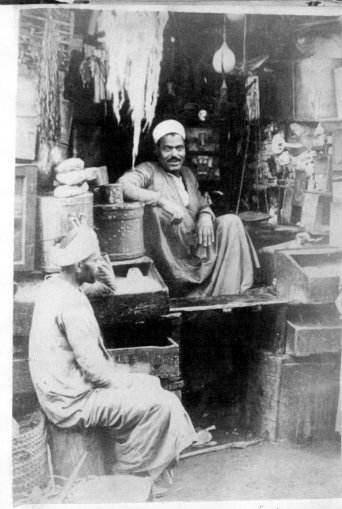

A typical shop in Assuan. "At Assuan
we bade farewell to Nubia and the blameless
Ethiopians, and found ourselves once more
traversing the Nile of Egypt. If instead of
five miles of Cataract we had crossed
five hundred miles of sea or desert, the

On January 6, 1899, Clara and her group of companions left Cairo for the five-hour journey to Luxor, traveling by train and the steamship *Mayflower*. Despite the fact that they were traveling in a first-class compartment on the train, several natives, including what Clara described as "a dirty child and a dog," sat next to them, causing a scene. It seems that although Clara wanted to see the natives—many of her souvenir photographs catalog different "types" of Egyptians—she did not want to sit next to them or in any way come into actual contact with them, particularly in first class. She writes of her relief in leaving the dirt and the natives, escaping to the pleasant confines of the *Mayflower*'s deck.

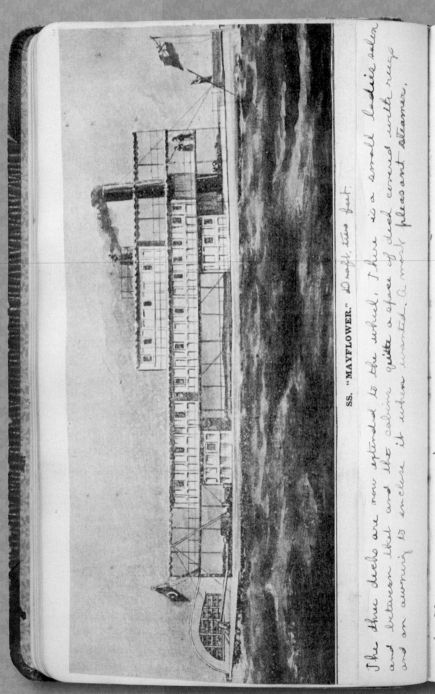

SS. "MAYFLOWER." Draft, two feet.

The three decks are now extended to the wheel. There is a small ladies salon and between that and the cabins quite a space of deck covered with rugs and an awning to enclose it when wanted. A most pleasant steamer.

On board Mayflower, Friday Jan. 6. 1899. Luxor,

Yesterday morning at eight we left Cairo reaching here this morning at one. The two most unlimited things I've observed in Egypt are time and space. We were slow in leaving the pension, then the driver started down toward the river, so we supposed he thought we were to take a steamer, when we noticed where we were going. It took time to get back to the station where we were just in time The car was crowded so we had to sit down with people who had a dirty child and dog. The dog was lost when they got out Next some natives sat down in our compartment and began to smoke. We objected and there was quite a scene which was ended by their being given seats in the next car. As this was first class we saw no more of them. We were left in peace the remainder of the journey that could not have been dirtier. The dust was so great we could see it as rain, and glad enough we were when at last it ended. We were driven at once to the steamer. During the day we saw several sugar cane mills belonging to the Kedive. He has the monopoly in Egypt. Tracks led off in various directions to take the cane to the mills. Also we saw houses of cornstalks wo-

Money

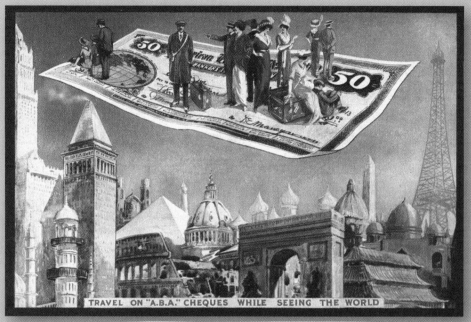

TRAVEL ON "A.B.A." CHEQUES WHILE SEEING THE WORLD

A journey like Clara Whitcomb's probably entailed travel through several countries, each of which used a different currency. By the time she arrived in Cairo, Whitcomb had likely used British pounds, French francs, and the currency of several other countries visited along the way.

The chart she pasted on the inside of her journal's cover illustrates one of the many ways she and other travelers managed to make sense of the currency of foreign lands. These drawn-to-scale pictures of Egyptian coins helped Clara recognize them without having to translate the Arabic inscriptions. The notation of equivalent values as well as exchange rates in pounds, francs, and dollars helped her understand expenditures in terms that were more familiar.

But how did Clara get more money when she needed it? Early travelers had no option but to begin their journeys with as much money as they could, in cash or on whatever credit they could acquire. By the 1870s, as international leisure travel increased, companies were stepping forward to take advantage of new inventions that helped streamline, among other things, the exchange of currencies. The invention of the telegraph in 1844 enabled Americans to communicate with each other over long distances. In 1851 a cable was laid across the English Channel, and by 1866, two transatlantic cables had been laid and were in use. These cables facilitated the global financial network that makes traveling—and paying for it—much easier today. Thomas Cook & Son was soon wiring money for its customers, and in 1871, Western Union introduced its money transfer service. These services corresponded with the introduction of the traveler's check, which Cook is said to have pioneered in 1873 with the Cook Circular Note; American Express introduced their own version of the traveler's check in 1891, eight years before Clara's trip. The ability to wire funds, and to use notes of credit that were recognized by overseas representatives, greatly facilitated travel for nineteenth-century explorers like Clara—but it did not reduce the headache of exchange rates and exchange fees, two things that continue to plague travelers today.

VALUE OF THE EGYPTIAN SILVER MONEY.

	Piastres 20 Tarif	Piastres 10 Tarif	Piastres 5 Tarif	Piastres 2 Tarif	Piastre 1 Tarif	Piastre ½ Tarif (Nickel)
Value francs	5 f., 20	2 f., 60	1 f., 30	0 f., 52	0 f., 26	0 f., 13
shillings	4/2	2/1	1/½	5 pence	2 pence ½	1 penny ¼
cents	104	52 cents	26 cents	10 c. ¼	5 c. 2	2 c. ½

Equivalent of European gold in Egyptian silver Money:

Pound sterling . . = Piastres 97 ½ tarif

20 francs piece . . = do. 77 — do.

Gazette

The area Clara covered in her Egyptian travels can be seen on this map, which she pasted into the back of her diary. Clara's routes included a trip down the Nile from *Cairo* to *Luxor*.

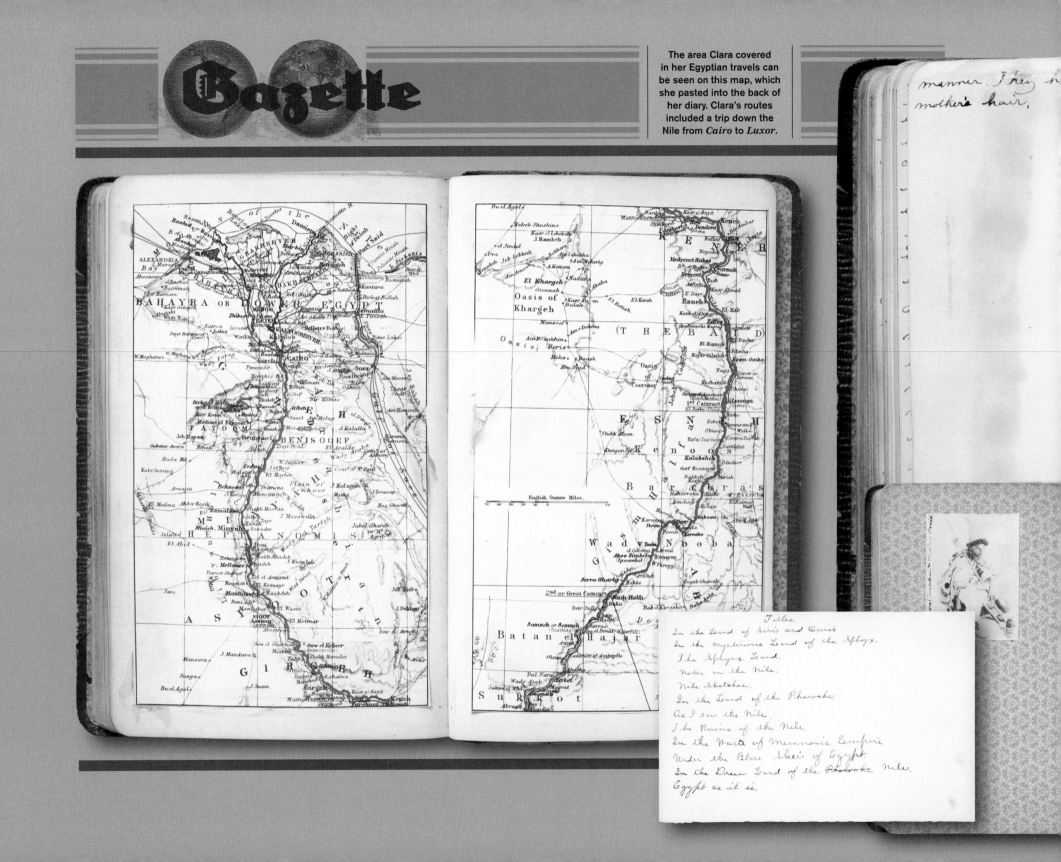

manner. They h
mother's hair,

Titles.
In the Land of Isis and Osiris
In the mysterious Land of the Sphynx.
The Sphynx Land.
Notes on the Nile.
Nile Sketches.
In the Land of the Pharaohs.
As I saw the Nile.
The Ruins of the Nile.
In the Waste of Memnon's Empire.
Under the Blue Skies of Egypt.
In the Dream Land of the ~~Pharaohs~~ Nile.
Egypt as it is.

97

82 Caire. Le Sphinx d'ablouge— Siouill

Wednesday Jan. 25, This is the day Dr. Beiler left for Greece. In the afternoon I drove with Miss Caruthers to see the Sphinx and Pyramids by moonlight. We took tea at the Meni House. I hurried though it as the sun was almost set. Walking rapidly I was just in time to see the last shadows that seemed so pointed & sharply outlined on the bright green fields and al—

On page 97 of her diary, Clara pasted a photograph of the Sphinx and Pyramids, writing "I drove with Miss Caruthers to see the Sphinx and Pyramids by moonlight." She reached the site just as the sun was setting, and her description of the lengthening shadows and the outline of the monuments becomes poetic. She wrote in her diary, "Walking rapidly I was just in time to see the last shadows that seemed so pointed and sharply outlined on the bright green fields, most reaching to the banks of the Nile that are five or six miles away."

Although it was evening, Clara had to make a special effort to have what she considered the proper vantage point of the monuments, dodging camel drivers and souvenir hawkers until she "had a view all alone in peace and quiet, and evening light…" Even without the hordes of other tourists that populated the site in daylight, Clara wanted to experience the monuments the way she saw them in photographs—timeless, and without the intrusion of tourists like herself, or those who were making a living from her travel.

In page after page of her diary, Clara offers her insights, observations, and honest opinions about the things she sees and how she sees them—her tone is very serious, as if she approached her tour of Egypt as work rather than leisure. Although the photographs she used to illustrate her diary are generic, her narrative is deeply personal, reflective of her time, place, and social status. Perhaps Clara had intended a wider audience for her diary, for at some point she jotted down prospective titles for a book: *The Sphinx Land, Notes on the Nile,* and *Egypt As It Is.* Had it been published, Clara's diary would have joined the burgeoning number of personal travel narratives published during the period, books that sought to capitalize on the tourist trade and the desire to "be there" without leaving the comfort of one's own armchair.

45

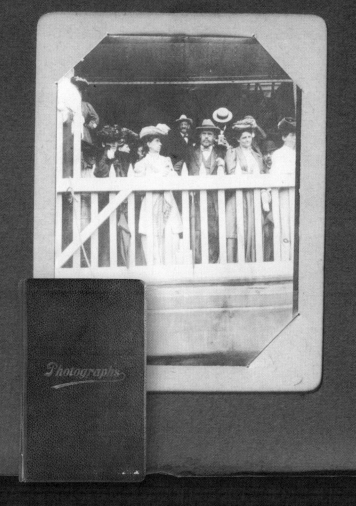

—1905—

An Italian
Idyll

I N **1905,** a young, unidentified couple from Worcester, Massachusetts, traveled to Europe with a hand-held Kodak camera at their side. On the inside of their album's front cover, faint with age, is a loving inscription from the wife revealing that the completed album was a Christmas present to her husband.

This is the first album of those presented in this volume to use personal snapshots, and it contains many evocative and stunning photographs, including images of the ruins of Pompeii, Venice, the castles along the Rhine River, and the Eiffel Tower in Paris. These photographs, infused with the photographer's personal visual style, reveal the beauty and wonder of the sites seen and through their use of light, shadow, and creative composition demonstrate with perfect clarity the budding relationship between travel and amateur photography. The album provides a window into how the new medium of photography shaped, and was shaped by, their experiences, as it did for many other travelers who suddenly had the ability to personalize their travel memoirs with snapshots, rather than relying on souvenir photographs with formal, standardized views of places and monuments.

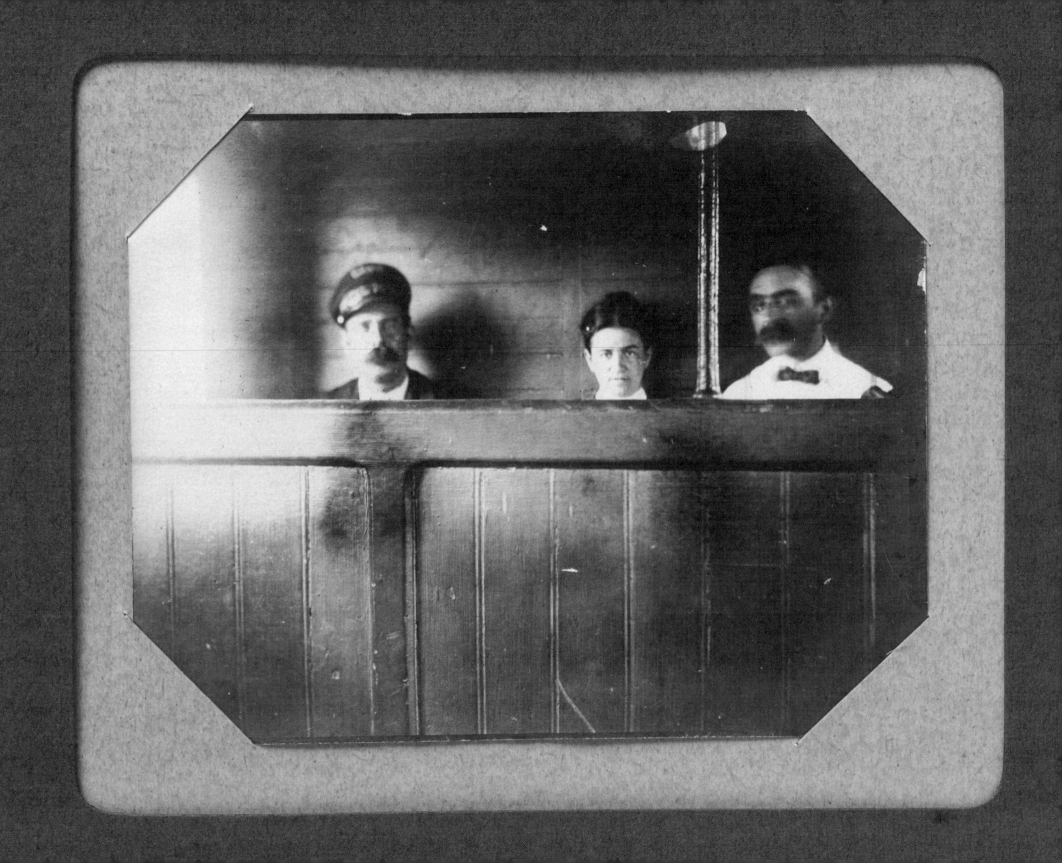

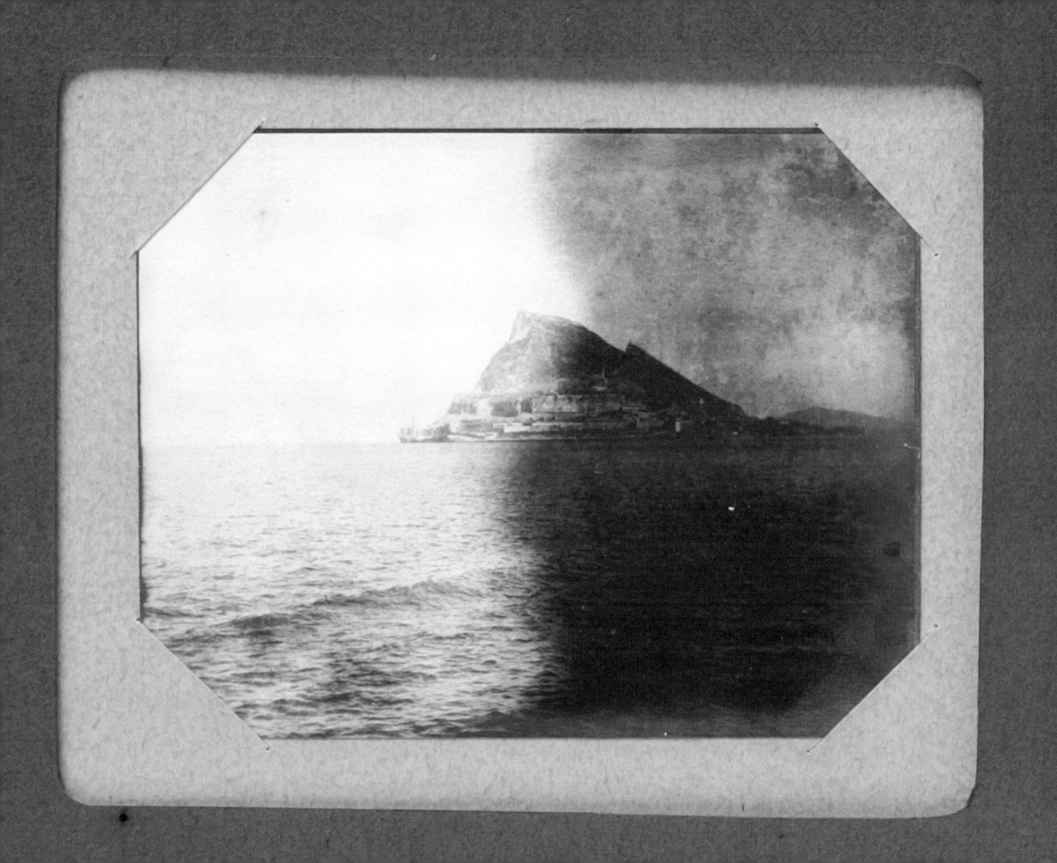

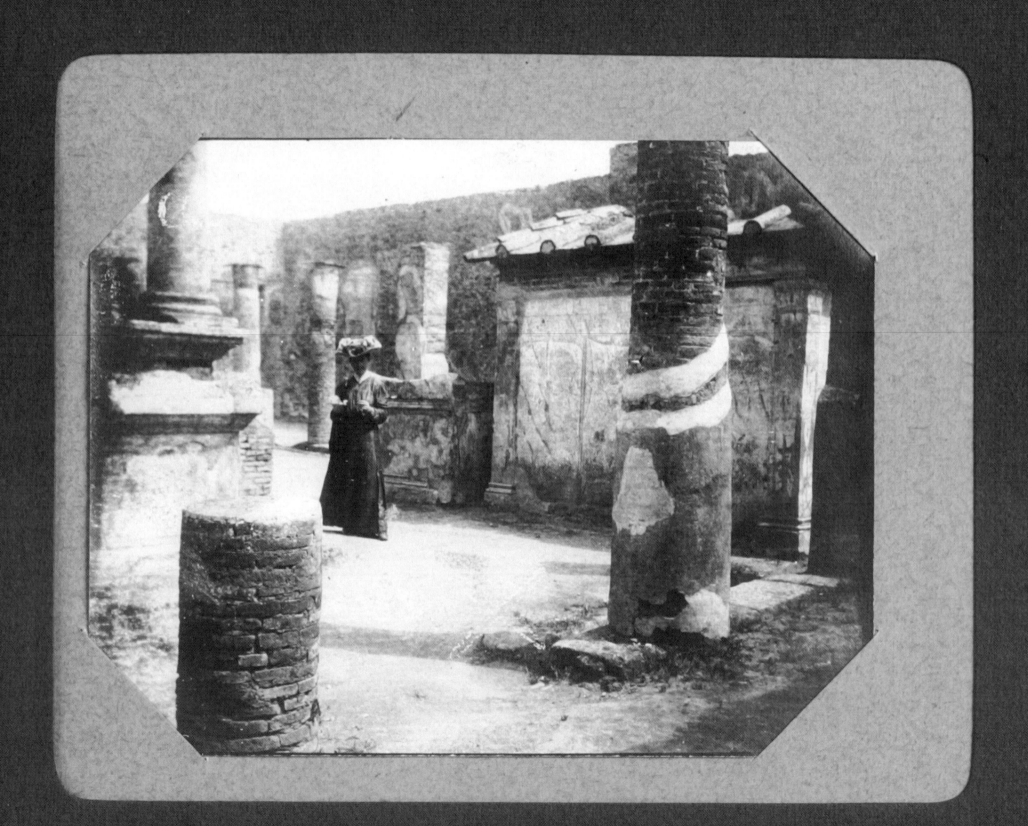

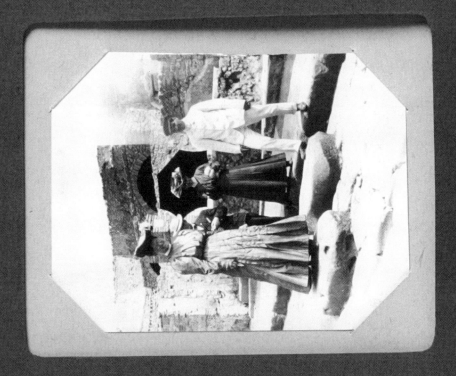

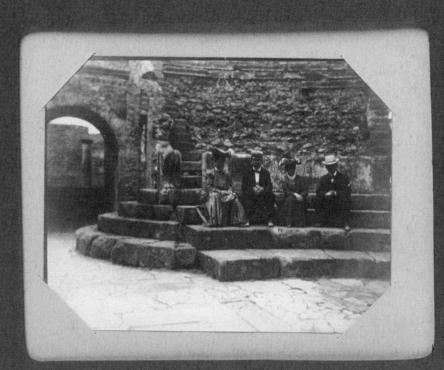

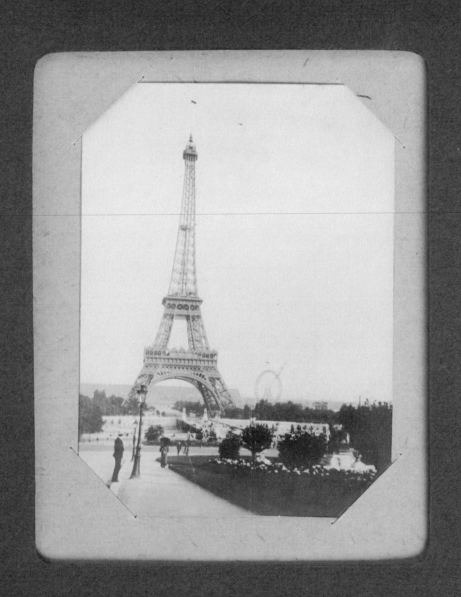
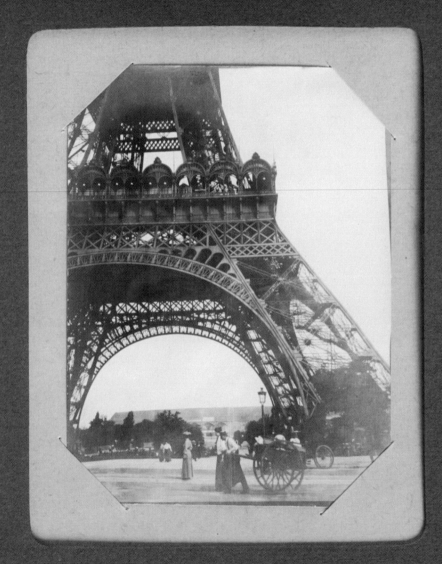

Gazette

The Camera

As the photographs in this album suggest, the era of the personal camera had dawned. Suddenly, taking pictures was becoming an integral part of the leisure travel experience. Whoever was holding the camera on this couple's trip was clearly captivated by its power to capture, for the first time, not only stark visual information, but a feeling of what was being seen and experienced. This couple may have been subscribers to *Kodakery*, "A Magazine for Amateur Photographers," which contained articles on lighting, exposure, and composition, as well as feature photo essays with titles such as "Around About the World" or "The Pictorial Diary of Our Trip Abroad." Such magazines provided instruction to camera enthusiasts on how to take photographs while on trips abroad, and may have inspired the Worcester couple. Certainly the resulting photographs are exquisitely composed and sophisticated.

Sometimes, as seen in this album, the camera itself became a preoccupation that trumped famous sites and monuments. Throughout this album, there are photographs of others holding up cameras or advancing the film forward to the next exposure. In one photograph, its subjects look back at us, as if laughing at their visual double entendre—they are also taking a picture of us, just as we are taking a picture of them.

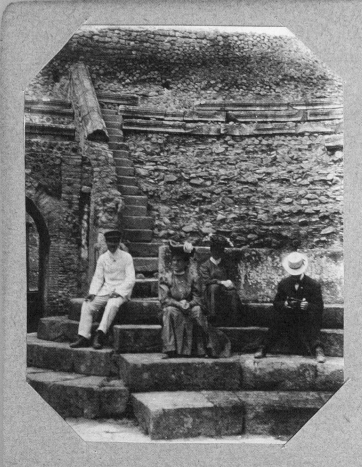

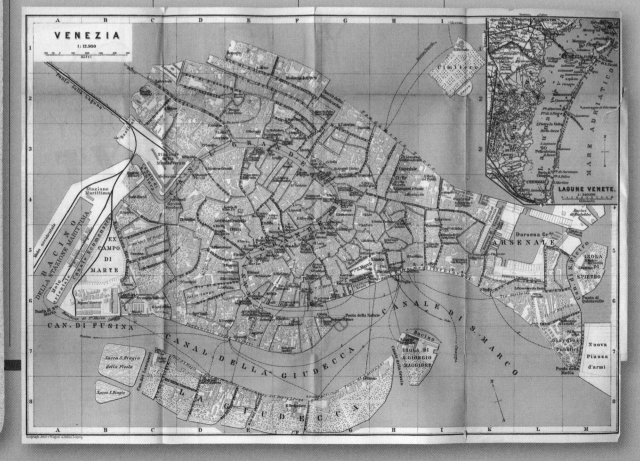

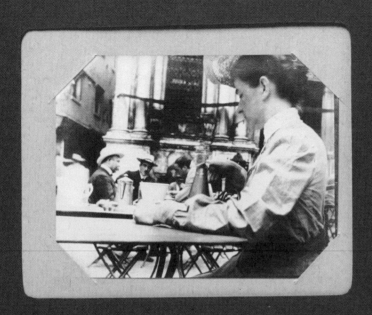

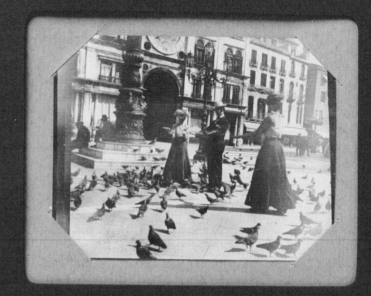

54

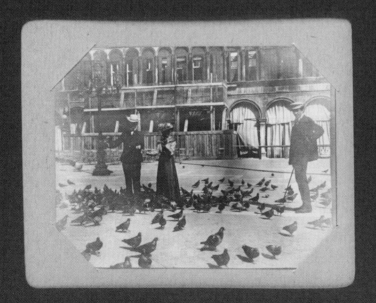

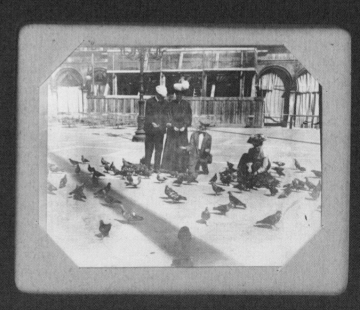

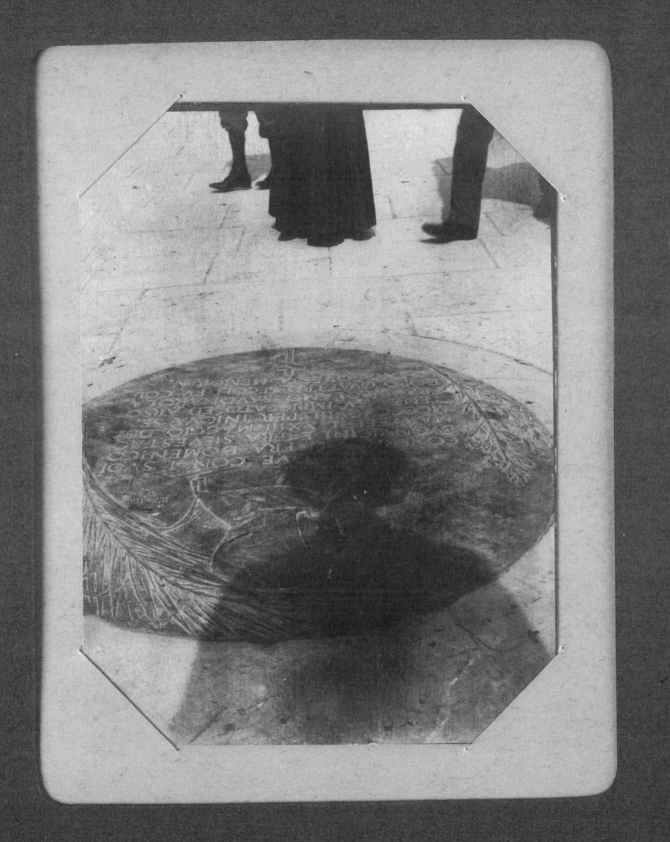

While the couple carefully documented some of the famous sites they saw on their trip, the majority of the album is concerned with personal images like these, the wife enjoying coffee and biscotti at one of the many cafes that line the Piazza San Marco in Venice, or feeding the pigeons—classic tourist snapshots that seem to transcend time. The close-ups and imaginative angles in some of these images testify to the level of skill and artistry of the photographer.

Although the couple traveled to London at the end of their journey, we see very little of its monuments in their album. Instead, the story they chose to tell was a more personal one about their experience as travelers and tourists. Often, they turned the camera inward to record highly intimate subjects, such as the husband resting in their hotel room.

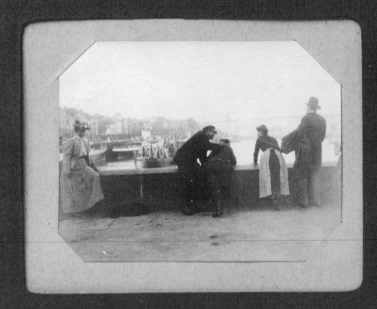

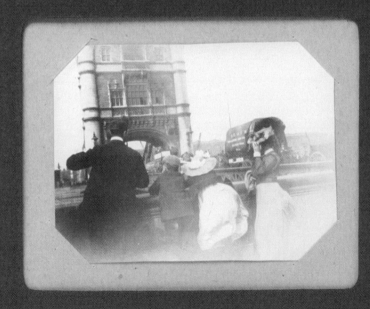

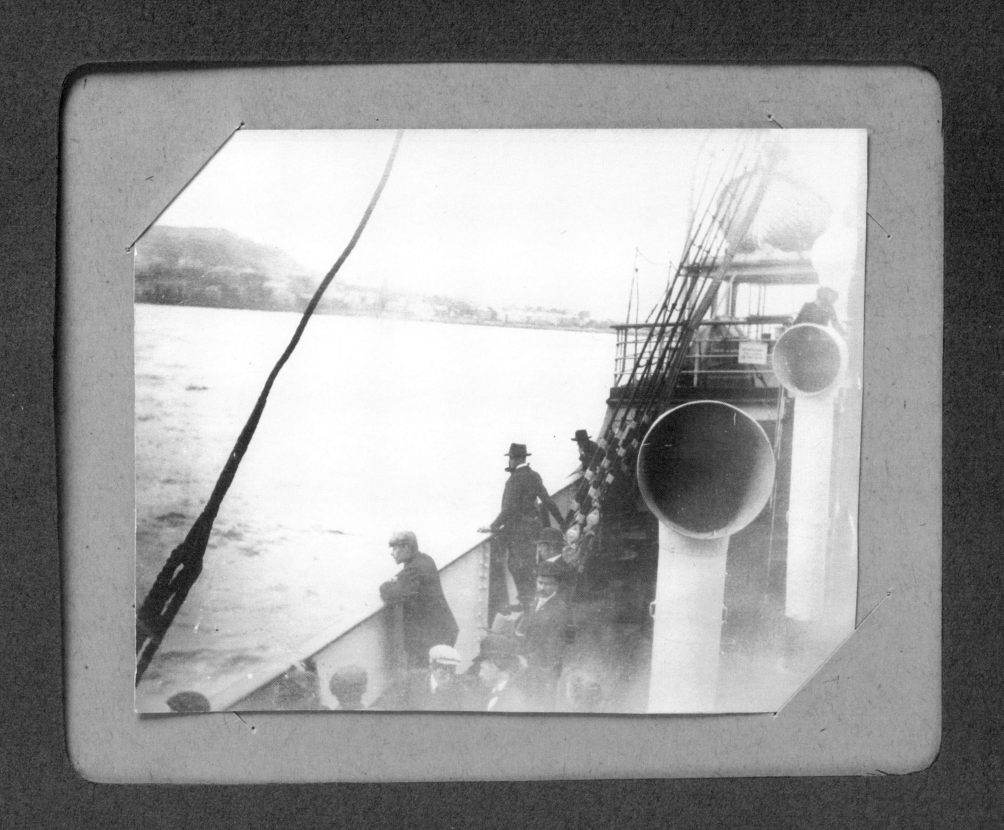

An Alpine Adventure

I N JULY 1909, S. D. Stevens traveled to Europe with his family and a small group of friends, crossing the Atlantic on the SS *Lucania*, bound for Scotland. Like many Americans, the Stevens family had relatives in Europe—in this case, Uncle John and Aunt Nellie Maclaren in Edinburgh—with whom they visited before setting off on the rest of their European tour. Stevens chronicled his eight-week journey through the British Isles, Holland, Germany, and across the Alps into Switzerland using his Kodak No. 3 camera. The No. 3 was a vertical, folding-bed camera with a wooden body covered in leather. It used roll film with six or twelve exposures—Stevens must have carried quite a stash of film with him on his trip! Perhaps not surprisingly, a number of the images in his album suggest, in both composition and subject, a familiarity with pictures by well-known photographers of the nineteenth century, such as Francis Frith, Bisson Frères, and Würthle & Spinnhirn.

It is obvious from the photos and commentary in Stevens's album that he was fascinated with cameras and the photography. The opening page of the album has the inscription: "Pictures taken by S. D. Stevens Jr. on European Trip during July, August, September 1909. Eastman Kodak No. 3 Used." The presence of the camera is so strong that you can easily make the case that he is as interested in the process itself as in the subject of his picture. The photographs in his album reflect his interest, shared by a growing number of his contemporaries, in not merely capturing a personal experience, but also in *how* one captures it. The result is an album compelling in its intersection of planned technique and the immediacy of the snapshot. An entire two-page spread of photographs taken from the window of a moving train documents the Black Forest countryside, several streaked with lines of motion as the photographer, camera, and train rush past. That Stevens chose not to edit these photographs out—indeed, that he took up two pages of his album to present them—suggests that he was not so much interested in the scenery they captured, but in the way the camera, in his hands, captured it while moving.

Photographs throughout these pages indicate Stevens's abundant interest in making pictures that have nothing to do with the monuments or rural villages seen on his trip. While touring Loch Tay in the Scottish Highlands, Stevens pointed his camera not at the scenery around him, but toward the seagulls flying alongside his boat, their wings a blur of white, catching bread thrown by his traveling companions—perhaps to entice them closer, to help him capture the birds in motion.

July 20- Seagulls following boat on Loch Tay in the Highlands. The birds caught bread thrown to them.

July 23- Warwick Castle. Watch
tower among trees

July 23- Kenilworth Castle.

July 26- Band concert in Hyde Park,
London. Fine carriage and horses
listening.

July 26- Driving in Hyde Park London.

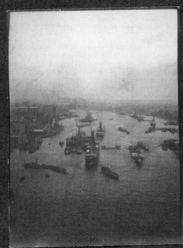

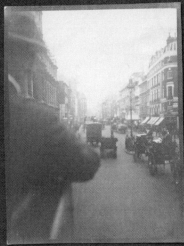

July 24- View of Thames
from London Tower Bridge

July 25- A London Street from
top of omnibus

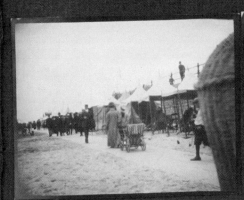

July 29- On the beach at Scheveningen
near The Hague.

July 29- Building where peace
conferences were held at The Hague

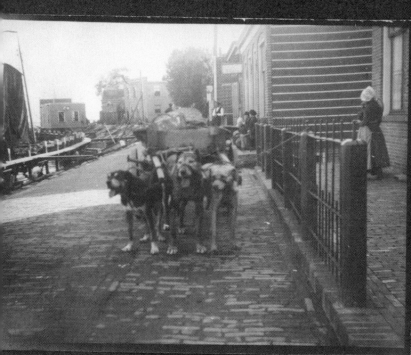

July 31 - Dog harnessed to milk cart at Volendam

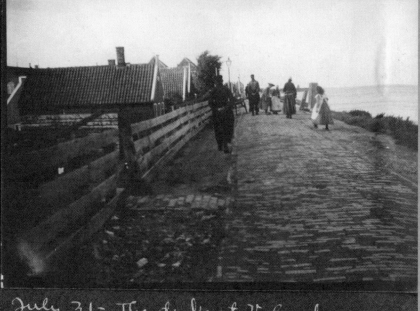

July 31 - The dyke at Volendam.

Volendam, a Dutch coastal town, apparently captivated Stevens: he devoted ten pages in his album to documenting its picturesque architecture, the fishing boats in its harbor, and the daily life of its inhabitants. Many of these photographs are interesting for the sheer artistry with which Stevens composed them, others for the wealth of information they contain about a rural village untouched by modern industrialization. Stevens's detailed captions similarly reveal his fascination with the town and its way of life: the milk cart he notes at the top left appears in a previous photograph, where he notes that it is harnessed to a group of dogs.

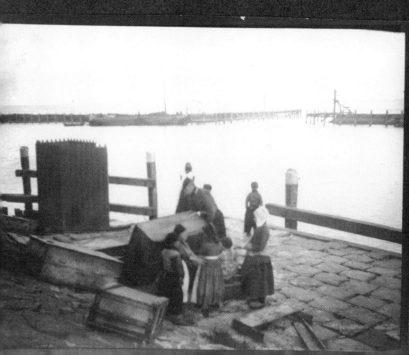

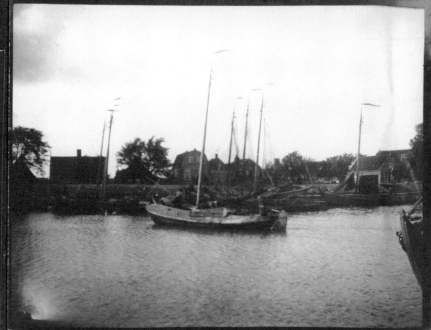

July 31 - Volendam from the breakwater across the harbor

Aug 2. Zeppelin in his airship just overhead. Camera pointed vertically so that part of smoke stack of boat is seen

Aug 4. First view of Lake Lucerne
From car window on train going
through the Black Forest from Heidelberg

Stevens's caption for a photograph of another novel invention, the Zeppelin airship, affirms his interest in the way he made his pictures. He notes how he angled his camera to frame the photograph as both a document of an experience and an artistic product: "Camera pointed vertically so that part of smoke stack of boat is seen." The smokestack and Zeppelin locate the photograph at a point in Stevens's journey and in historical context (the Zeppelin had just been purchased by the German government), but it also becomes an artistic, carefully composed and nearly abstract picture of geometric shapes. The Stevens album is unique among the ones represented here for its use of photography as a creative medium as well as a documentary device.

63

Most of the highlights of Stevens's trip appear to have been his mountaineering expeditions in the Alps with his friends—they seem, in fact, to be the primary subject of his album and were, perhaps, the main reason for his European tour. The photographs that he took on his far-flung hikes highlight an aspect of travel rarely seen in private albums from this period.

Stevens's stunning photographs of glaciers and mountain peaks suggest new ways of looking, of framing a view, that were likely as much a product of camera technology as the early twentieth century's increasing interest in abstraction. Illustrations published in guides, or the sites and monuments reproduced in souvenir photographs, tend to be documentary; they take in the whole scene, rather than focusing on particular details. Stevens's photographs of hiking in the Alps, however, are incredibly modern. In places, he crops his photographs so that all sense of scale is lost: gorges, glaciers, and snow-covered slopes become disembodied, tonal shapes composed of varying qualities of light and darkness. Few traveling snapshooters were so adventurous, in either the terrain they photographed or the photos themselves.

By 1870, all the principal Alpine summits had been scaled, and photographers like Bisson Frères had published books such as *Le Mont Blanc et ses glaciers* (1860) that captured the beauty of the region. Given Stevens's interest in photography, these or similar books might have fueled his interest in taking his camera to the top of the mountains and trying his own hand at making photographs of the glittering snow-covered slopes. His pictures of the Matterhorn from Gornergrat are breathtaking in their clarity, and Stevens's ability to juxtapose the filmy clouds with the hard and angular peaks of the mountains is remarkable for an amateur.

64

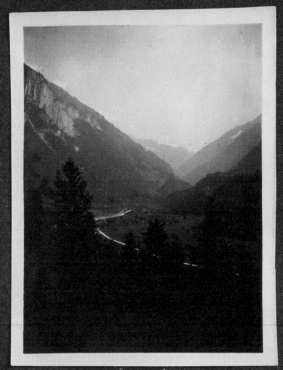

Aug 13 - Looking down the Grimsel Pass to Meiringen.

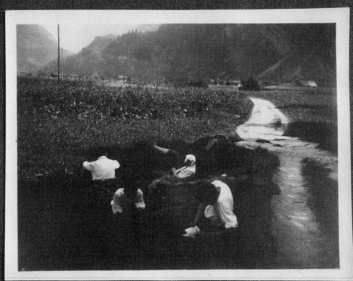

aug 13 - Resting near a brook on our first day's walk. Rad has foot in air.

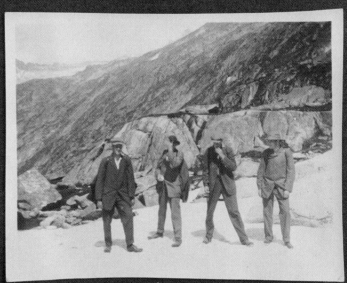

aug 14 - Thayer, Rad Bob, Dale part way up Grimsel Pass.

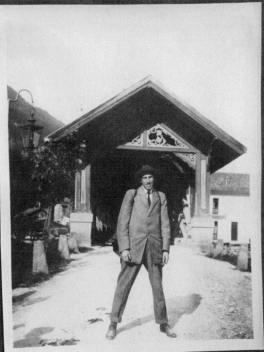

aug 13 - Rad just after he bought a felt hat at

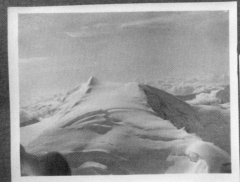

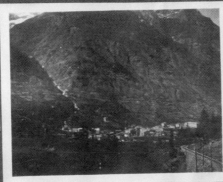

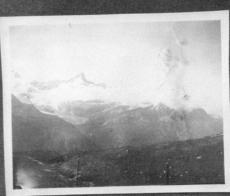

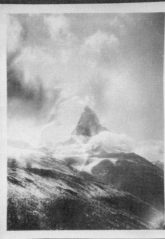

Aug 24 — Looking toward Italy from the Gornergrat showing snow slopes and clouds. The Strahlhorn.

Aug 24 — Zermatt with patches of cultivated land on slopes of valley behind it. On right is railway up the Gornergrat.

Aug 24 — Another view from the Gornergrat.

Aug 24. The Matterhorn from the Gornergrat at Zermatt.

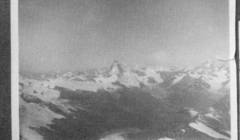

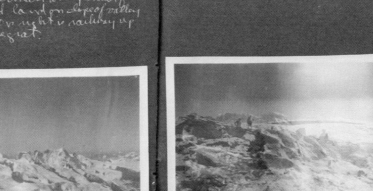

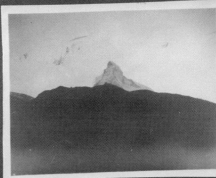

Aug 24 — The Matterhorn and other peaks from the Gornergrat.

Aug 25 — View from top of the Rumpfischhorn of the Lyskam Weisshorn, Rothorn.

Aug 24 — A double picture in our way up the Gornergrat. Forgot to turn the film.

Aug 24 — The Matterhorn from part way up the Gornergrat.

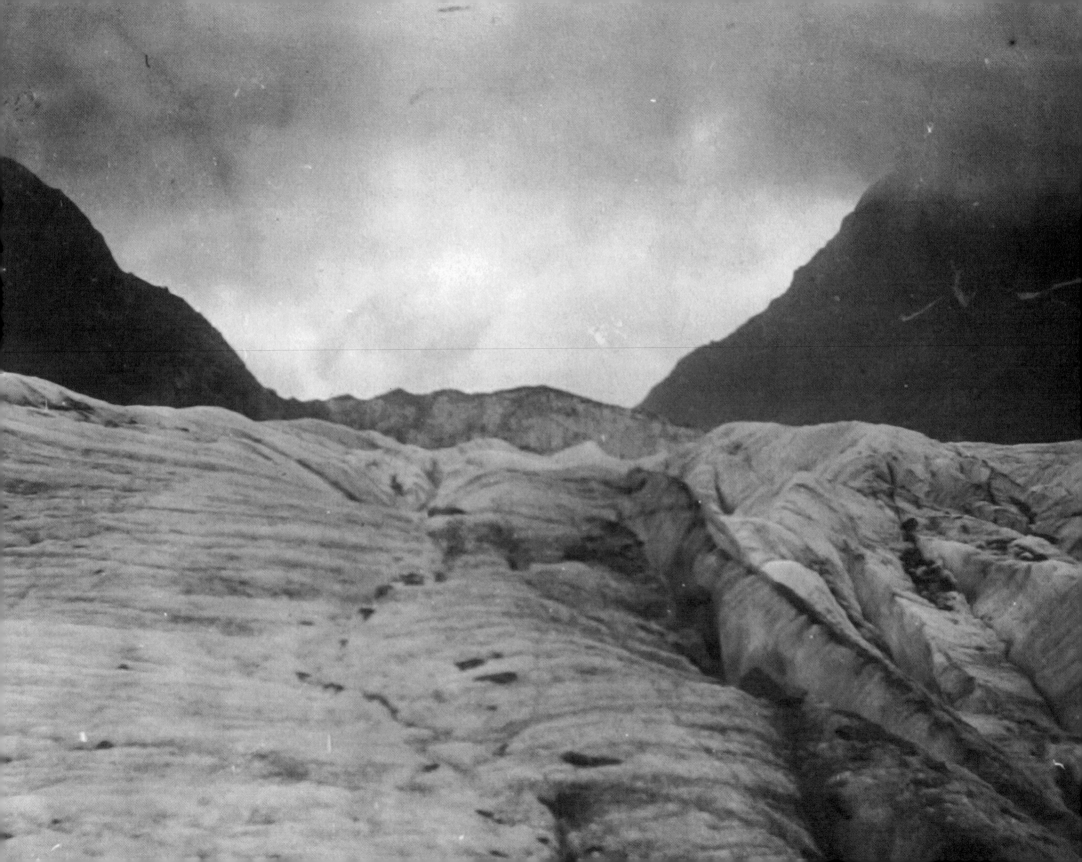

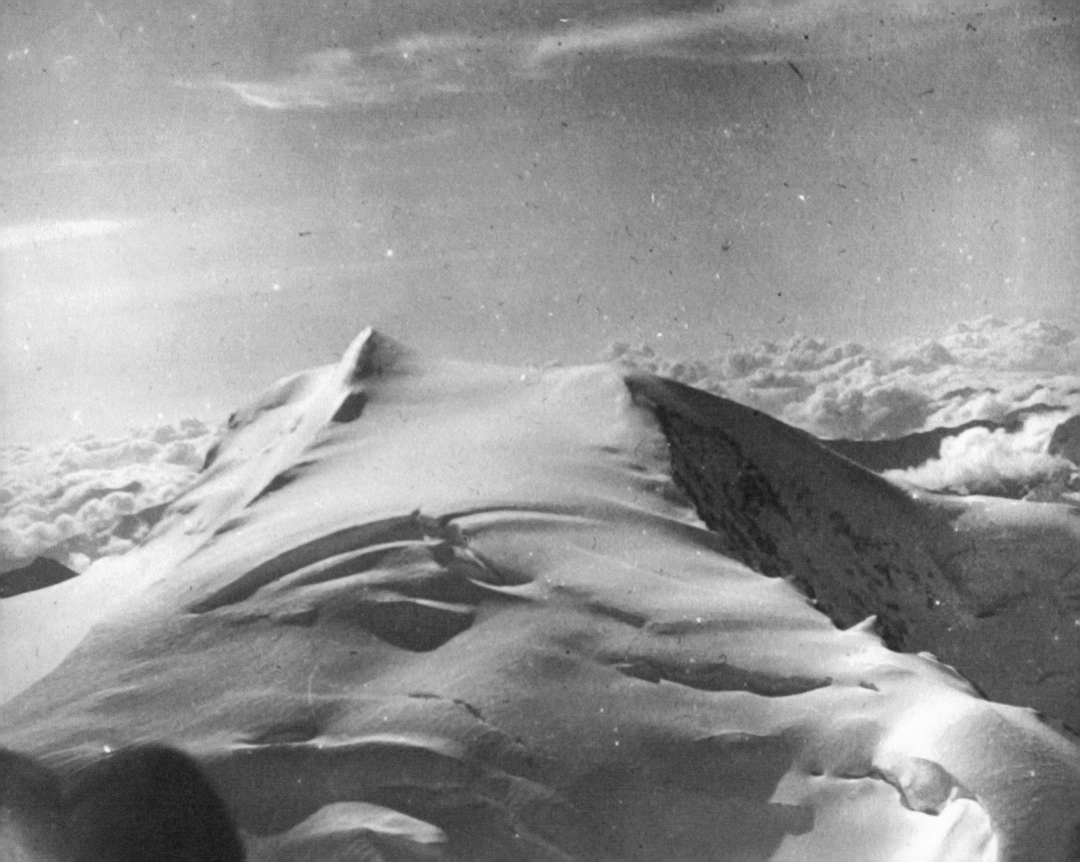

Sadly, a number of the photographs Stevens made during his Alpine treks have been lost over time. Perhaps glue that dried as it aged, loosening the bonds between the album paper and the photograph, is to blame. Or perhaps others found Stevens's photographs so compelling they removed them from the album to keep for themselves, as "souvenirs" or as works of art.

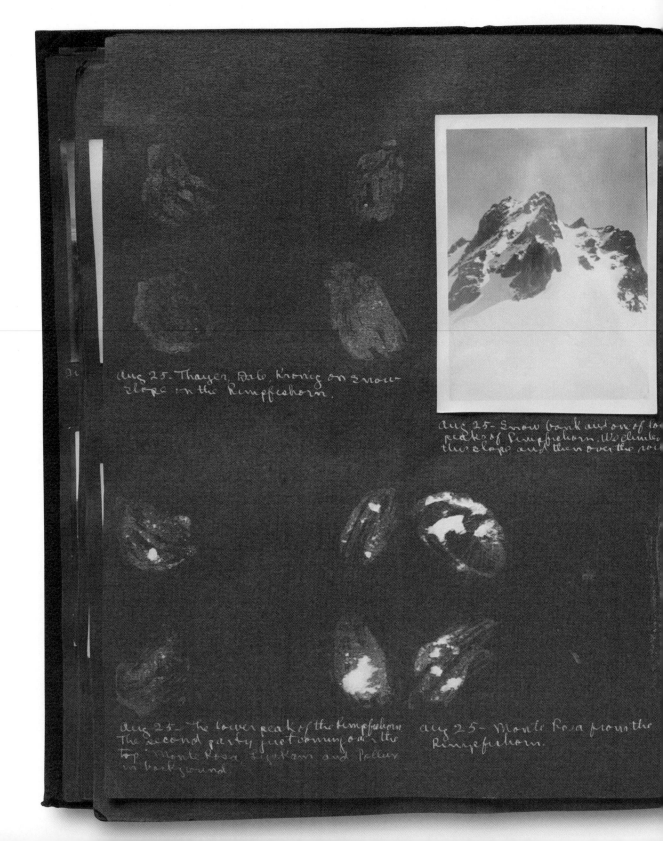

Aug 24 - View from the Gornergrat.

Aug 25 - Theodule Biner, Rad, Ale Thayer, Hieronymus Krone, roped together part way up the Rimpfishhorn.

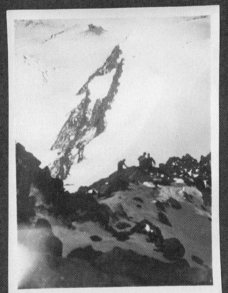

Aug 25 - When we first struck snow on the Rimpfishhorn

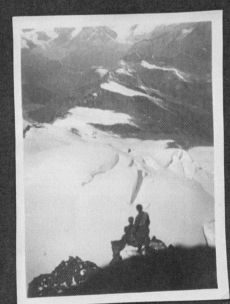

Aug 25 - Descending the Rimpfishhorn

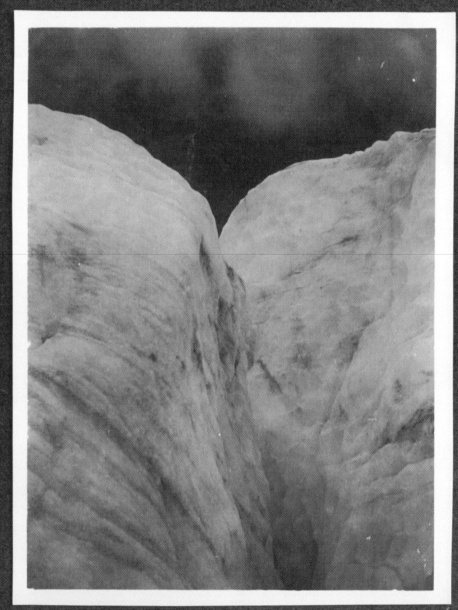

Aug. 26. Crevasse on the Mer de Glace, over which we walked.

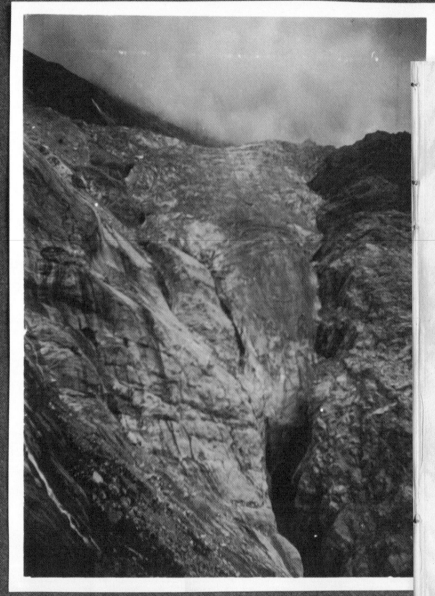

Aug. 26. Another view of glacier — Mer de Glace.

Gazette

The Stevens' journey included *Volendam* in Holland, Germany, and *the Alps* in Switzerland. They returned to New York via France.

OST · Höllengebirge · Schafberg 1784 · Steirische Alpen · Faistenauer Schafberg · Königsberghorn · Haberfeld 2025 · Dachstein 3000 · Donnerkogln 2054 · Schmidtenstein 1694 · Tännen-Gebirge

Schober 1330 · Höllkogel 1753 · Zwölferhorn · Strohnberg · Rinnkogl 1906 · 1620 · Gurlberg · Ochsenberg · Schwarzenberg 1335 · Schlenken 1629 · Bleikogl 2409 · Wieselstein 2297 · Tirolerkopf 2353 · Ankogl 3253

Faistenau · Rettenkogl · Pass, Lueg

dossene Alp 2939 · Hoher Göll · Hohes Brett · Stuhlwand 2430 · Grossglockner 3796 · Watzmann · Hochkalter 2629 · Untersberg · Kaisergebirge · Sonntagshorn · Hochstauffen 1813 · WEST

Rossfeld 1434 · 2528 · 2343 · Jenner · Schönfeldspitze · Glaidköpfe · Kleiner · Grosser · Palfhorn 2303 · Hohe Thron · Lattengebirge 1685 · 2353 · 1960 · Hinter Kaiser · Hochgern 1747 · Chiemsee

Göll · 2578 · 2324 · 2304 · 2740 · Bercht. · Salzburger · Loferer Steinberge · Müllnerhorn 1453 · Ristfeuchthorn

752 · Steinernes Meer · 1978 · 1862 · 2500 · 1670

Piding

Kaltenhausen · Rif · Leopoldskron · Salzburg · Capuzinerberg

Salzach

PANORAMA VOM GAISBERG.

1288 Meter.

Quaran-tine

Before S. D. Stevens's ship, the *Ryndam*, was allowed to dock and let off its passengers in New York's harbor on September 14th, it was intercepted by a boat carrying quarantine officers. Stevens caught the moment on camera as the crew of the *Ryndam* lined up on a lower deck to have their papers reviewed and their health checked. This was not an unusual occurrence; Stevens photographed the *Kaiser Willhelm II* as it, too, waited in New York's harbor for inspection before it could dock.

In 1879, to protect against the importation of contagious diseases, the United States Congress passed the National Board of Health Act, which required quarantine officers to board ships entering U.S. ports and that the captain have on board a clean bill of health from the American consul at the ship's port of departure. The quarantine officers functioned both as health inspectors and immigration officials, giving the crew and those passengers traveling in first or second class a cursory inspection for disease and proper paperwork before allowing them to disembark at the East River Piers where they went through Customs, from which they were then free to enter New York. Passengers traveling in third class or steerage were not so lucky, particularly if they were immigrants. From the East River Piers, immigrant passengers boarded ferries to Ellis Island, where they were more thoroughly inspected for disease and orderly paperwork, and sometimes held, while their worried families waited onshore. These initial inspections were important not in controlling the immigration process, but also in preventing the spread of highly contagious diseases such as cholera, trachoma, yellow fever, tuberculosis, and the plague.

Many travelers to faraway shores were themselves concerned with disease and maintaining health. Cook's *Guide to Egypt* urged travelers to have on hand a few ordinary medicines, "not necessarily for use, but as a precaution." Guidebooks like *Baedeker's* frequently included practical tips to help travelers avoid specific diseases that might be endemic to less-developed areas of the world. Such health advice often conveyed useful information, but also reveals a worldview that presupposed that European and American travelers generally had more healthy habits than those inhabiting the places they visited. *Baedeker's* practical health tips for visitors to Greece in its 1909 English guidebook suggested that travelers "who take sufficient nourishment and observe the most ordinary precautions are much less likely to suffer from [malarial fever] than the poorly-fed and badly-housed natives." Simple and ordinary precautions included being "on guard against the vapours rising from the ground after heavy rain" and "avoiding the evening, night, and early-morning air as much as possible, especially when fasting." *Baedeker's* also suggested that "a moderate use of spirits is said to be a prophylactic against fever, and quinine and change of air are the best cures." However, if a traveler avoided evening, night, and early morning air, it begs the question how such a therapeutic change of air might have been accomplished!

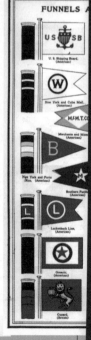

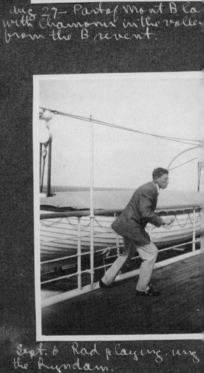

aug 27 — Part of Mont Blanc with Chamonix in the valley from the Brevent.

Sept. 6 Rad playing ? the Ryndam.

Sep 27 - Donkey used to carry provisions
the mountains. Taken near the top of
Brevent.

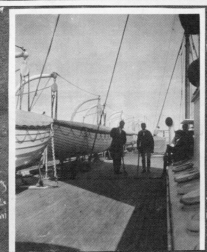

Sept 7.
Worn a
tooth shake
away

Sept 7.
Playing
ringtoss
on the
Ryndam

Sept 9.
Players +
the playing
shuffle
board on the
Ryndam

Sept 13
Nantucket
lightship
24 hrs from
New York.

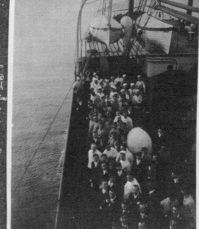

Sept 14.
The Kaiser
Wilhelm II
waiting
in New York
Harbor for
the
quarantine
officers,
examined
Sept 14
soon after
Ryndam

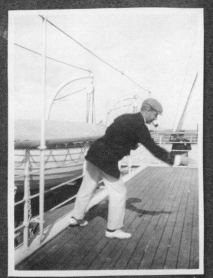

Sept 6 - Donghan playing ring toss on board
Ryndam in mid ocean

Sept 14.
Stewards
lined up to
be inspected
by quarantine
officers in
New York
Harbor.
All the
passengers
and crew
were
inspected

87

After his final descent
from the Alps at the end of
August, Stevens provided
few visual clues as to how
his group ended their jour-
ney. In the last pages of
his album, we travel from
the summit of Le Brévent
in France to the deck of
the steamship *Ryndam*,
en route to New York. Pho-
tographs of Stevens and
his friends cavorting on
the deck and playing ring-
toss offer a sharp contrast
to rough mountain trails
and soaring summits that
dominate the preceding
pages. The following week,
the passengers and crew
sighted land as their ship
passed the Nantucket light-
house before heading south
toward New York.

73

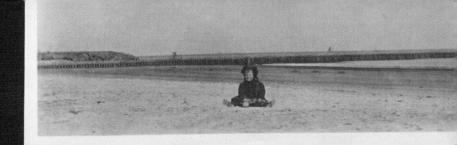

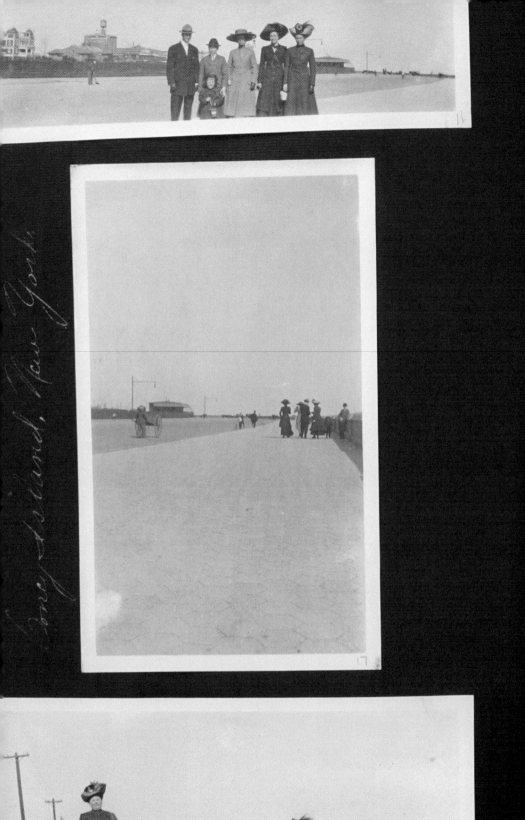

Coney Island, New York.

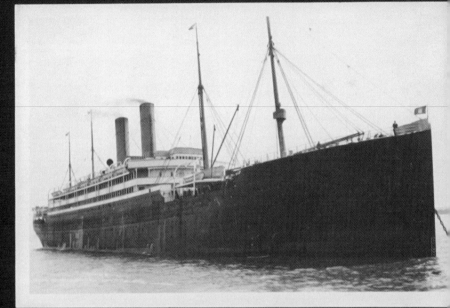

S.S. "Amerika" Cuxhaven

Here's a Tip, Take an Auto Trip

THIS exquisitely tooled and woven leather album, monogrammed on the back with the name Lucy Hauerwaas, opens with a photograph of the family sitting in and on their automobile. The caption tells us that they are about to set off on their trip abroad from April to November 1910. For Lucy and her family, *getting* there was almost as interesting as *being* there. As the pages of the album progress, we begin to realize that the Hauerwaases, who must have been relatively wealthy, went to Europe by automobile. Literally. Beginning their eight-month journey in Los Angeles, they drove up the coast to Vancouver, Canada, across the Canadian Rockies, stopped in Chicago, and then drove on to New York, where they boarded the SS *Amerika* bound for Cuxhaven, Germany, at the mouth of the Elbe River. The family then proceeded to drive through Germany, Holland, Switzerland, Italy, and France, where they and their car boarded the SS *Kaiserin*

Augusta Victoria en route for New York. The itinerary of their journey was not that different from others taken during the same period. For Lucy and her family, however, the automobile became a transformative vehicle for new modes of travel as well as an expression of that travel. The car is the star of their album's show: it appears in almost every photograph. Many of the photographs of the countryside, castles, churches, statues, fountains, and street views in Berlin, Dresden, and Munich appear to be taken while leaning out the car window and vividly convey a sense of the open road. If the automobile was shortly to transform American life, then the Hauerwaases were trailblazers, using it to transform their experience of Europe.

There are countless pictures in this album of the Hauerwaas family car: we see it in front of a hotel in Hamburg, in front of a restaurant in Cassel, in front of the Friedensengel monument in Munich—with or without the Hauerwaases in it. Everything else, it appears, is just background. The family was conscious of the fact that it was their car, and not their camera, that was the novelty, and there are numerous snapshots of passersby—from rural townsfolk to city slickers—posing with their prized automobile.

In Germersheim, the Hauerwaases reunited with the German side of their family. The family business appears to have been selling military uniforms; for fun, the Hauerwaas daughters dressed up and posed in front of "Uncle Hauerwaas's" store.

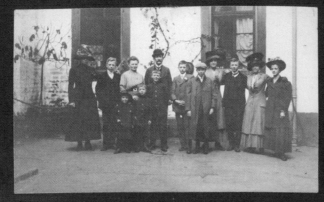

Hauerwaas families

In Military Uniform.

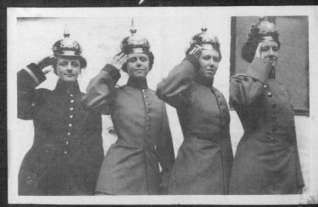

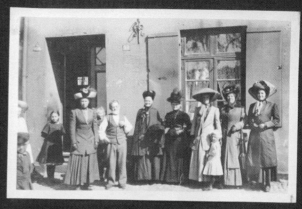

The "Preston Home" Wismar.

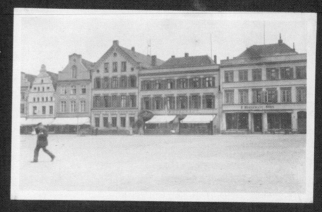

"Market Place" Wismar.

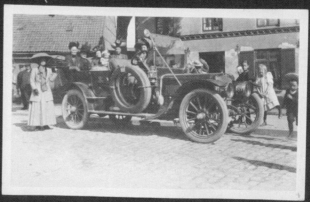

At Wismar.

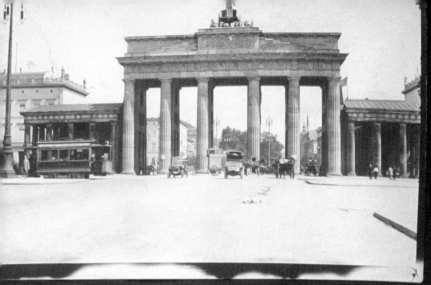

Brandenburger Tor" Berlin, Ger.

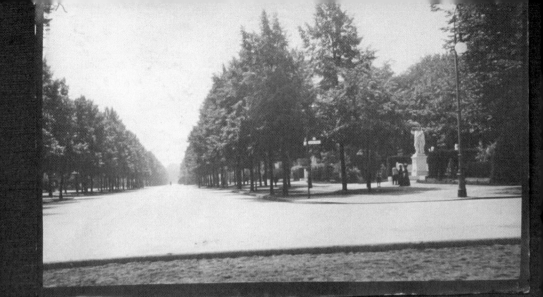

Street scene, Berlin.

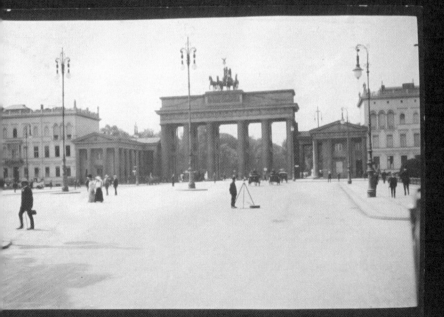

Brandenburger Tor from opposite side

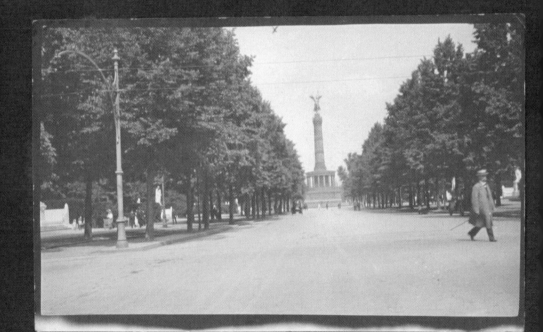

Statue of Justice," Berlin.

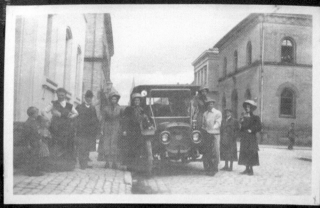

take a ride - Germersheim

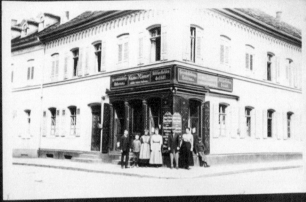

"Hauerwaas' Store," Germersheim.

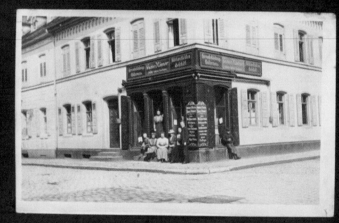

Uncle "Hauerwaas'" Store, Germersheim

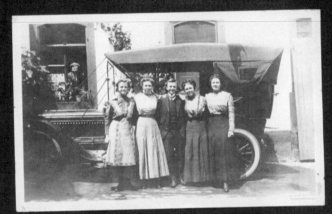

A "thorn" between four "roses".

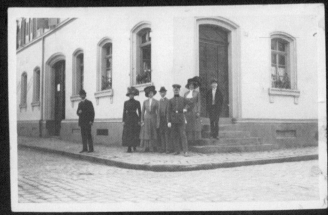

"Home"

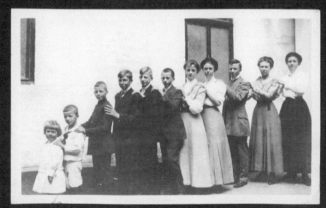

The younger Hauerwaas generation.

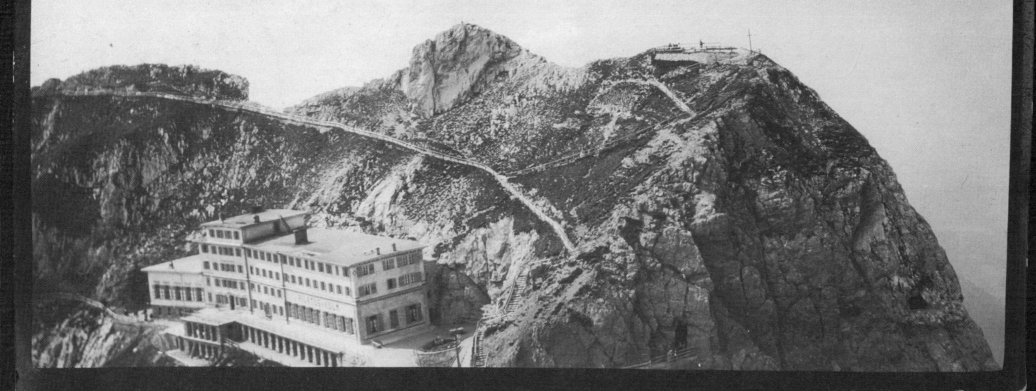

Build the road—to paraphrase the popular adage—and they will come. Leaving Germany, the family set off through Switzerland. They stayed at the famed Hotel Mt. Pilatus, which clearly overlooks some spectacular scenery.

Hotel "Mt Pilatus" Switzerland-

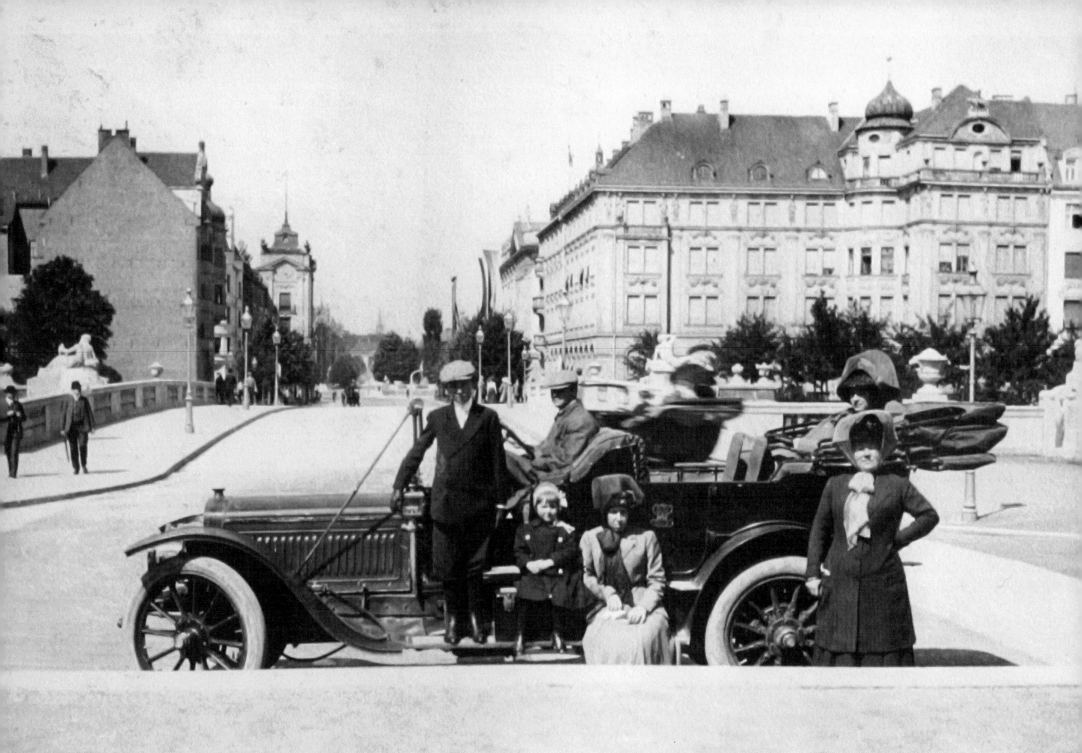

Auto Touring

By 1910, when the Hauerwaas family made their auto tour of Europe, a number of auto clubs had been established in both the United States and abroad (the Automobile Club of Southern California—to which the Hauerwaases may have belonged, was established in 1900). These clubs worked to improve driving conditions, pass safety laws, map desirable driving routes, and, of course, promote auto touring.

The world's first long-distance automobile journey, sixty-two miles, was undertaken by Bertha Benz (wife of Karl Benz, inventor of the three-wheeled Patent Motor Car) in 1888. The trip had proven the safety and suitability of the automobile for travel, but when the Hauerwaases made their trip in 1910, the automobile was still a novelty. They had to take into consideration a number of factors that other travelers did not—factors that likely influenced their routes and stops along the way. Where would they find gas to refuel? What would happen if they had a flat tire? The family did, in fact, run into trouble on St. Gothard Pass as they made their way across the Alps from Italy into Switzerland. As recorded by Lucy, the family had to rely on more . . . well . . . reliable means of transportation.

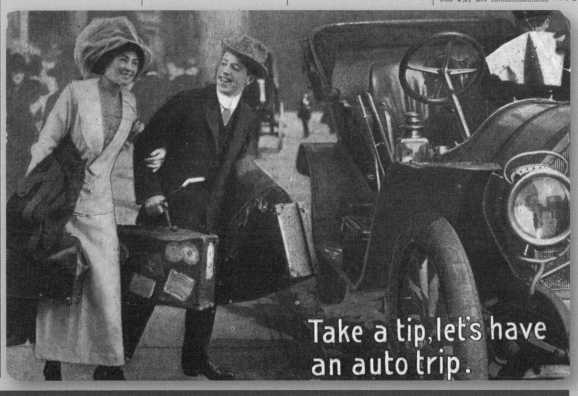

Take a tip, let's have an auto trip.

Gazette

The Hauerwass family drove throughout Germany to Holland, Switzerland, Italy, and France.

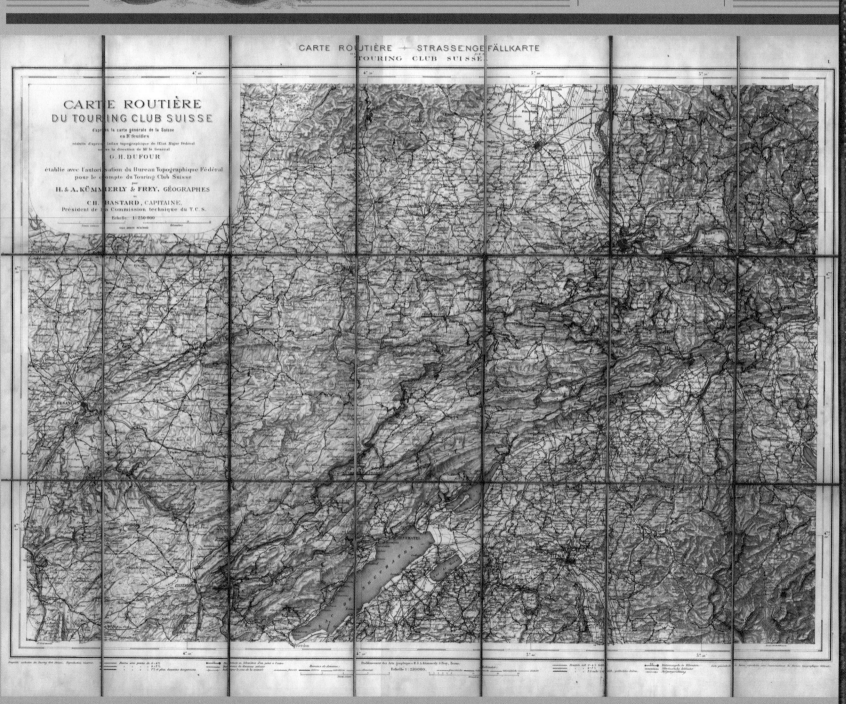

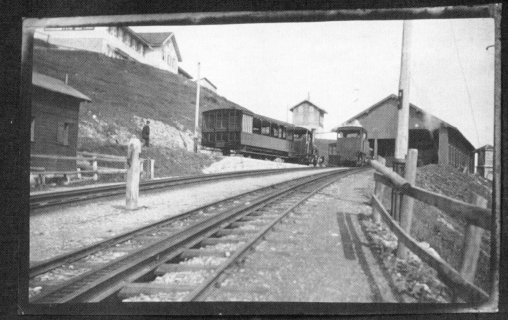

Incline Railway on "The Rigi".

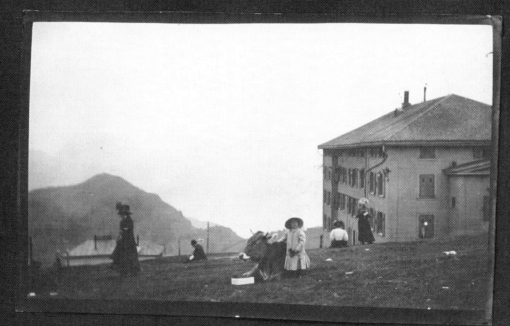

of "The Alps" from Mt Pilatus.

On the summit of "The Rigi"

The Hauerwaas family saw a very different landscape from the vantage point of their automobile, and their journey took a different route from the usual train line. Someone must have gotten out and gone ahead to capture this picture of the car emerging from the underpass; they were clearly proud of their automobile. Judging from these pictures, they didn't have to worry about traffic jams.

84

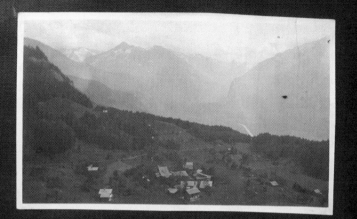

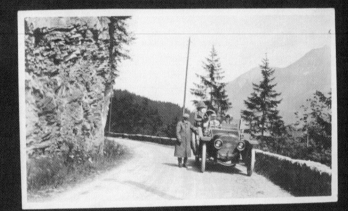

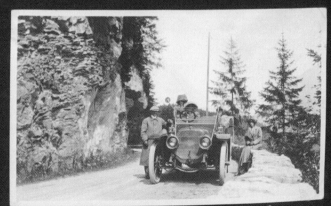

Scenes on road between Lucerne and Interlaken — Switzerland.

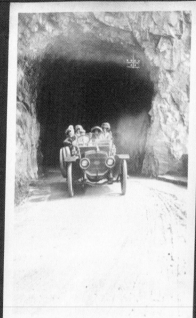

Tunnell on way to Interlaken.

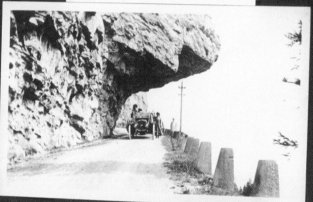

On road to Interlaken.

Road around Lake Lucerne on way to Interlaken.

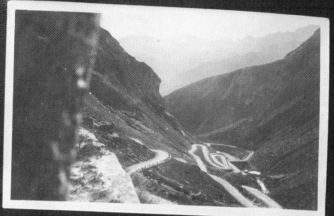

"St. Gothard Pass."

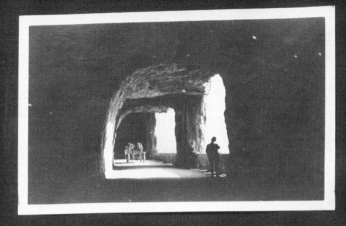

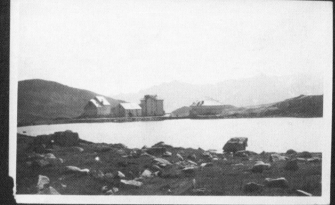

"Summit" St Gothard Pass

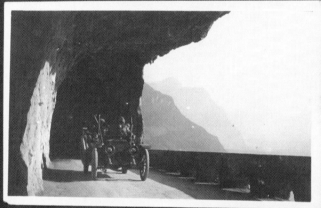

Views on Axen Strut, Switzerland.

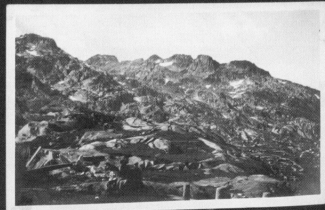

On St. Gothard Pass

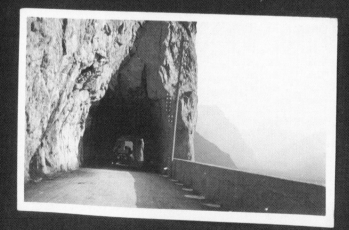

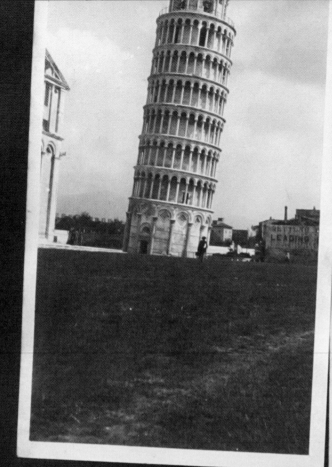

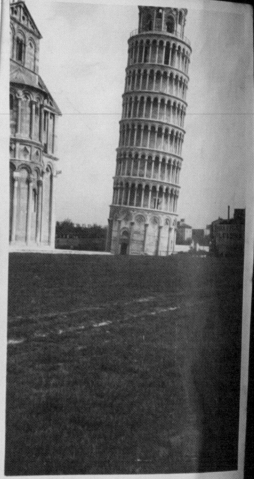

Leaning Tower of Pisa.
Italy.

"Crossing The Appen
to Genoa.

Birds-eye-view of Genoa

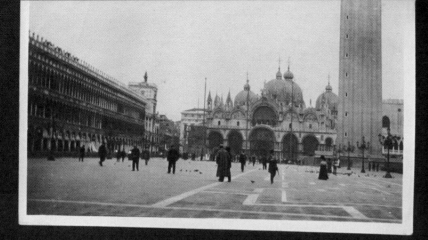

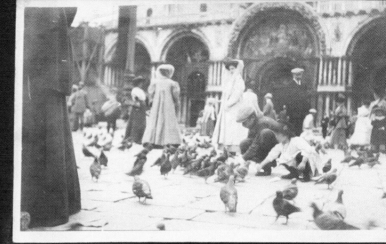

Pigeons in St. Marks Square.

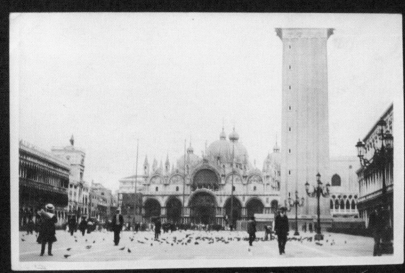

Views of "St. Marks Square" Venice.

Views on Grand Canal, Venice.

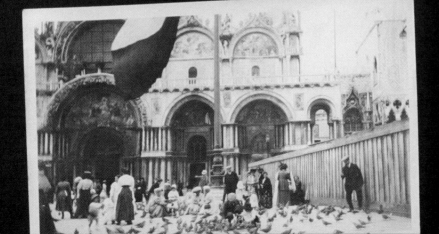

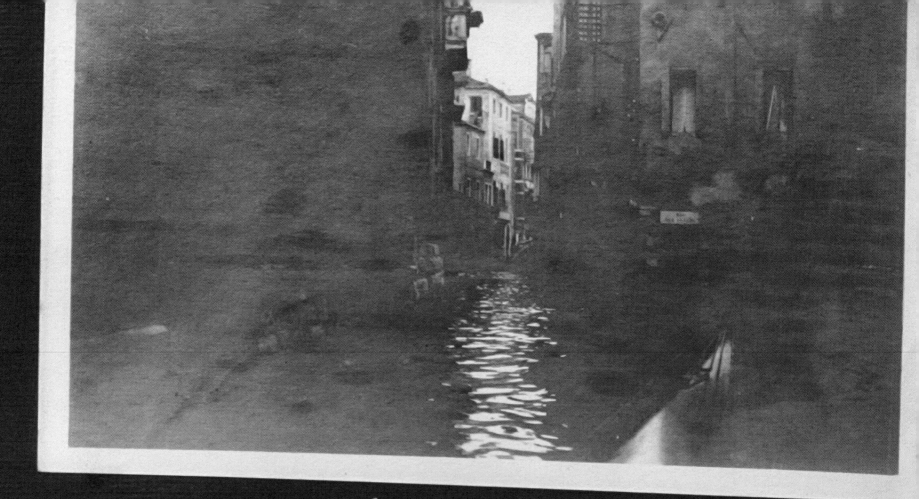

Small Canals, Venice

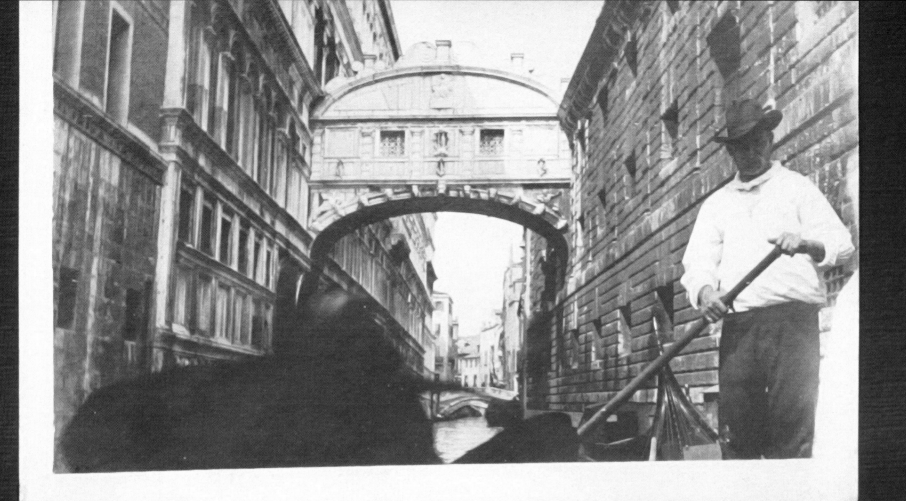

"Bridge of Sighs" showing Gondalier.
Venice, Italy.

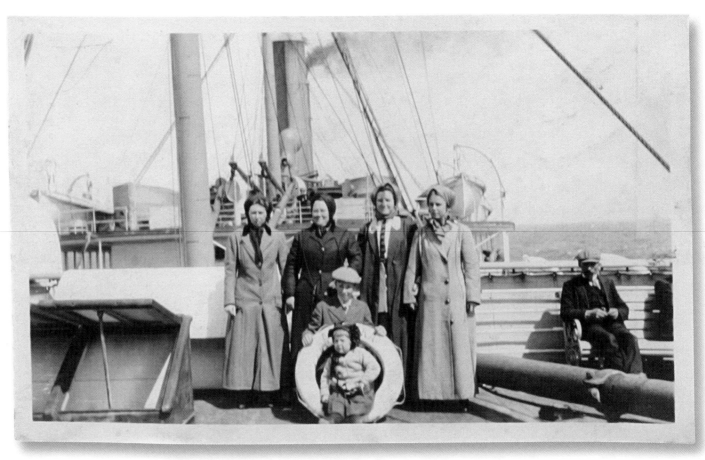

"On board S.S. Amerika."

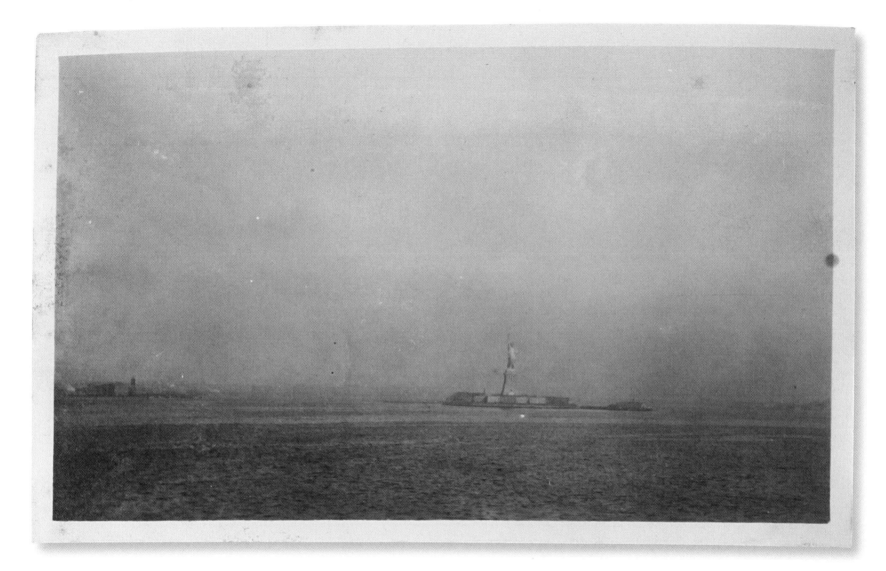

"Statue of Liberty", N. Y. Harbor.

—1914—

The H.M.A., Honolulu

BETWEEN the cryptic inscription "H.M.A. Honolulu 1914" written on the cover of this otherwise non-descript album, and the photographs and memorabilia pasted within, it is possible to make the assumption that its author was Helen Maxwell, one of a group of American musicians who traveled to Hawaii and Asia between 1914 and 1915. Whether they were there to perform or for leisure is unclear. Hawaii was still a U.S. territory in 1914 (it did not become a state until 1959), and the album's photographs, ephemera—like these maps—and brochures published by the Hawaii Promotion Committee present a view of an unspoiled Hawaii, before it became a prime American tourist destination.

What distinguishes this album are its beautiful hand-colored photographs—color film was not available for still images until Kodachrome was introduced in 1936—and its candid, "fun-in-the-sun" images of the travelers rehearsing and traipsing about the island: swimming at Waikiki, hiking to a lava flow at Hilo, looking at the koa trees. After a lengthy stay in Hawaii, the group traveled to Asia, stopping at Yokohama, Tokyo, and Misaki in Japan and Peking and Canton in China.

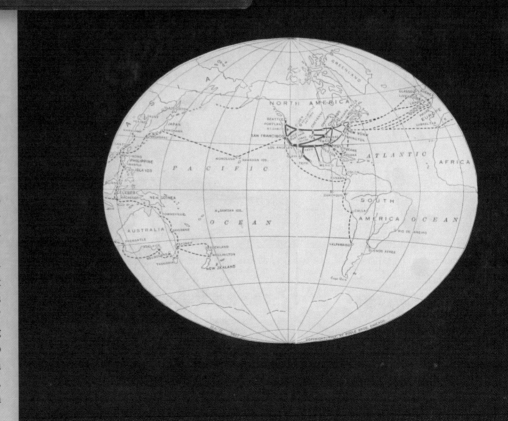

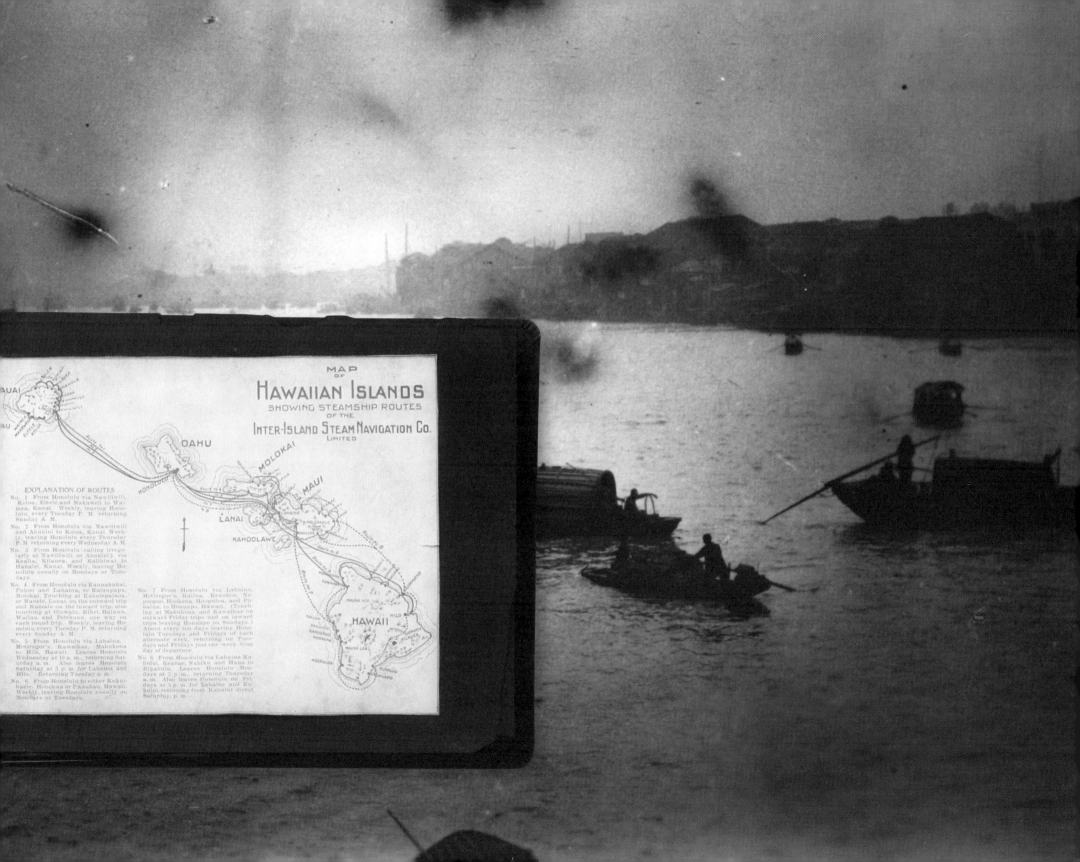

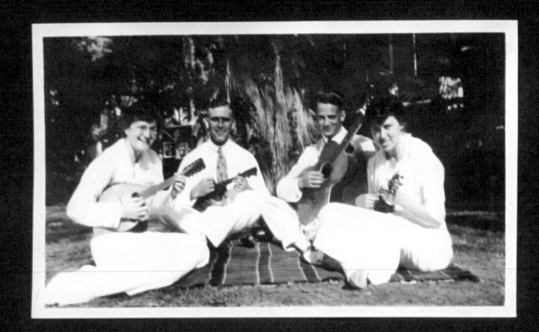

The Waikiki Orchestra
1915

Helen Maxwell
Wolfgang Pflüger
Carl Henoch
Lucia Morris

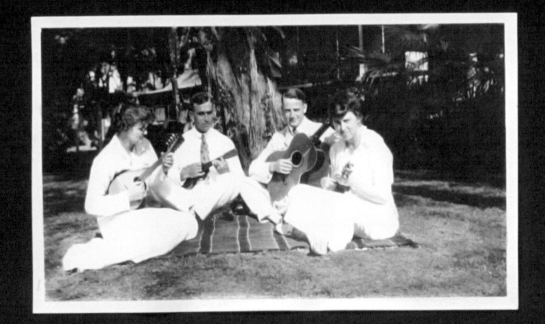

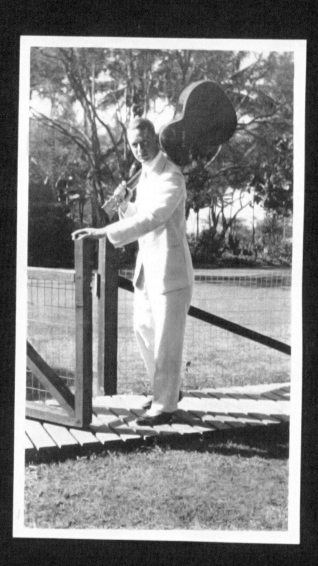
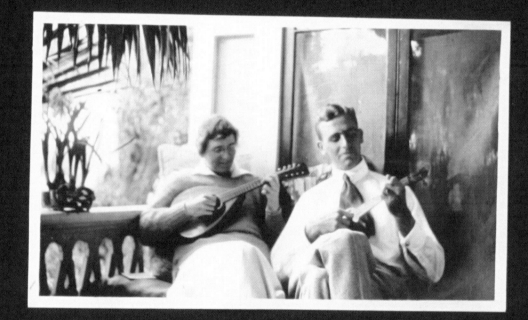

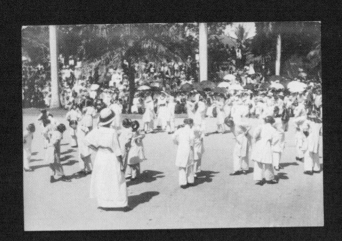

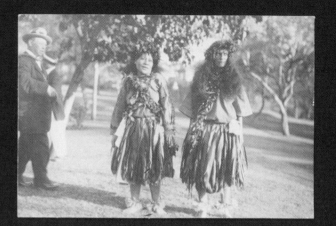

I'm perspiring hot!

Off to The Rescue
'just a minute'

January 3, 1915

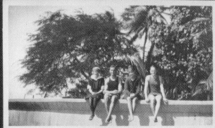

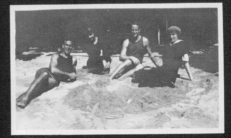

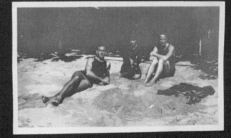

Kanakas swimming at Waikiki

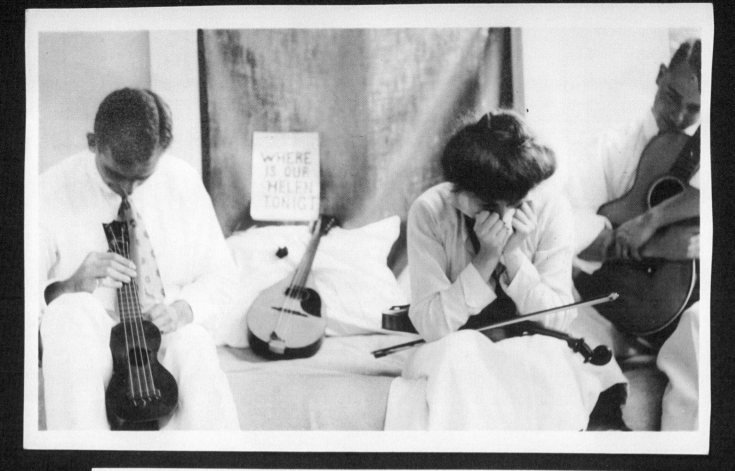

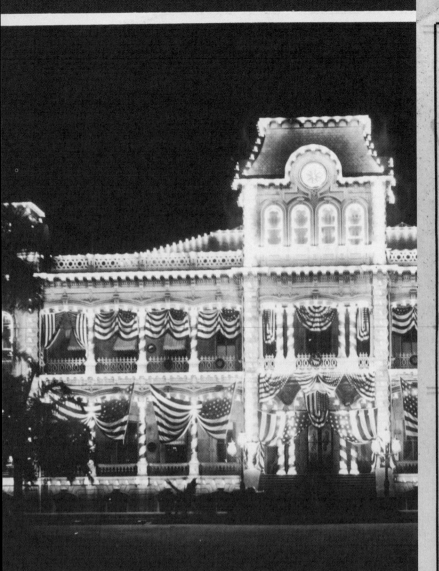

Palace

1915

VOLCANO Trip Hilo, Hawaii

Miss Paul
Mrs. Anprus
Lucia
Aunt Jn.

Aunt in the Koa
tree.

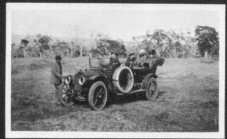

Our Car.

Sunset — Hilo Harbor.

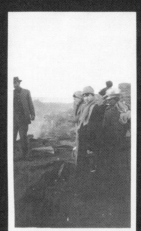

At the Crater.

View across the Lava.

Sulphur flames in the crater.

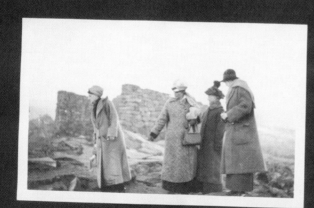

Peeking over the edge.

Fern trees.

Koa Tree.

From Hawaii the group took the steamship *Manchuria*, which operated "The Sunshine Belt to the Orient"—a route between San Francisco and Manila—to Japan. Steamships still required coal for fuel, and the black smoke pouring from the *Manchuria*'s smokestack was probably unappealing to holiday makers on its deck.

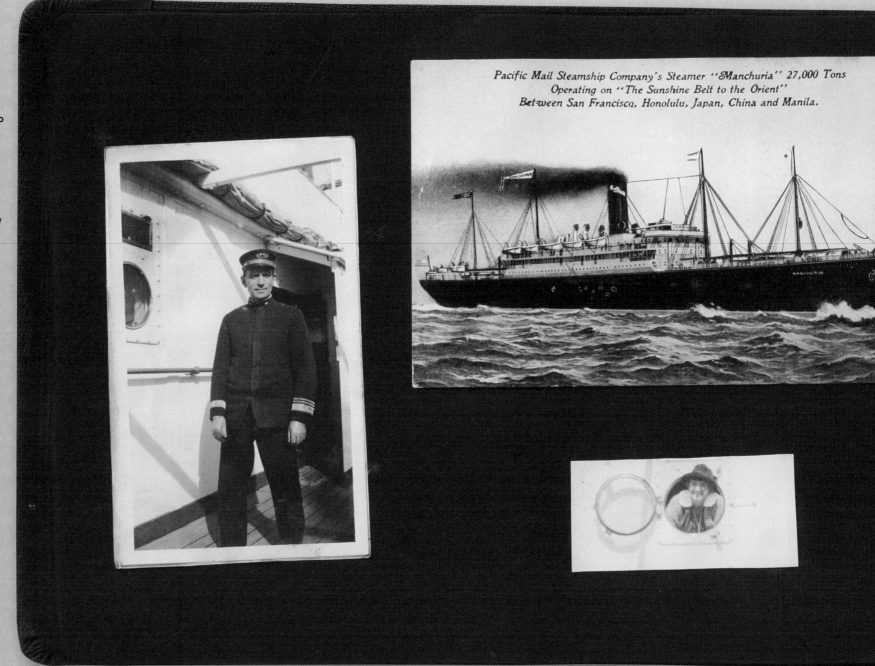

Pacific Mail Steamship Company's Steamer "Manchuria" 27,000 Tons
Operating on "The Sunshine Belt to the Orient"
Between San Francisco, Honolulu, Japan, China and Manila.

Sunset — Hilo Harbor.

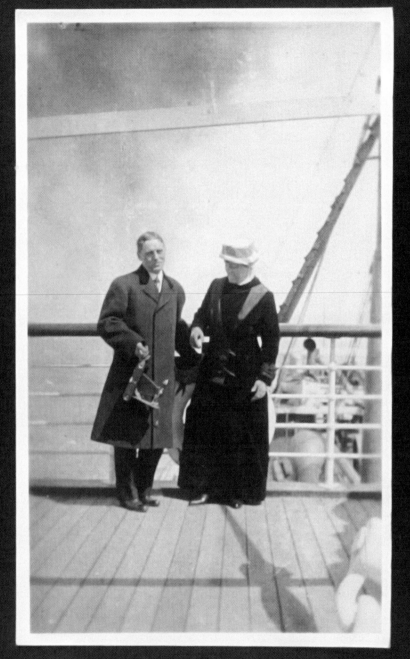

ldrew

Mrs. Marshall

Our Traveling Comrades
Mr. & Mrs. F. M. Brown

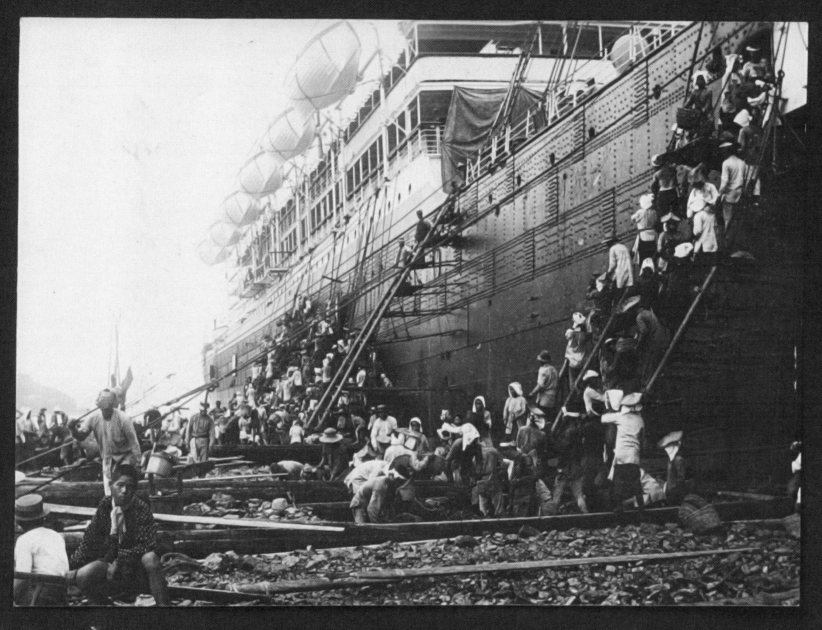

Women loading coal at Nagasaki, Japan.

At Nagasaki, the *Manchuria* stopped to load coal, and the event was captured in a tourist photograph purchased by the album's author and affixed to one of its pages. It is one of the few souvenir photographs that appears in the album, suggesting that the author missed seeing it in person, or preferred the head-on, dockside vantage point to her own view from the deck of the ship. Verging on social realism, the photograph is arranged in the album in such a way that it almost forces the viewer to juxtapose the wealth represented by leisure travel, and the poverty of those who serve it. It may well have been the album maker's intention to make this point, as a commentary on her privileged position.

Temple at Otsu, Japan

My usual audience

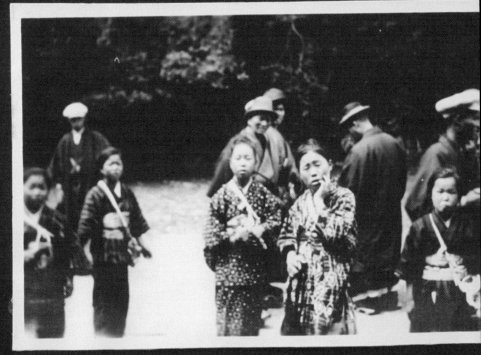

Throughout this album, the author appears fascinated by the meeting of Western and Eastern cultures, of modern and more traditional ways of life. While the camera may by this time have become relatively common for those who could afford to travel, for many it remained a novelty. One such interaction between the snapshooter and a group of Japanese onlookers was wittily captured and titled "My Usual Audience."

Going Native

Traveling in foreign countries often awakens the impulse to adopt the native dress and customs. This may be driven by the desire for a more authentic experience, to simply make a joke, or to indicate an appreciation for the beauty of the native craftsmanship. Mexican serapes and sombreros, Indian saris, Chinese fans, African beads, and Scottish kilts are some examples of costume trappings travelers adopt as part of their desire to experience—if only for a short time—what it is to be native. These women, or at least the album's author, seem fully aware of their play-acting. Pasted on the adjacent page is a photograph of a child named Chyo, who appears very dignified in his native dress, in contrast to the dress-up mimicry of the American women.

Even before they left for Japan, members of the musical troupe prepared themselves for experiencing a new culture by dressing in Japanese kimonos, captured here in a beautiful spectrum of hand-applied color. For these women, the silk kimonos were a way of touching and experiencing the exotic.

In addition to wearing the native dress of their host culture, they are making gestures to suggest that by putting on the costume they have put on a new skin and "become" Japanese. Perhaps, through adapting the native dress, they hope to blend in in some small way.

NOTHING NOXIOUS

There is not a SNAKE in all Hawaii, nor poisonous insect more to be feared than bees or yellow jackets. Neither is there poison oak or ivy, nor other plant of noxious character. Although some of the forests are exceedingly dense, it is with a most delightful sense of security that one forces his way through tropic vegetation or most luxuriant and beautiful character, confident that no unseen peril lurks in his pathway.

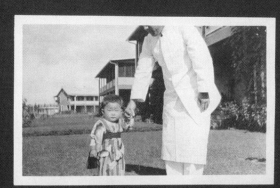

Chyo

Gazette

Helen and her friends traveled first to *Waikiki* in Hawaii, then boarded a boat to *Nagasaki*, Japan and on to *Peking* and *Canton* in China.

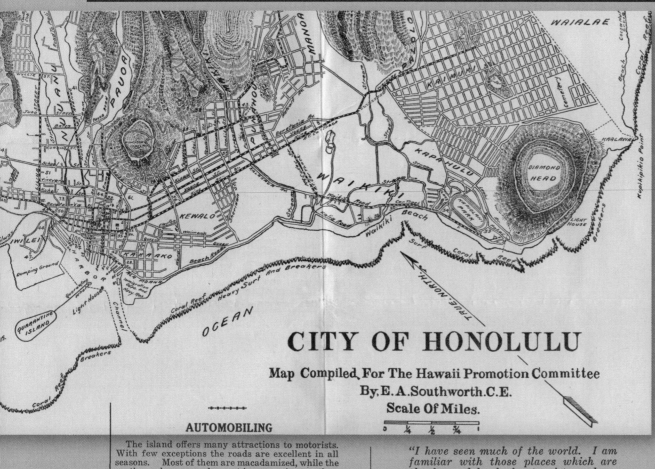

CITY OF HONOLULU

Map Compiled For The Hawaii Promotion Committee
By, E. A. Southworth. C. E.
Scale Of Miles.

The Island of

HAWAII

TERRITORY of HAWAII

MAP and GUIDE

Issued by the
Hawaii Promotion Committee
Representing The

TERRITORY OF HAWAII
CITY AND COUNTY OF HONOLULU
CHAMBER OF COMMERCE OF HONOLULU
MAUI CHAMBER OF COMMERCE
KAUAI CHAMBER OF COMMERCE
:: HILO BOARD OF TRADE ::

1914

A fully equipped Information Bureau is maintained by the Promotion Committee at its rooms, Bishop Street side, Alexander Young Building

Illustrated pamphlets, descriptive of Hawaii, Railway and Steamship Time Tables, Hotel folders and general travel data, relating to all parts of the World at your service—Free.

ISLAND OF

OAHU

TERRITORY OF HAWAII

Map and Guide

Issued by the
Hawaii Promotion Committee
Representing the

TERRITORY OF HAWAII
CITY AND COUNTY OF HONOLULU
CHAMBER OF COMMERCE OF HONOLULU
MAUI CHAMBER OF COMMERCE
KAUAI CHAMBER OF COMMERCE
:: HILO BOARD OF TRADE ::

A fully equipped Information Bureau is maintained by the Promotion Committee at its rooms, Bishop Street side, Alexander Young Building

Illustrated pamphlets, descriptive of Hawaii, Railway and Steamship Time Tables, Hotel folders and general travel data, relating to all parts of the World at your service—Free.

1915

AUTOMOBILING

The island offers many attractions to motorists. With few exceptions the roads are excellent in all seasons. Most of them are macadamized, while the earth roads are good except in very rainy weather, this very periodical. Between 1,800 and 2,000 machines are owned in Honolulu and the Island of Oahu.

The most extensive single trip possible is about 87 miles in length, extending around the northeast and northwest sides of the Island and through the valley between the two mountain ranges. This is a very popular drive, and one of great beauty, but there are numerous shorter trips equally fascinating.

"I have seen much of the world. I am familiar with those places which are the favored lands for tourists and my eight days' stay here has convinced me that there is no land on the face of the earth, considering climate and population, and considering beauty and attractiveness of scenery and charms of hospitality which offer so much to the tourist either in health or pleasure as in this Eden of the Pacific."—HON. OSCAR S. STRAUS.

nikko

yakohama.

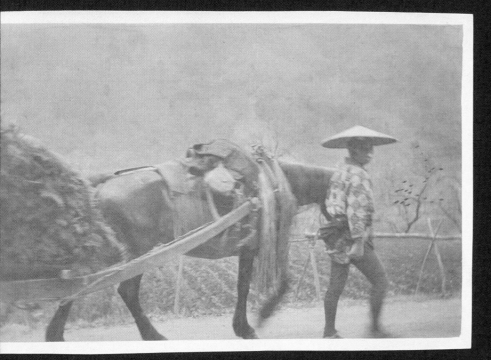
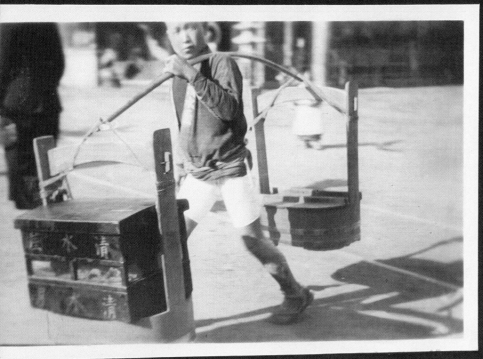
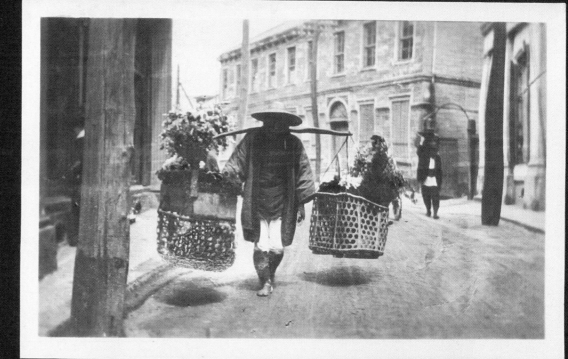

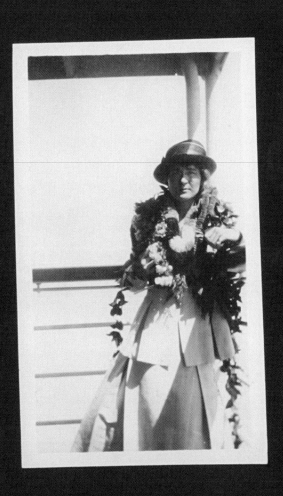

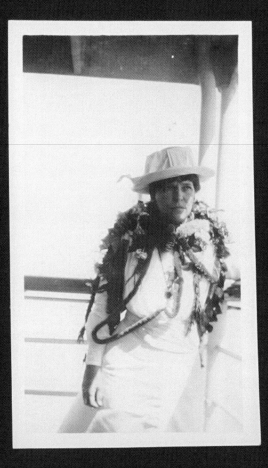

Across the Sahara on Camelback

At the outset of their adventure, in mid-December, we are introduced to the two men "who arranged and conducted my caravan journey across the Sahara." She points out that one of the men, Yousef ben Saad, was "courier companion of Robert Hichens for two years while he was writing 'The Garden of Allah.'" Hichens's *The Garden of Allah*, published in 1904, was a wildly popular and epic tale of the adventures of a young English woman traveling alone in the Sahara Desert, celebrated as much for its titillating subject as for the rich cultural background Hichens wove into his narrative. By the time our travelers made their journey, the novel had been made into an equally successful silent film starring Camille Astor. How much Hichens's novel and the subsequent film influenced the itinerary of the album's creator we will never know, but her mention of the book is provocative, and it may be she wished for those who looked at her album to make a connection between the published book and her own tale of adventure and exploration in the Sahara.

I N 1921, an unknown woman traveled to Egypt with a handsome young man named Ernest Tilburg. Ernest, we learn, had been a motorcycle courier during World War I. The album opens by introducing Ernest as the photographer, but it is soon apparent that the woman assembled the album. Any retelling of their journey, which included a ten-day camel trek across part of the Sahara Desert, is therefore one of collaboration, between a well-traveled older woman and her companion, perhaps her lover or muse—a pairing that was probably not common at that time.

The album and its photographs are captioned charmingly with educated, precise, and often witty text on every page. Ernest's snapshots

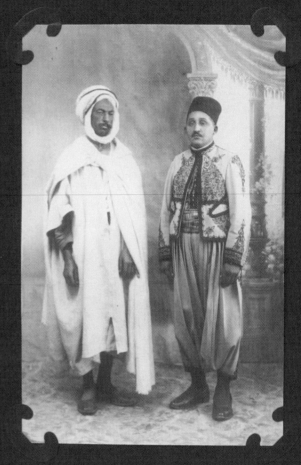

Left – Youssef Ben Saâd, Royal Hotel, Biskra, Algeria
Right – Saâdi Amar, Cirta Hotel, Constantine, Algeria, Africa.
Saâdi and Youssef arranged and conducted my
caravan journey across the Sahara. Dec. 1921.
Youssef was the courier companion
of Robert Hichens for two years while he
was writing "The Garden of Allah."

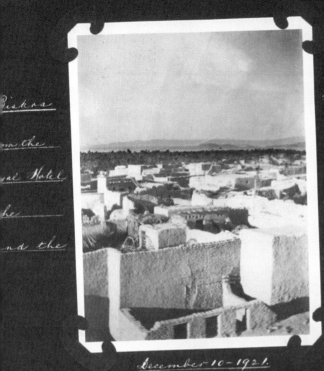

Biskra

m the

al Hotel

he

nd the

at sunset

tower of the

looking toward

Aurès Mountains

desert.

December 10 - 1921.

Around the camp fire before breakfast.

December 1921.

Left to right: A camel driver, Mohammed. Ernest, myself, Saïdi, two Arab servants, and my camel driver.

Photographs

Ernest Tilbury

London Eng. November 192

By whom most of these pictures were taken.

of camp life, monuments, and native people are extraordinarily beautiful, suggesting a facility with the camera not seen in many travel albums. Throughout the album, they are accompanied by the author's brief but meticulous descriptions of the temples, shrines, and other sights they saw in England, Palestine, Egypt, and Rome, creating a rich visual and textual narrative of their trip, a tale that is infused with the personality of its creators, who occasionally witnessed scenes of intense international drama.

One can only imagine the heat of the sun at the time the group posed for this photograph: our fearless female traveler is wrapped from head to toe in white. In describing this photograph she lets us know that her Arabian horse had been trained for the fantasia, a chaotic, rambunctious horse race run by rifle-wielding riders in traditional costumes, deeply rooted in Moroccan culture and a symbol of manhood, courage, and hospitality.

In one caption accompanying a photograph of stern-looking villagers, she recounts another example of the extremes of her journey. While stopping at a village in an oasis, Ernest prepared to take photographs of the village and its inhabitants, but they were forced to beat a hasty retreat when the villagers objected to having their photograph taken.

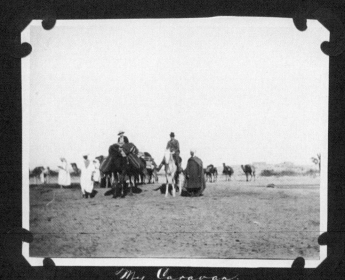

My Caravan.

The Sahara Dec. 1921.

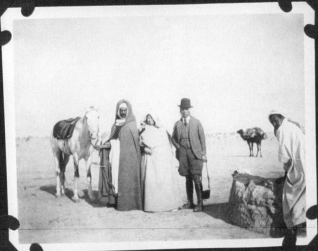

A midday stop at an oasis.

Our thoroughbred Arabian horse trained for the "fantasia"; his master, Mohammed a Wild Arab (?), Ernest & a servant drawing water.

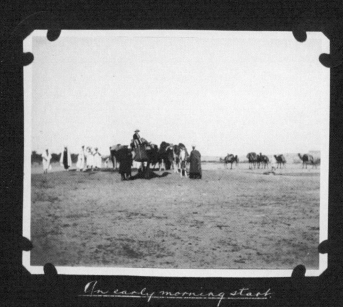

An early morning start.

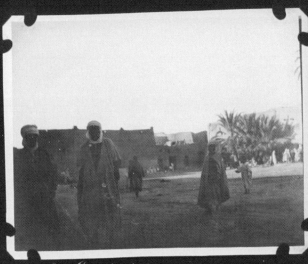

An Arab village in an oasis.

They objected to being photographed and we left hurriedly.

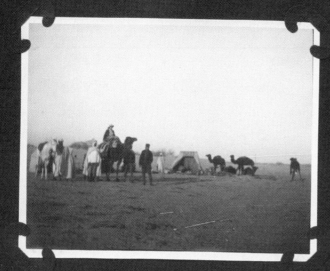

Breaking camp just outside
Nefta, Tunisia - Dec. 22, 1921.
(This is the last day of the caravan journey.)

An Arab funeral outside Nefta,
Tunisia, Dec. 22 - 1921.
(Note the Arab men about the grave
while the Koran is chanted.)

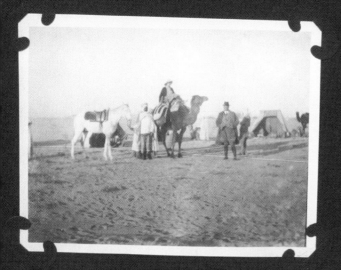

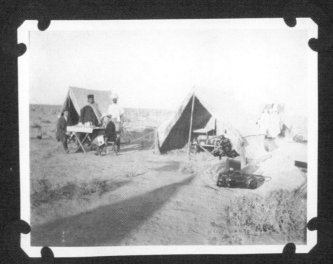

Breakfast in the Sahara just after
sunrise. Mohammed (wearing the turban)
has just brought our coffee & eggs, and Saädi is inspecting the service.

Almost all these photos contain more than meets the eye. For example, we are made aware in the top photo that an Arab funeral is occurring. Our storyteller points out that there are Arab men standing about the grave while the Koran is chanted. In the bottom photo she tells us that they are in the Sahara, having a breakfast of coffee and eggs just after sunrise. She includes the detail that one of the tour guides is inspecting the service. Without her text filling in the details, we would miss many of the nuances of the scenes pictured in these photographs.

113

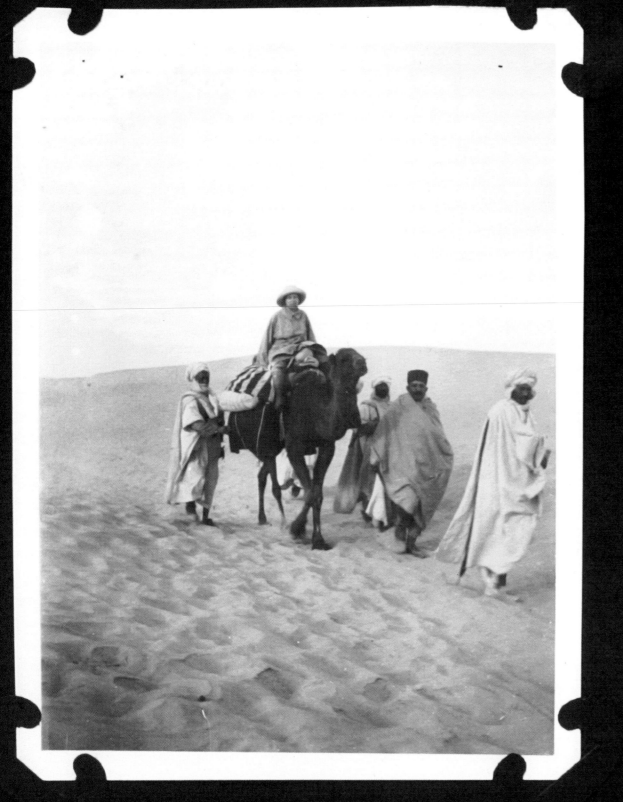

Crossing the
Sand Dunes.

Dec. 17 - 1921.

It is work to
stick to the beast
going down a moun-
tain of sand.

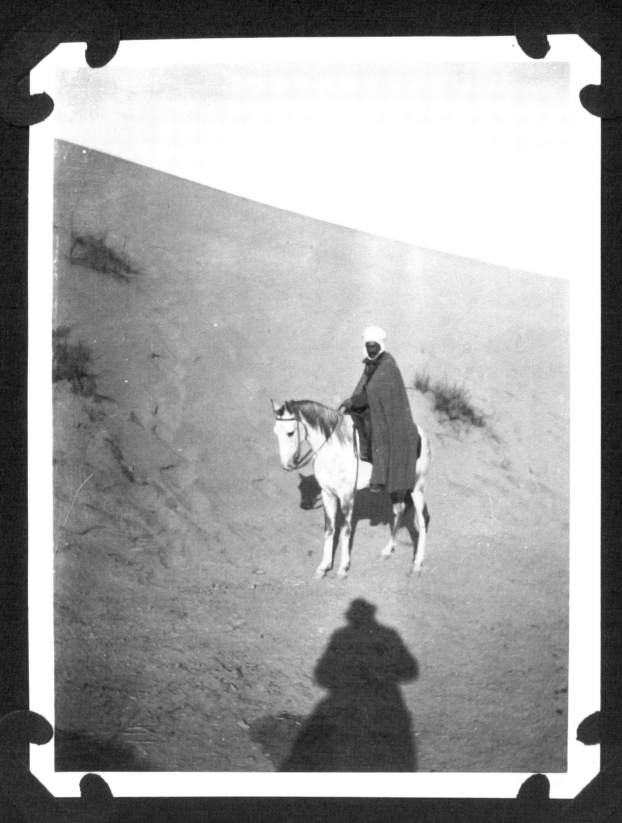

An Arab ("Mohammed")
and his steed.

(Note the shadow
of Ernest taking
the "snap".)

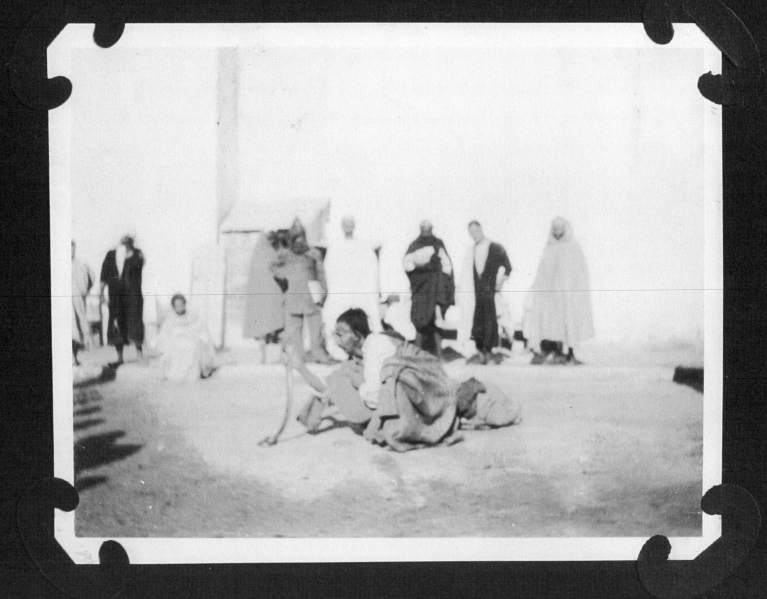

The Snake Charmer & his cobra

Kairouan

Dec. 24-1921

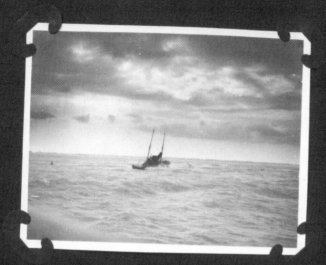

This steamer was sinking
as we entered Alexandria
Harbor during a storm.
January 9 - 1922.

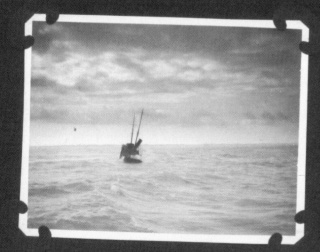

Next we see our traveler remark on a sinking ship in the Alexandrian sea during a storm on January 9th; in the next shots she is safely on the ground, in a carriage with her friend on the main boulevard of Alexandria, Egypt (her caption implores us to note the Egyptian driver).

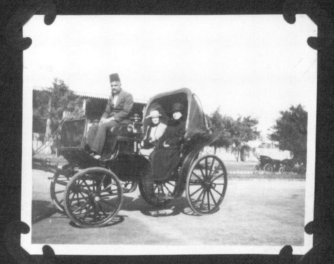

Driving on the Boulevard
in Alexandria with Mme.
Luzzatta - Jan. 28 - 1922.

(Note the Egyptian
driver.)

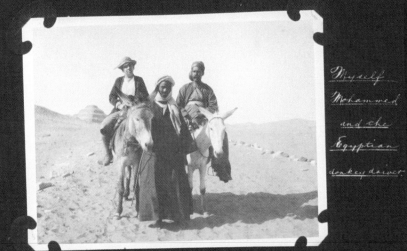

Myself
Mohammed
and the
Egyptian
donkey driver

The Step Pyramid, Third Dynasty
Sakkāra near Memphis, Egypt.

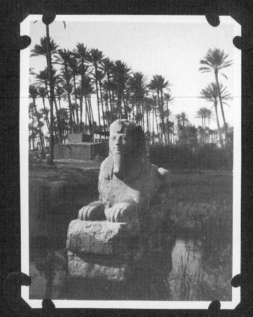

Another view of the Sphinx - Memphis.

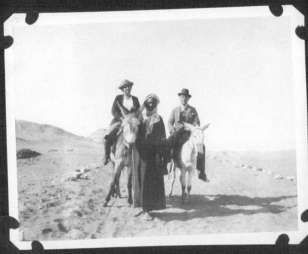

Myself
Ernest
and the
Egyptian
donkey driver

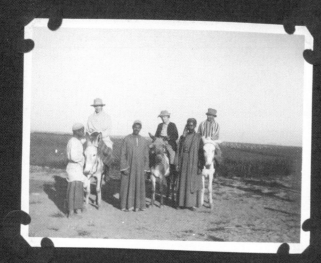

Near the Rock Tombs of
Benihasan (middle Empire)
(Noted for their architecture and important inscriptions.
The Nile - Jan. 17-1923
(Mohammed was born at Luxor and knows the
Nile like the Sphinx.

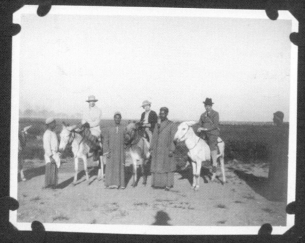

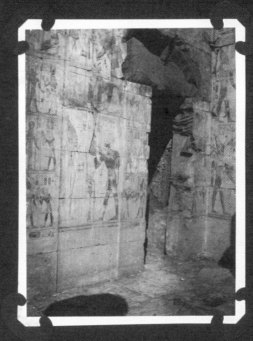

The Innermost Alabaster Shrine
Temple of Ramses II (ruin)
Abydos - on the Nile, Jan. 15-1922.

(Note the brillant mural decorations in
low relief.)

The obelisk
in the
Place de
la Concorde,
Paris, came
from this
temple.

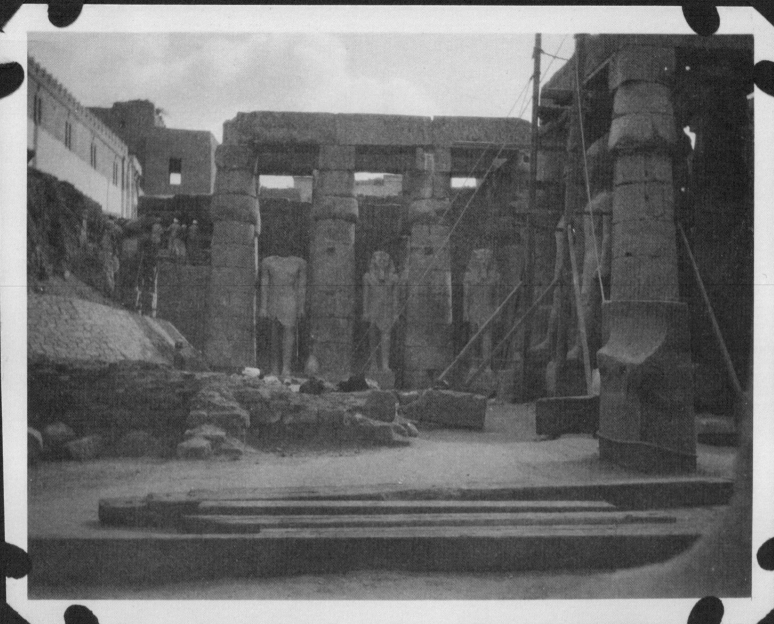

Colossal Statues of Ramses II,
Greatest of the Pharaohs, Temple of Luxor, 18th
Dynasty — The Nile, January 11 – 1922.

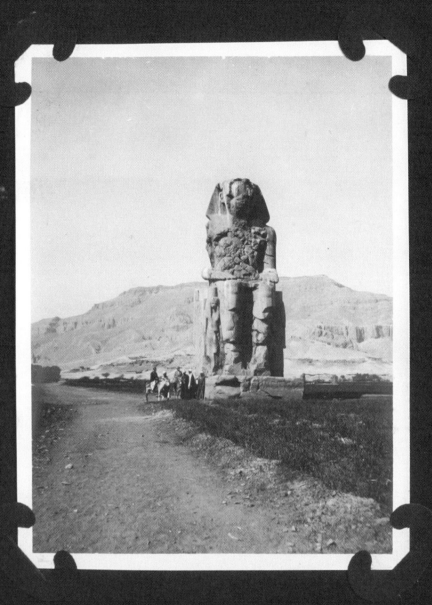

The Colossi of Memnon,
with Tombs of the Kings
in the background. Thebes.

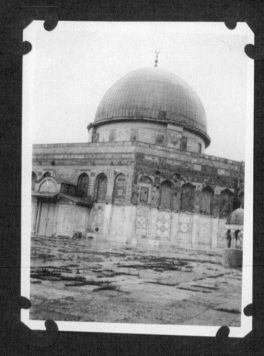

A nearer view
of the Mosque
of Omar, Jerusalem
January 24 - 1922.

Entrance to
the Church
of the Holy
Sepulchre
Jerusalem

Jan 23 - 1922.

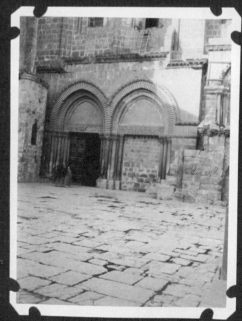

The "Tree of the Agony"
Gethsemane (outside Jerusalem.)

(Nearby is the place where Peter, James and
John slept; and where Judas betrayed Jesus.
Jerusalem - Jan 24 - 1922

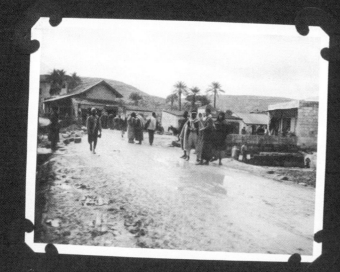

Another village scene
near ancient Jericho, Palestine.

January 24 - 1922.

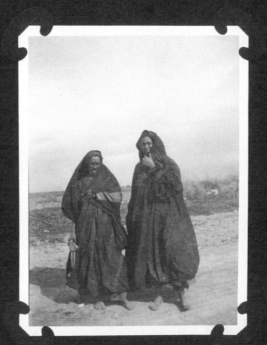

Two Native Women
of Palestine.

(this picture is typical)

January 26 - 1922.

The Sea
of
Galilee

Lake
Tiberias
at
Tiberias

Jan. 26th
1922.

(In some strange way 2 pictures were printed here.

This dirigible flew over Rome
daily in February of 1933.

A painting on the wall of the church
up at San Martino, Naples. Guido
Reni's "Nativity" in this church,
was not finished when he died in 1642.

Taken in
my rooms
at the Grand
Hotel, Rome
Feb. 12 - 1922.
the day of
the coronation
of Pope Pius XI

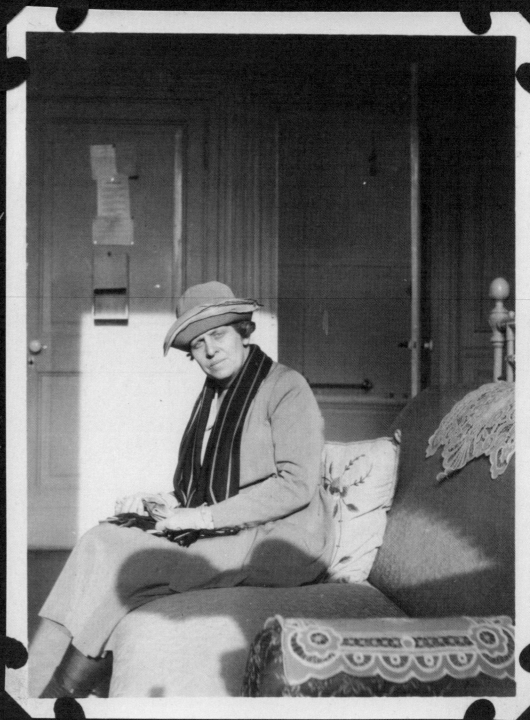

Gazette

World Event:

The Naming of a New Pope

In Rome, our travelers found themselves in St. Peter's Square where they chronicled the tense atmosphere as they, along with thousands of others, awaited the outcome of the Cardinals' vote to see who would succeed Pope Benedict XV. We have no way of knowing if our travelers timed their itinerary to coincide with the world event taking place in the Vatican between February 4 and 6, 1922, but if they did not, the opportunity to see and document history-in-the-making must have been irresistible.

The naming of a new Pope is a rare event: the whole world watches the highly ritualized process. After the death of a reigning pope, the cardinals gather in a conclave in the Sistine Chapel to select a new one from amongst themselves. Each time an unsuccessful vote has been completed, chemicals are added to the ballot papers before they are burned in a small stove, producing black smoke above the Chapel that is visible to those anxiously waiting in the square below. When a new Pope is elected, the papers are burned with other chemicals to produce white smoke, a signal announcing to the world that the conclave has been successful. The highest ranking cardinal emerges from the chapel to announce the new Pope, who, draped in his new papal garments, then emerges and gives his first blessing.

Ernest's photographs capture the crowds of people standing in the square, waiting for the white smoke indicating the election of a new Pope. We can see our traveler in the foreground of one photograph, wearing a hat amid a sea of umbrellas, as the announcement that Pius XI had been chosen is made from the balcony of St. Peter's on February 6. To make sure we are aware that she witnessed this monumental world event, she noted in parenthesis underneath the somewhat blurry snapshot: "I am among those present."

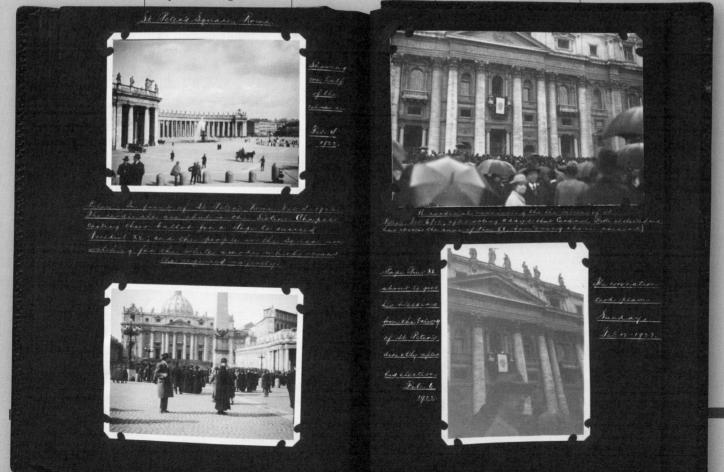

Gazette

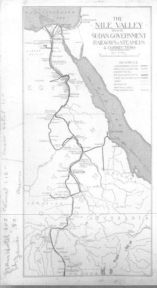

THE NILE VALLEY AND THE SUDAN GOVERNMENT RAILWAYS & STEAMERS & CONNECTIONS

HOW TO SEE EGYPT, THE SUDAN & PALESTINE
1925-26

D. E. MUNARI · TOURIST AGENT
to the Sudan Government Railways & Steamers
AGENT "LLOYD TRIESTINO S. S. Co.,"
CAIRO (Egypt)

THE SEVEN WONDERS OF THE ANCIENT WORLD

The Pyramids of Egypt and the Sphinx—are situated close to the west bank of the Nile River nearly opposite Cairo, and were built between 4731 B.C. and 4454 B.C.

The pyramids were royal tombs, the largest being Cheops, 461 feet high, 746 feet square at the base and covering 12 acres of ground.

The Sphinx, hewn of solid rock, has the head of a man and the crouching body of a lion. It is 146 feet long and 100 feet to the top of the head.

The Hanging Gardens of Babylon—were near the Euphrates River in the palace of King Nebuchadnezzar, 60 miles south of the present city of Bagdad. The terraced gardens planted with flowers and small trees and with fountains were 75 to 300 feet above the ground. They date from about 600 B.C.

The Temple of Diana—at Ephesus in Asia Minor an ancient but now vanished city, was built in the Fifth Century B.C. by the Ionian states as a joint monument. The building was of marble 425 feet by 225 feet and the roof was supported by 127 columns of Parian marble, each 60 feet high and each weighing about 150 tons. In 356 B.C. the temple was destroyed.

The Statue of Jupiter Olympus—in the valley of Olympia 12 miles inland from the west coast of the southern peninsula of Greece, was begun in 432 B.C. It was of marble encrusted with ivory and the draperies were of beaten gold.

The Tomb of Mausolus—was in Asia Minor on the Eastern shore of the Aegean Sea opposite Greece. It was built of marble about 352 B.C. by Queen Artemisia and was remarkable for its beauty and magnificent interior. It was destroyed by an earthquake.

The Pharos of Alexandria—a white marble lighthouse or watch tower on the island of Pharos, in the port of Alexandria, Egypt, was completed in 283 B.C. The island had been joined by Alexander the Great to the mainland of Egypt by a causeway when he founded Alexandria. Fires were used as a beacon by night and were kindled in the upper part of the tower.

The Colossus of Rhodes—was a brass statue of the Greek sun-god Apollo, about 109 feet high and was erected at the port of the City of Rhodes on the Island of Rhodes in the eastern part of the Mediterranean Sea north of Alexandria. It took 12 years to build; was completed about 280 B.C. and was thrown down 224 B.C. by an earthquake. There it lay for nearly 1000 years, until 672 A.D. when the Turkish Government sold it to a man who broke and pulled the huge brass

MORE RECENT WONDERS OF THE WORLD

The Great Wall of China—Besides the so-called seven wonders of the world there were many other ancient marvels of architecture and construction, among them the Great Wall of China which was built about the third century B.C. and which extended along the Northern frontier from the Yellow Sea north of Pekin in a zigzag course to the border of Turkestan, a distance of 1728 miles though only 1300 miles as a bird flies. The wall was over 20 feet high with towers over 35 feet high at intervals of about 250 yards. Following the national boundary line as it did, the Great Wall crossed mountains, gorges, rivers, and valleys, overcoming all natural obstacles built to keep out the war-like hordes from Mongolia and Manchuria, then known as Tartars. It served its purpose for 1000 years.

The Tower of Babel—in the Chaldean City of Ur has completely disappeared, but a well authenticated clay tablet gives its exact dimensions. The base of the tower was 300 x 300 feet tapering through seven stages to the shrine at the top which was 300 feet high.

The Catacombs—or subterranean tombs were a feature of human burials in Egypt and in Asia Minor thousands of years before the Christian era. The name is applicable also to the Baths of Cleopatra at Alexandria and to the ancient underground burial places in Etruscan, Italy. The catacombs at Rome were the sepulchres of the early Christians and consisted of more than 40 groups of labyrinths covering 615 acres and sometimes extending 8 stories of about 70 feet below the ground.

The Circus Maximus—at Rome built 605 B.C., rebuilt and enlarged by Julius Caesar several hundred years later was 312 feet high, 1875 feet long and 625 feet wide. It then held 150,000 spectators but the capacity was increased to 385,000 in the 4th Century A.D. The place was used for games and for horse and chariot races.

The Colosseum at Rome—one of the largest amphitheatres in the world was finished about 82 A.D. 150 years later a 4th story was added. The ruins still stand. The building elliptical in shape was 615 x 510 feet and the floor of the arena was 281 feet by 176 feet. The walls were stone and the seats marble. 50,000 persons could sit and 20,000 could stand. The cost was about $15,000,000 and the work was done by 12,000 slaves from Jerusalem. Wild animals were kept in dens under the floor and thousands of persons including early Christians perished in combats with lions and tigers.

The Mosque of St. Sophia—at Constantinople was built as a Christian Cathedral by the Roman Emperor Justinian about 535 A.D. in the form of a Greek cross, 260 feet by 143 feet and 180 feet high. The Sultan of Turkey, Mohammed II, turned the cathedral into a mosque in 1453 A.D.

The Leaning Tower of Pisa—a round eight story bell tower built of marble in 1154 A.D. is 188 feet high and the top is 16 feet out of the perpendicular. The architect had no such intention but the foundation gradually sank during construction so that certain changes were made in the upper stones to keep it standing.

The Vatican at Rome—is the largest residence in the world containing several thousand rooms. It stands on the North side of the River Tiber and its nucleus was a house built in the time of the Emperor Constantine. It was enlarged from time to time and has been the only regular home of the Roman Pontiffs since they abandoned their palace at Avignon, France, in 1377.

The Cathedral of St. Peter at Rome—the largest church in the world begun in 1506 by Pope Julius and completed in 126 years, covers 18,000 square yards and is 636 feet long with a nave 141 feet long. The top of a cross on the dome is 435 feet above the ground.

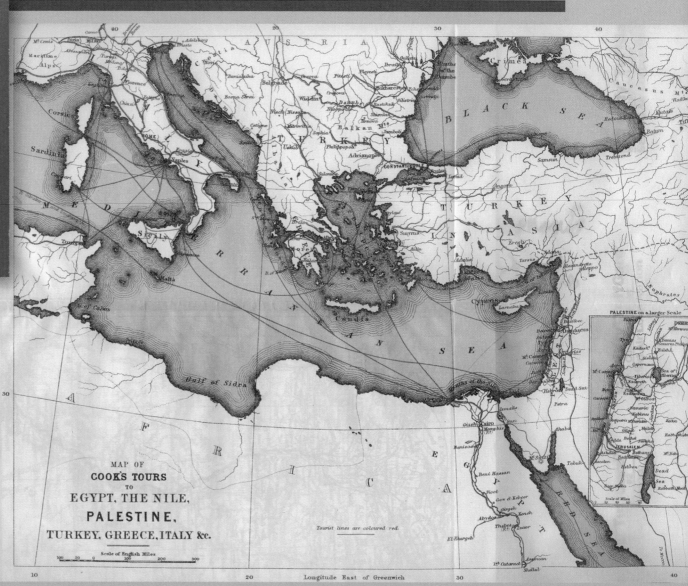

MAP OF
COOK'S TOURS
TO
EGYPT, THE NILE,
PALESTINE,
TURKEY, GREECE, ITALY &c.

Scale of English Miles

Tourist lines are coloured red.

Longitude East of Greenwich

PALESTINE on a larger Scale

Ernest Tilbury
my English
courrier.

(Taken Feb.
12, 1922, just
before leaving
Rome for Paris.

A Flapper's Trip Around the World

IN 1924 Vera Talbot, a California socialite, departed San Francisco on a two-year journey of Japan, China, Southeast Asia, Egypt, and Northern Africa that culminated in a tour of some of the familiar sites of Europe. Vera's album is a dense collage of images culled from books, souvenir, postcards, maps, brochures, itineraries, and her personal photographs. The result is an album as energetic as her time: the Roaring Twenties. Vera seems less interested in neat presentation than in making sure that she doesn't leave anything out. Each page is jammed with layers of images, pasted down only on one edge so you can read inscriptions on the back of the photos, overlapping and combining in a dizzying array.

Vera's album is a frenetic jumble, and the voracity with which she seemed to peruse every site and cultural experience is palpable on every page. Vera made no distinction between which images were purchased and which were made with her or her companions' camera, although careful inspection reveals which is which—Vera used whatever images or memorabilia she had handy to tell the story of her two-year odyssey. It is quite a story.

PACIFIC MAIL S.S. CO.

MANAGING AGENTS
UNITED STATES SHIPPING BOARD
S. S. PRESIDENT TAFT

PROGRAMME

OF

Entertainments and Deck Sports

Voyage No. 11-64 Outward

DECEMBER 1924.

Between San Francisco and Yokohama

———:0:———

Executive Committee

———:0:———

HONORARY CHAIRMAN	Captain John G. Moreno
CHAIRMAN	Mr. H. B. Fowler
SECRETARY	Mr. D. C. Sims
TREASURER	Mr. Joseph Huckins Jr.
DECK GAMES	Mr. Chester Fritz
ENTERTAINMENT	Mr. W. L. Applegate
FINANCE AND PRIZES	Mr. C. F. O'Neil

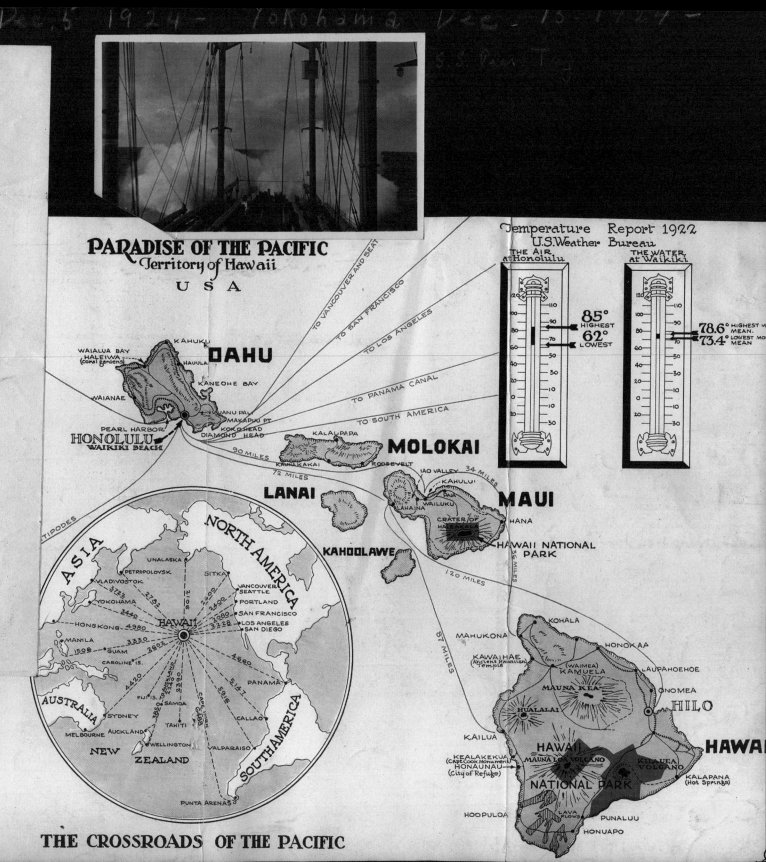

PARADISE OF THE PACIFIC
Territory of Hawaii
USA

Temperature Report 1922
U.S. Weather Bureau

THE AIR at Honolulu — 85° HIGHEST, 62° LOWEST

THE WATER at Waikiki — 78.6° HIGHEST MEAN, 73.4° LOWEST MEAN

OAHU — WAIALUA BAY, HALEIWA (Coral gardens), KAHUKU, HAUULA, KANEOHE BAY, WAIANAE, NUUANU PALI, MAKAPUU PT, KOKO HEAD, DIAMOND HEAD, PEARL HARBOR, HONOLULU, WAIKIKI BEACH

TO VANCOUVER AND SEATTLE
TO SAN FRANCISCO
TO LOS ANGELES
TO PANAMA CANAL
TO SOUTH AMERICA

90 MILES — 72 MILES

MOLOKAI — KALAUPAPA, KAUNAKAKAI, ROOSEVELT

LANAI

MAUI — IAO VALLEY 34 MILES, KAHULUI, PAIA, WAILUKU, LAHAINA, CRATER OF HALEAKALA, HANA, HAWAII NATIONAL PARK

KAHOOLAWE

120 MILES

87 MILES

HAWAII — KOHALA, MAHUKONA, HONOKAA, KAWAIHAE (Ancient Hawaiian Temple), (WAIMEA) KAMUELA, LAUPAHOEHOE, MAUNA KEA, ONOMEA, HILO, HUALALAI, KAILUA, KEALAKEKUA (Cape Cook Monument), HONAUNAU (City of Refuge), MAUNA LOA VOLCANO, KILAUEA VOLCANO, KALAPANA (Hot Springs), NATIONAL PARK, LAVA FLOWS, HOOPULOA, PUNALUU, HONUAPO

HONOLULU TIME CHART

NOON STANDARD TIME

SHANGHAI 6:30, YOKOHAMA 7:30, SYDNEY 8:30, AUCKLAND 10:15, CHICAGO, WASHINGTON, NEW YORK 4:30, LONDON 5:30

WEST — EAST

TO-MORROW — TO-DAY

THE CROSSROADS OF THE PACIFIC

ASIA, NORTH AMERICA, AUSTRALIA, NEW ZEALAND, SOUTH AMERICA

UNALASKA, PETROPOLOVSK, SITKA, VLADIVOSTOK, YOKOHAMA, HONGKONG, MANILA, GUAM, CAROLINE IS., FIJI IS., SAMOA, TAHITI, SYDNEY, MELBOURNE, AUCKLAND, WELLINGTON, VANCOUVER SEATTLE, PORTLAND, SAN FRANCISCO, LOS ANGELES, SAN DIEGO, HAWAII, PANAMA, CALLAO, VALPARAISO, PUNTA ARENAS, ANTIPODES

AIL

ER

ER

085

Souvenir
Passenger List

MATSON
NAVIGATION
COMPANY

HONOLULU

Compliments of
MOANA HOTEL
(Waikiki Beach)
HONOLULU, T. H.
MR. PHIL. POIRIER, Manager

134

Coolie with rain-coat.

Sedan chairs

RICKSHAW

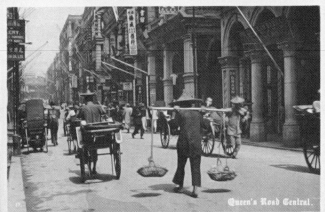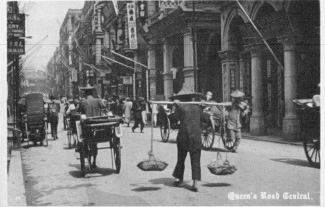

Queen's Road Central.

Hong Kong, China.

Canton.

Canton

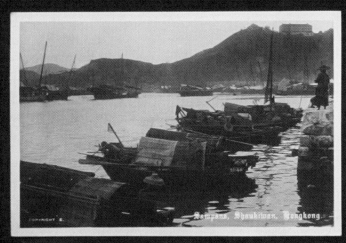

Sampans, Shaukiwan, Hongkong.

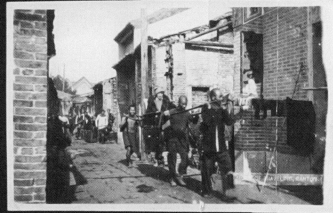

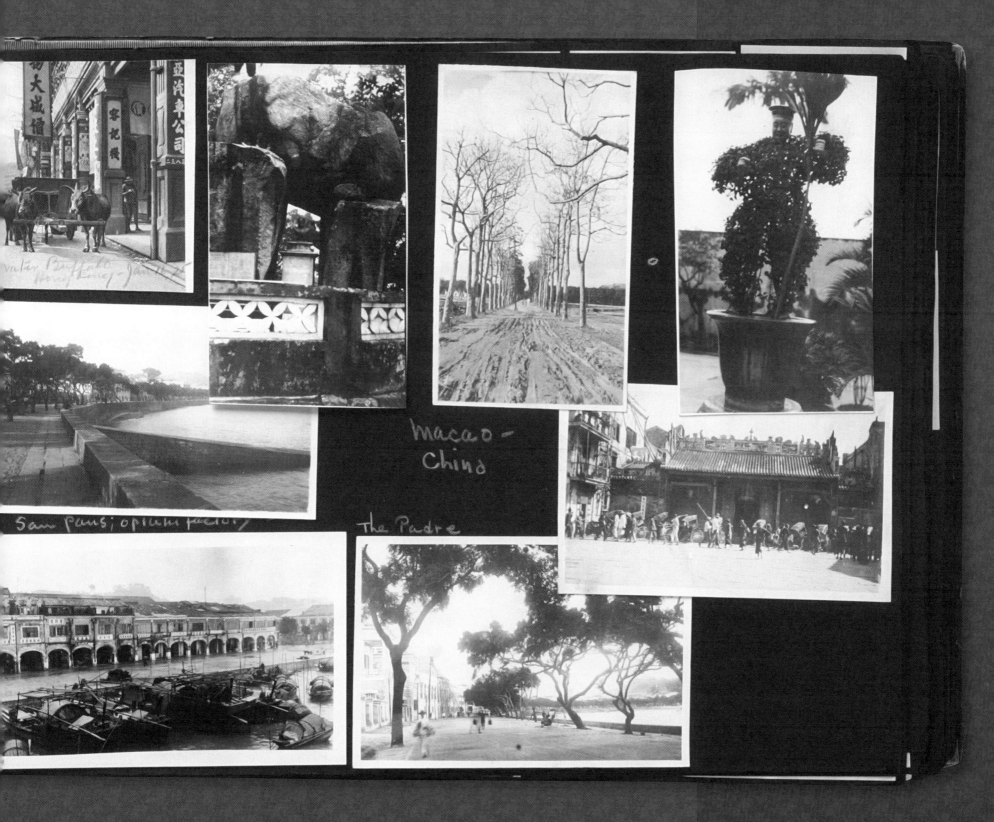

water Buffalo
Hong Kong - Jan

San Pan, opium factory

Macao - China

The Padre

135

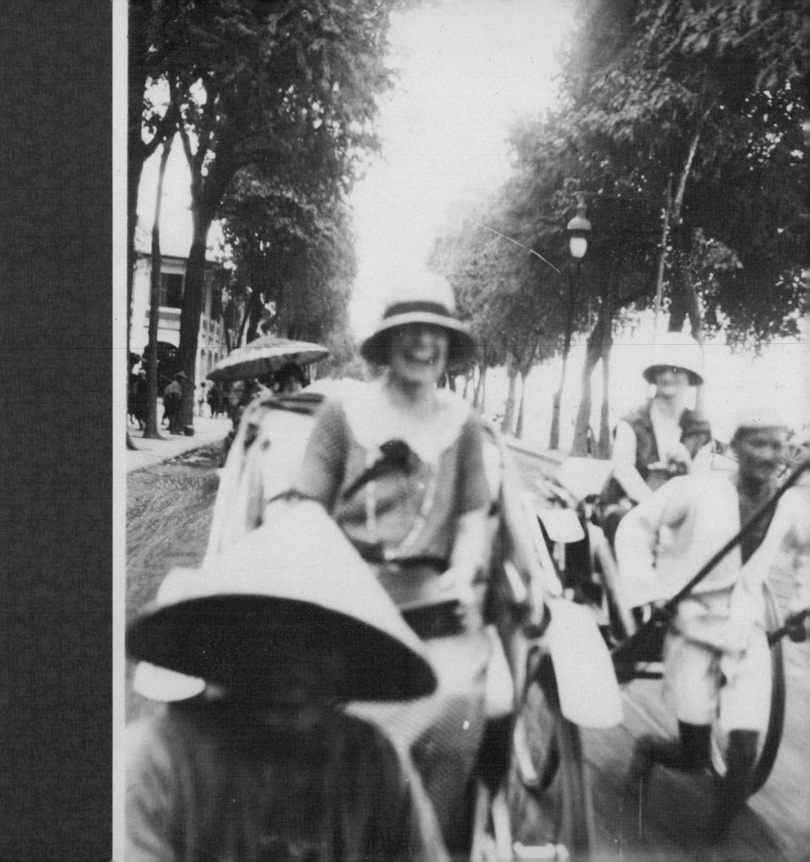

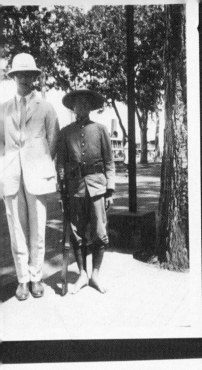
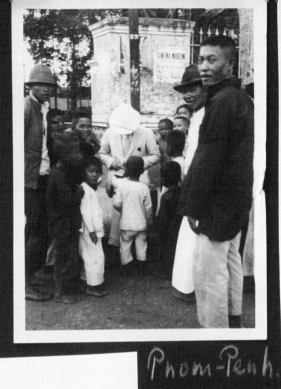

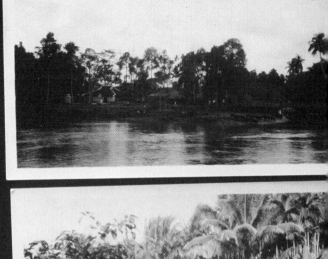

Phom-Penh.

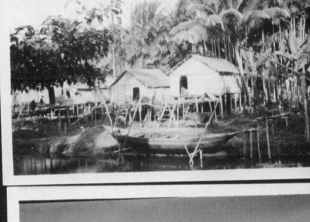
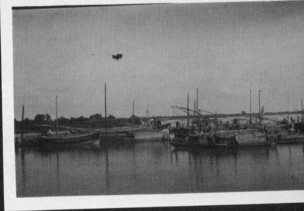
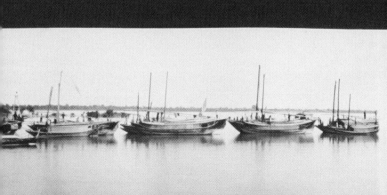
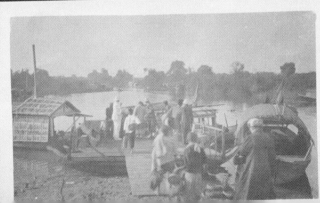
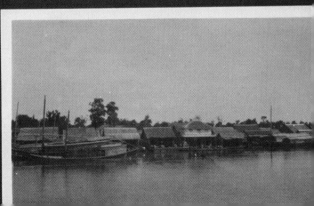

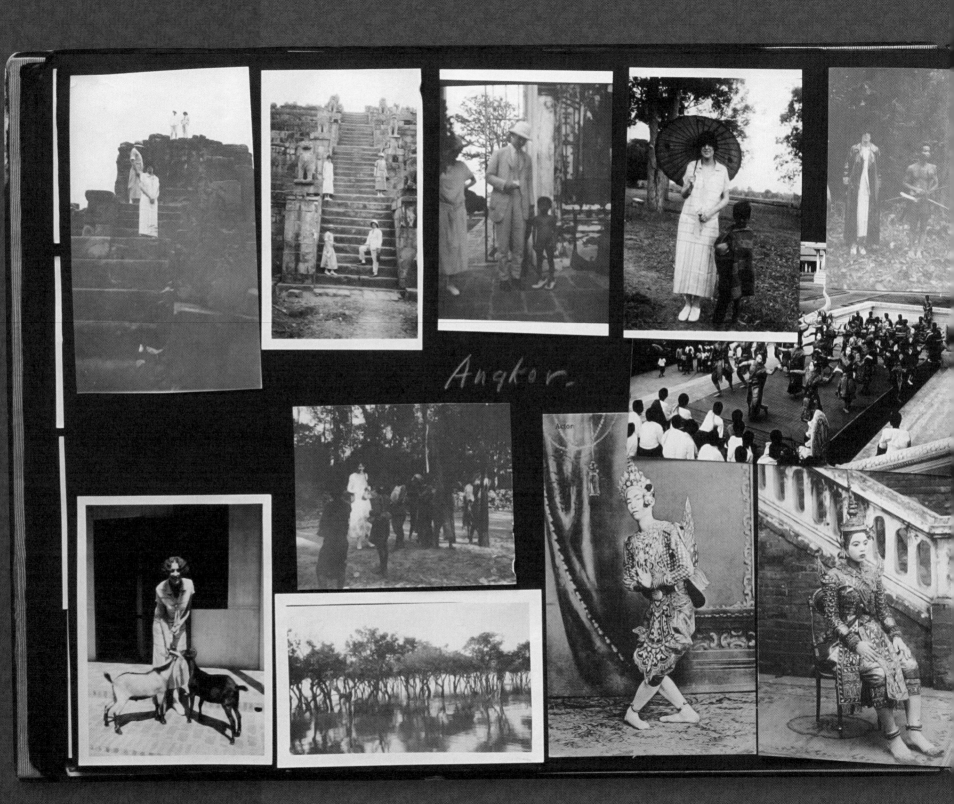

138

Angkor.

Actor

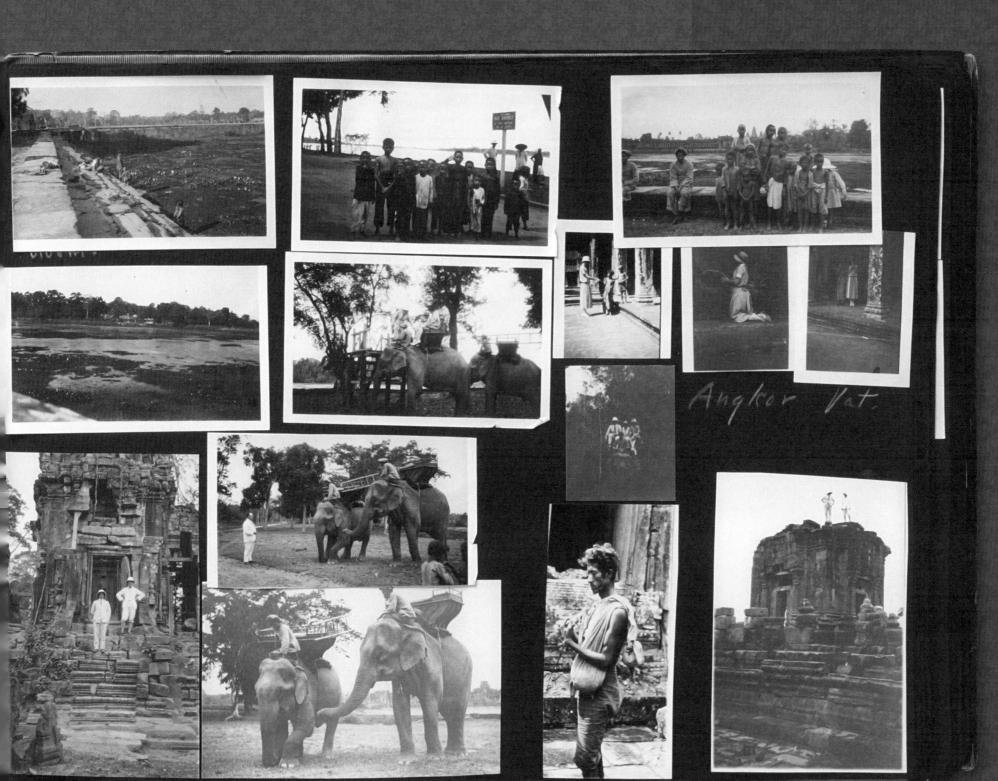

Angkor Vat.

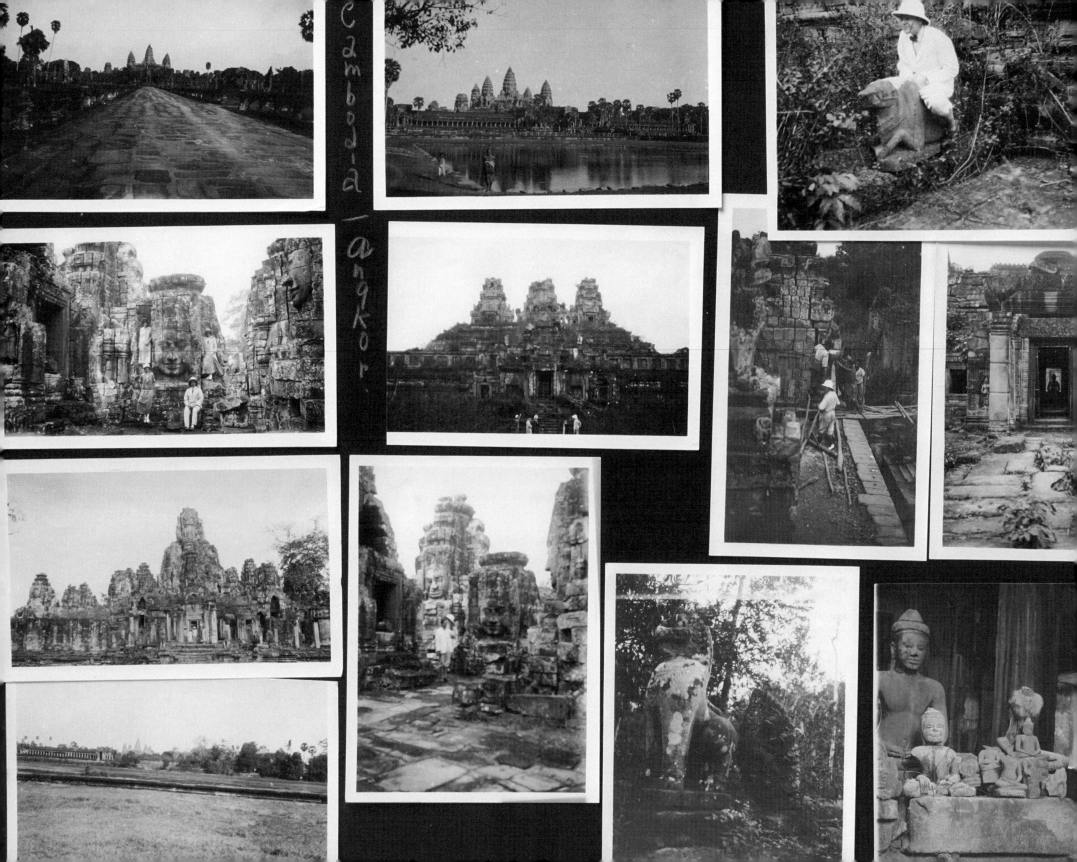

Cambodia — Angkor

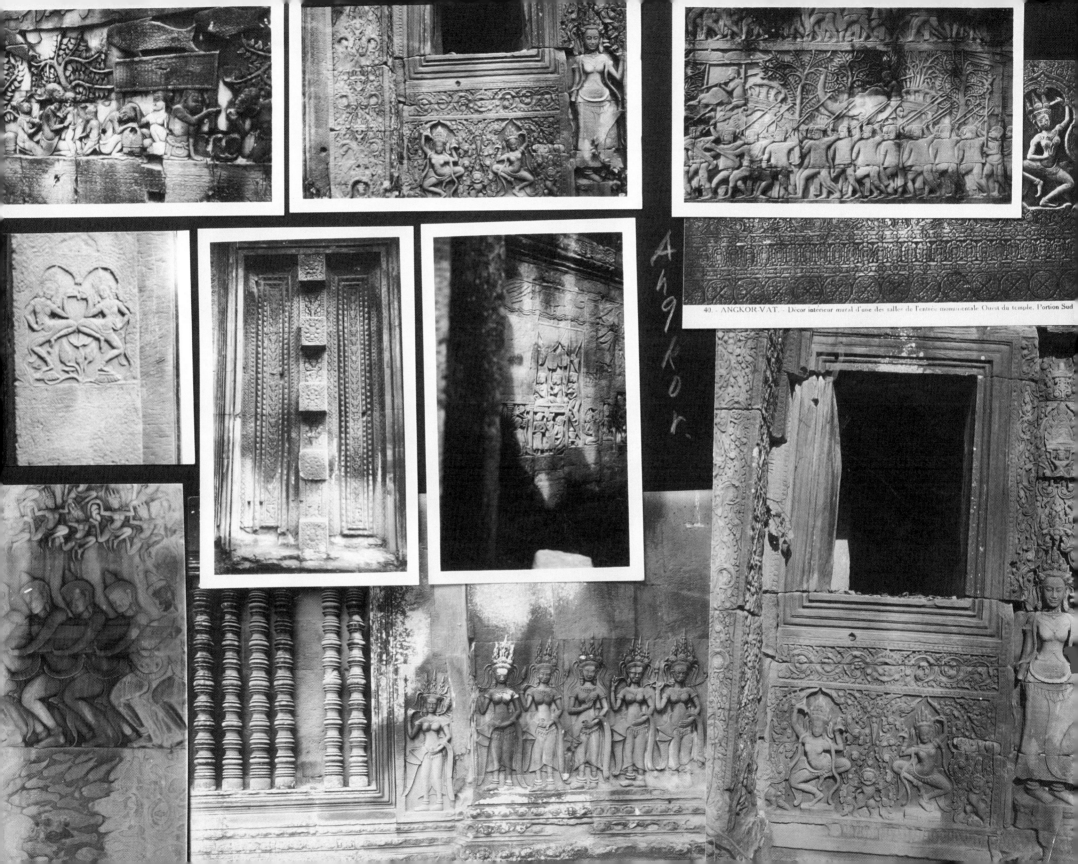

40. – ANGKOR-VAT. – Décor intérieur mural d'une des salles de l'entrée monumentale Ouest du temple. Portion Sud

Angkor.

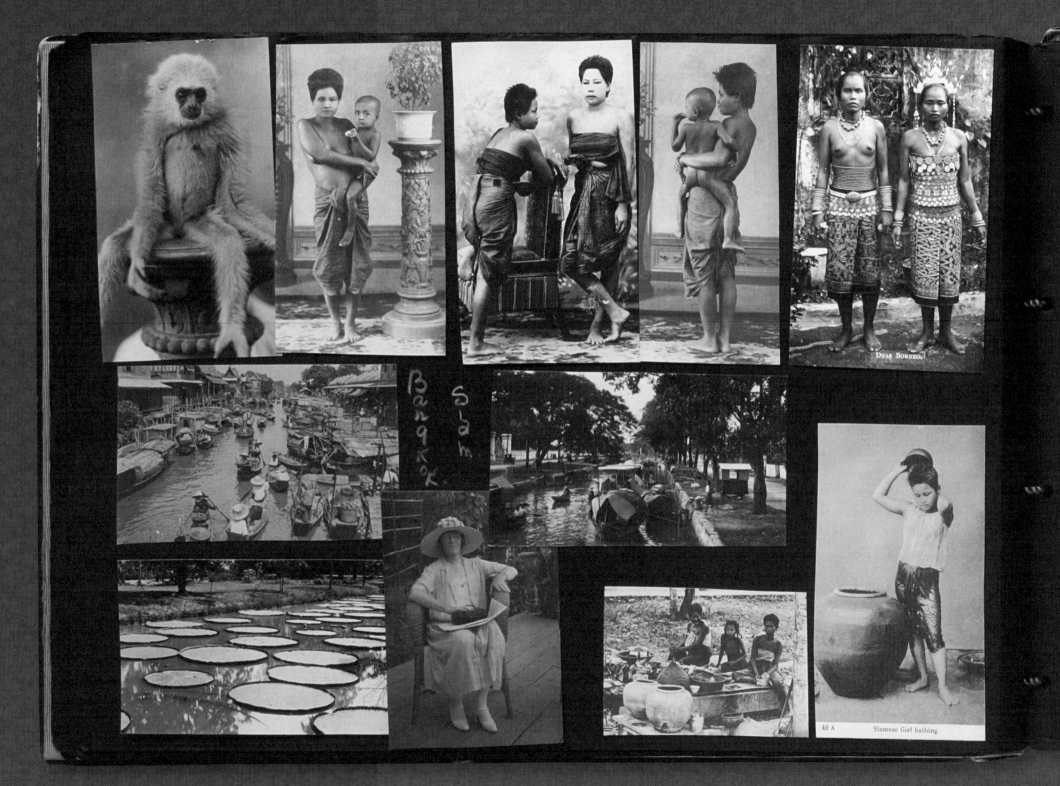

Bangkok Siam

Dyas Borneo.

42 A Siamese Girl bathing.

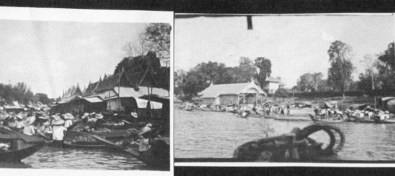

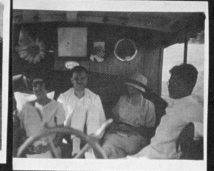

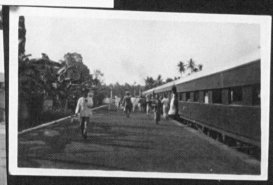

Bangkok to Penang.

Eyruthia – Ancient Capital of Siam.

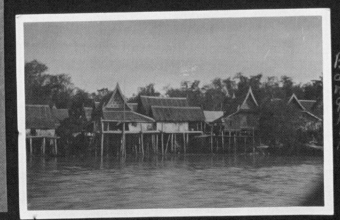

Bangkok.

143

These were exotic places, worlds away from the civilized realm of Vera's upbringing. Although many of her destinations were still under the thumb of colonial rule, traditional customs remained woven into the social fabric, and Vera made an effort to capture them. She was fearless; unlike more squeamish travelers, Vera eagerly sought out and documented everything she encountered—including a public execution in Bangkok. Her photographs of the event are discreetly placed in an envelope pasted to the page and annotated in her hand, "Public execution in Bangkok, Siam—Priests dance themselves into a frenzy before chopping off head of victim or prisoner."

There is little editorializing in this album; Vera made few judgments about the execution or the traditional, "primitive" societies that seemed to fascinate her. Browsing her album, you get the sense that Vera was not attempting to "go native," but was thoroughly carried away—enraptured even—by her whole experience of exotic cultures, places, and people.

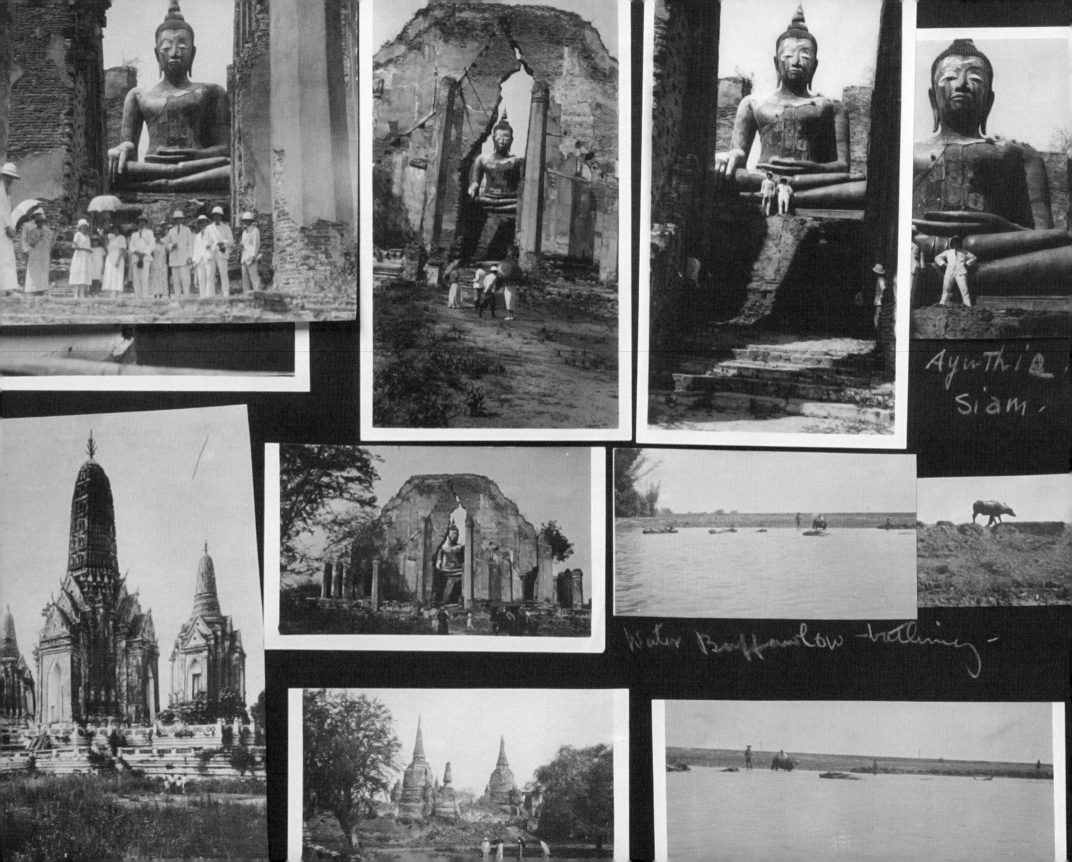

Ayuthia
Siam

Water Buffalow bathing

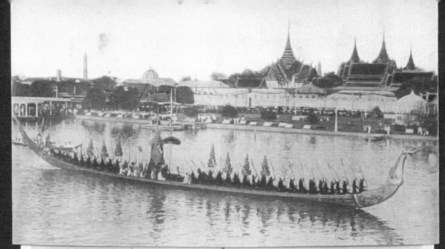

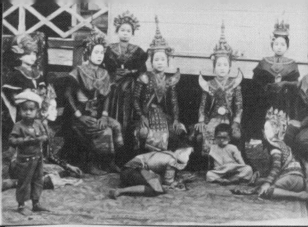

Siam.

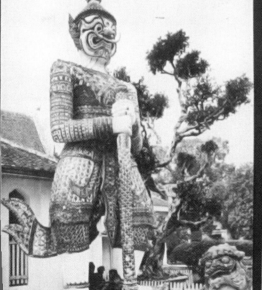

G84 Gate Guardian, wat Cheng

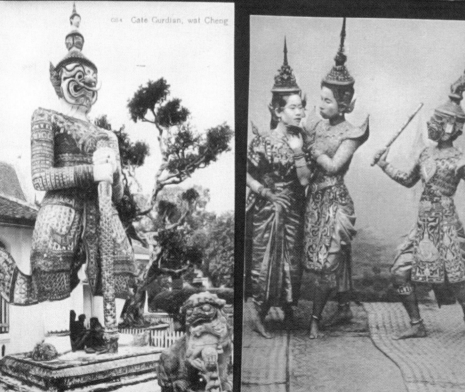

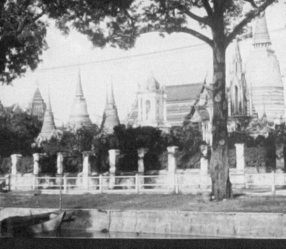

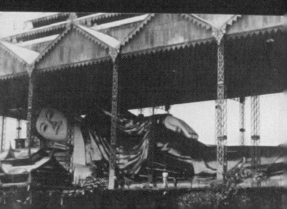

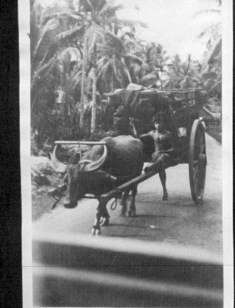

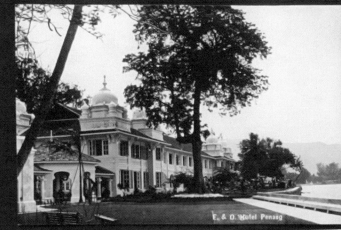

E. & O. Hotel Penang

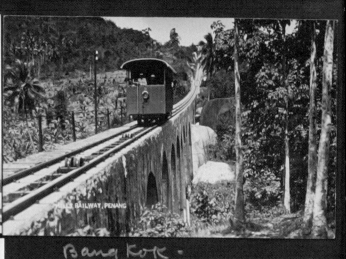

E. RAILWAY, PENANG

Bang Kok.

Penang.

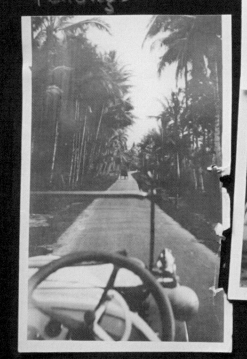

THE GEORGETOWN DIS

MAP
OF
THE
F.M.S.
&
SIAMESE RAILWAYS

Reference

BAY OF BENGAL

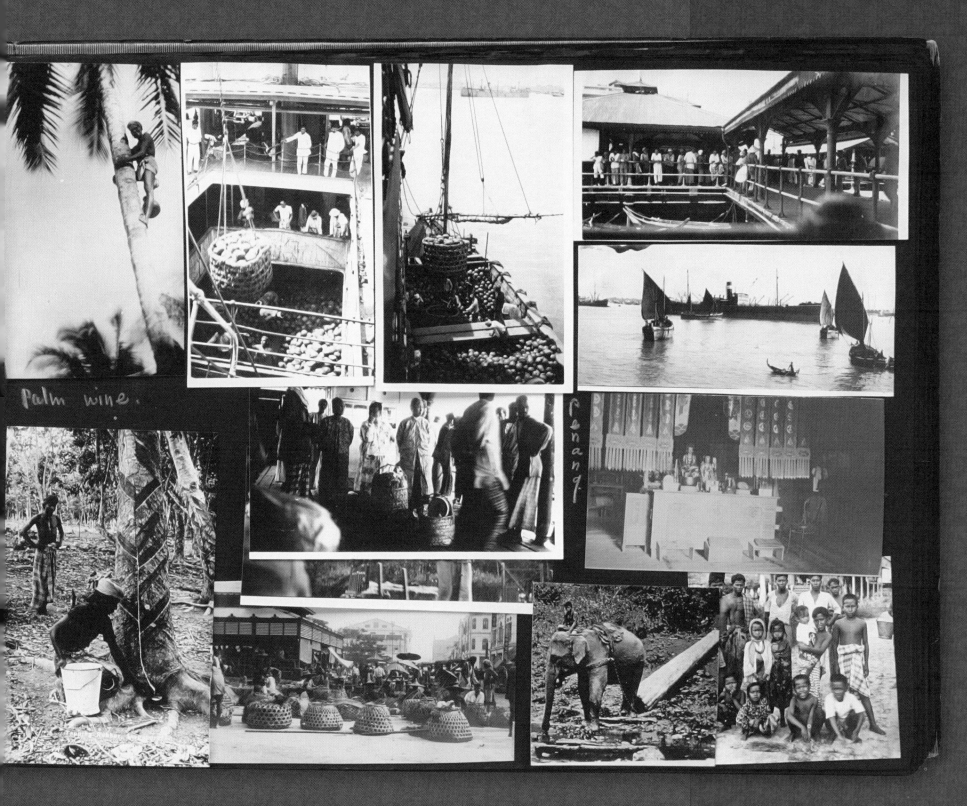

Palm wine.

Penang

147

Burma - Lumber Yard.

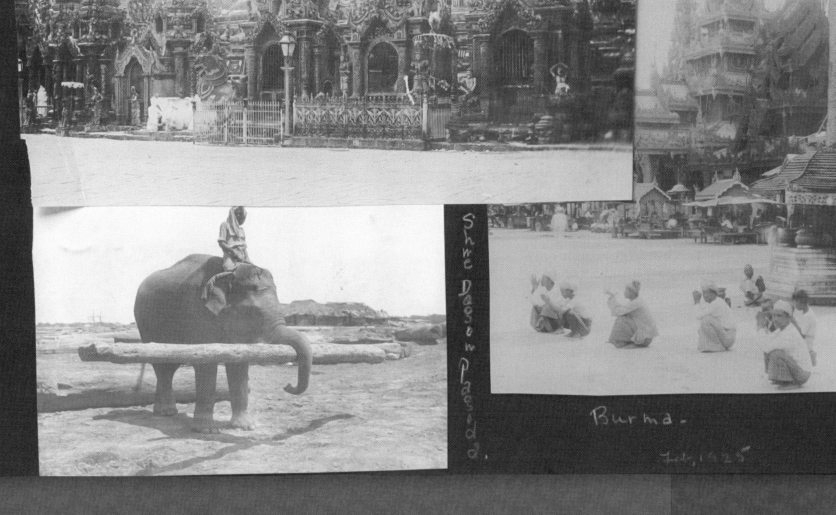

Shwe Dagon Pagoda.

Burma.

Feby, 1925

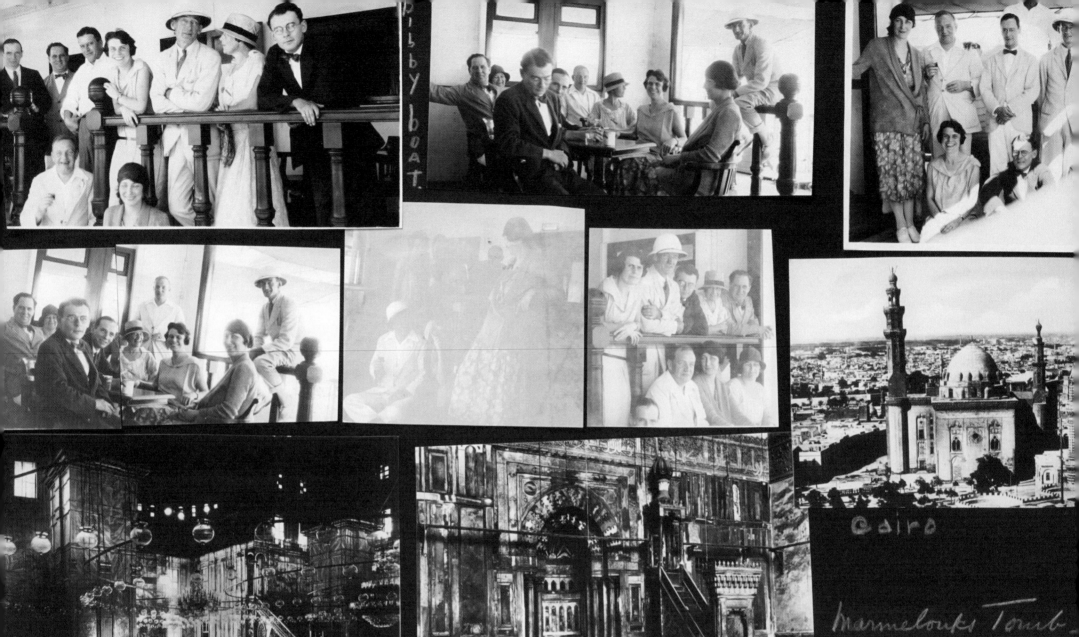

pilby boat.

mosque - Cairo

S. gloustershire. Crossing the Red Sea

EGYPT.

Cairo

Marmelouks Tombs

Witnessing an Historical Event:
Visiting King Tut's Tomb

On her trip, Vera witnessed events with international and historical resonance—including the recovery of artifacts from the tomb of the boy king, Tutankhamen, which was discovered in 1922 by British egyptologist Howard Carter. The discovery of the undisturbed tomb captured the world's imagination. Newspapers and magazines published articles discussing the dazzling array of treasures found inside: gilded figures, shrines, jewelry made of gold and precious stones,

and even petrified foodstuffs. In February 1923, journalist Maynard Owen Williams covered the public opening for *National Geographic* magazine, calling the tomb "the most remarkable funeral treasures unearthed in historic times."

Vera visited the famous tomb on January 5, 1926, as Carter was removing some of the objects for transport to the Cairo Museum (excavation continued until 1932). Like everyone else, Vera was fascinated by what she saw. The page in her album devoted to her trip to Luxor is composed of souvenir postcards, which she annotated in considerable detail. In the center of the page, Vera pasted a postcard with an artist's rendering of what the king's funeral might have looked like, replete with priests and female mourners in exotic costume. Vera wrote on its back, "Tut's tomb as it might have been in the good old days when his death occurred."

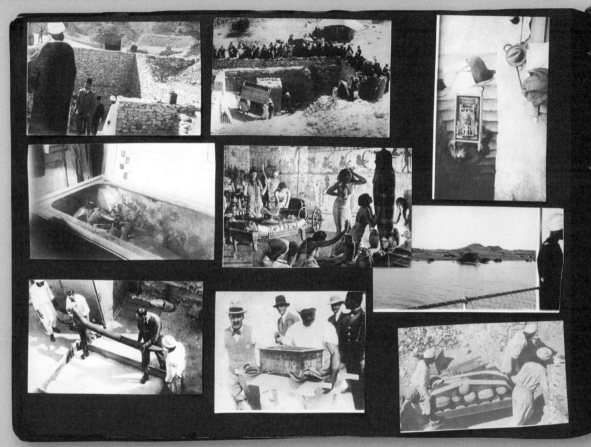

On the back of the snapshots on this page are written the following descriptions:
(TOP RIGHT) "Men at work removing an alabaster vase from Tutankhamen's tomb now placed in the Cairo museum. Luxor, Egypt Jan 1926"
(MIDDLE LEFT) "King Tutankhamen in his beautiful sarcophagus of raw granite— the objects wrapped in cotton on the side are to be removed to the Cairo museum"
(BOTTOM LEFT) "Mr. Carter removing Tutankhamen's bed from the tomb—to be placed in the Cairo museum. Egypt. 1926 Jan."
(BOTTOM MIDDLE) "Mr. Carter removing treasure chest from Tut's tomb. Luxor. Egypt. Jan. 1926"
(BOTTOM RIGHT) "Removing petrified bread buried in Tutankhamen's tomb."

Gazette

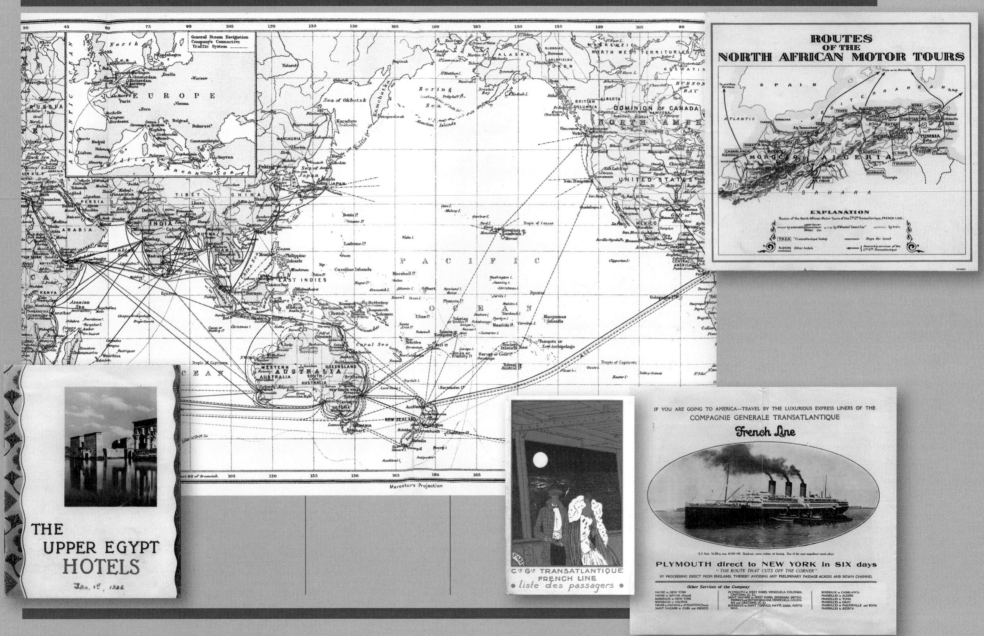

ROUTES OF THE NORTH AFRICAN MOTOR TOURS

THE UPPER EGYPT HOTELS

Cⁱᵉ Gⁱᵉ TRANSATLANTIQUE FRENCH LINE
• liste des passagers •

IF YOU ARE GOING TO AMERICA—TRAVEL BY THE LUXURIOUS EXPRESS LINERS OF THE COMPAGNIE GENERALE TRANSATLANTIQUE

French Line

PLYMOUTH direct to NEW YORK in SIX days

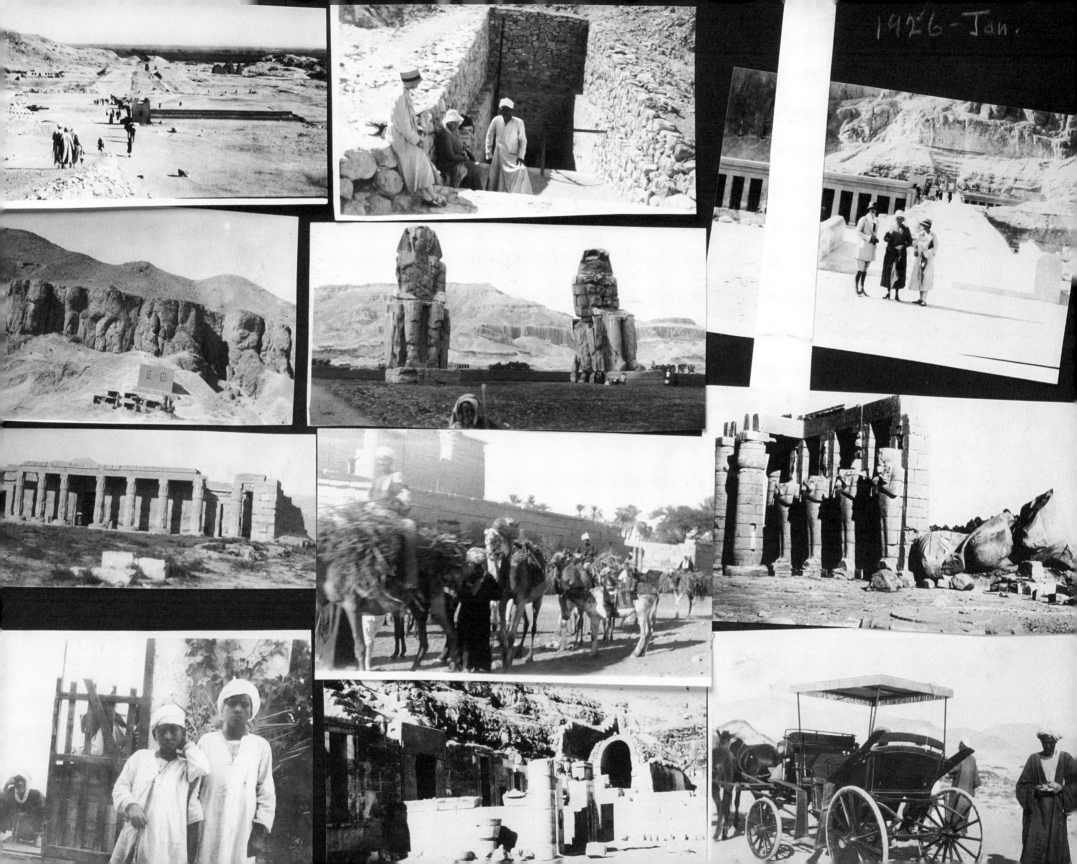

1926 - Jan.

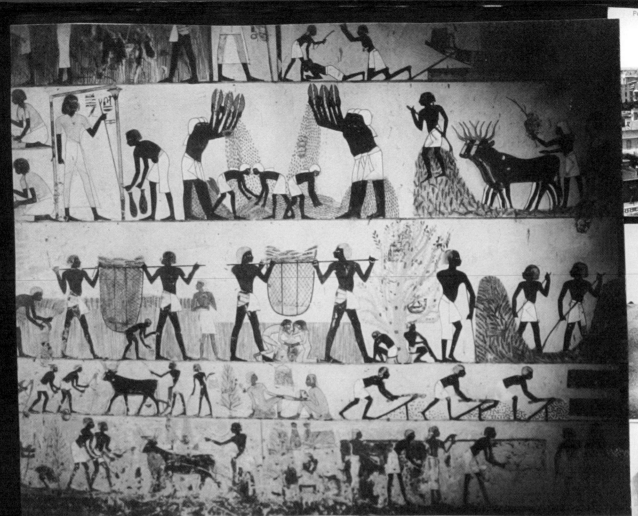

154

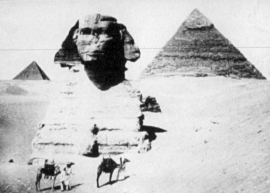

Xmas
1925.

The Harvest.

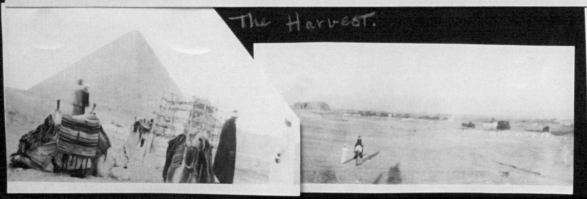

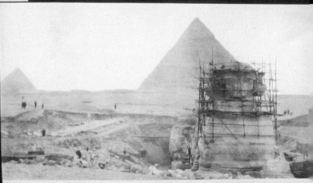

Cairo

EGYPT-Native Woman

The Sun God -

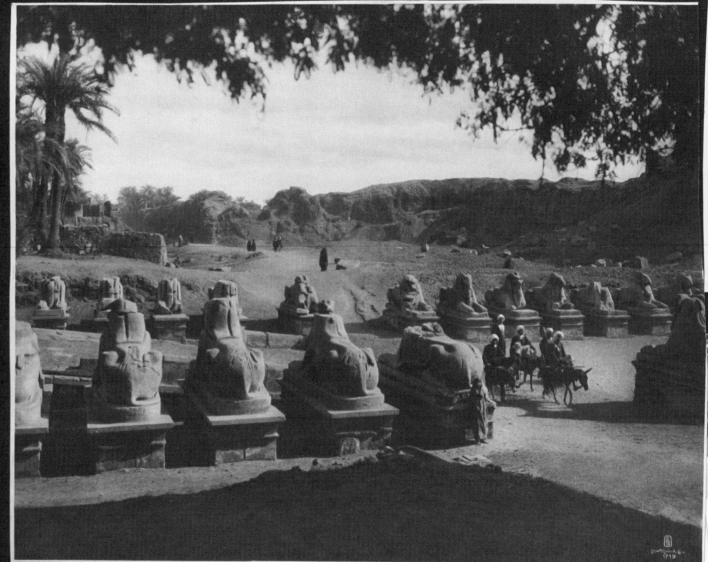

KARNAK - AVENUE OF SPHINXES

Sikhmet. g...

Temple of Karnak - Sphinx Ave

Luxor. Mr. Hichens.

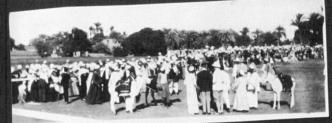

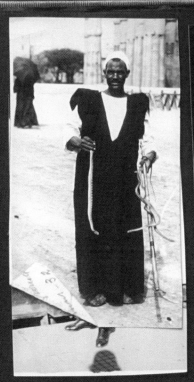

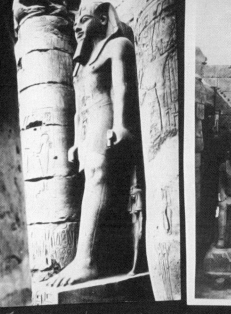

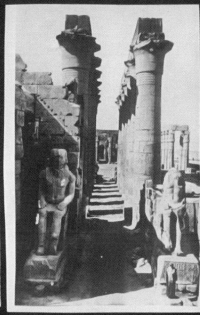

Temple of Luxor.

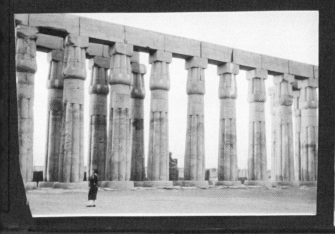

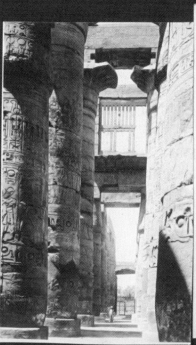

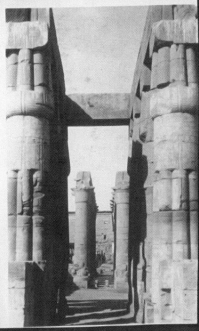

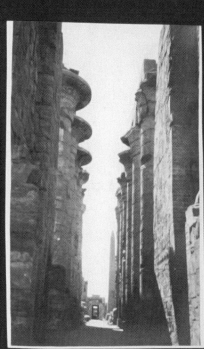

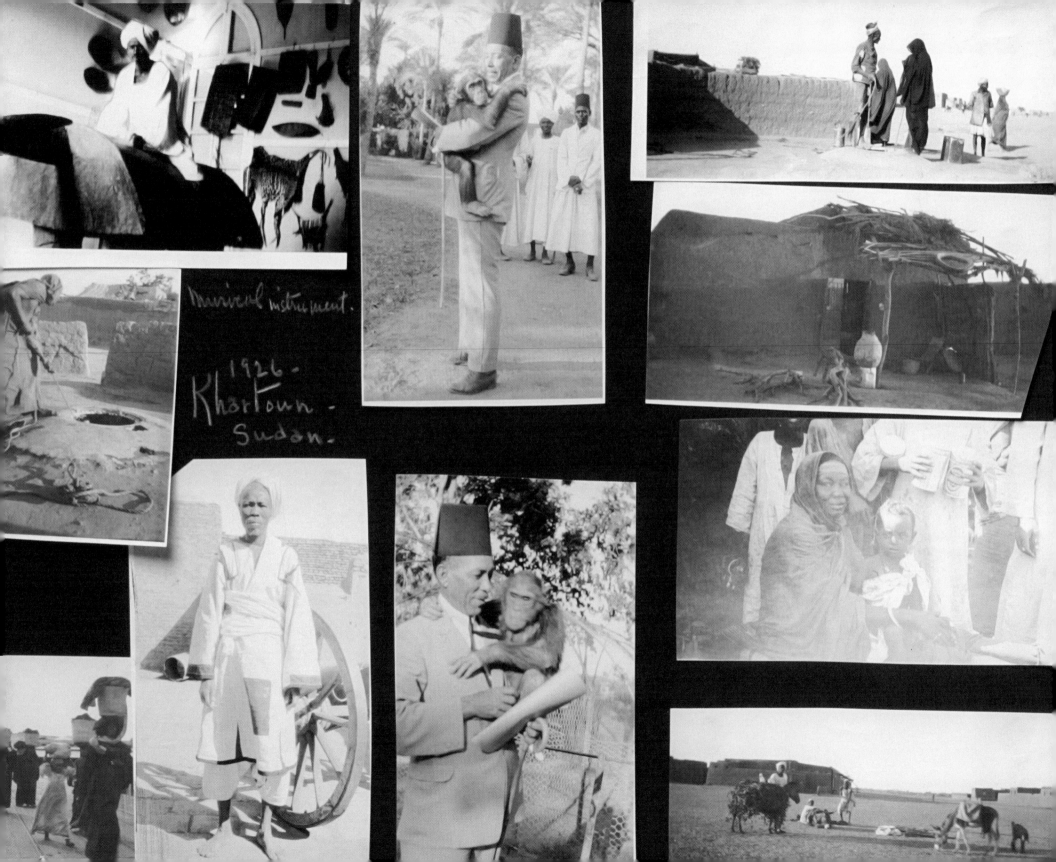

Musical instrument.

1926.
Khartoun -
Sudan.

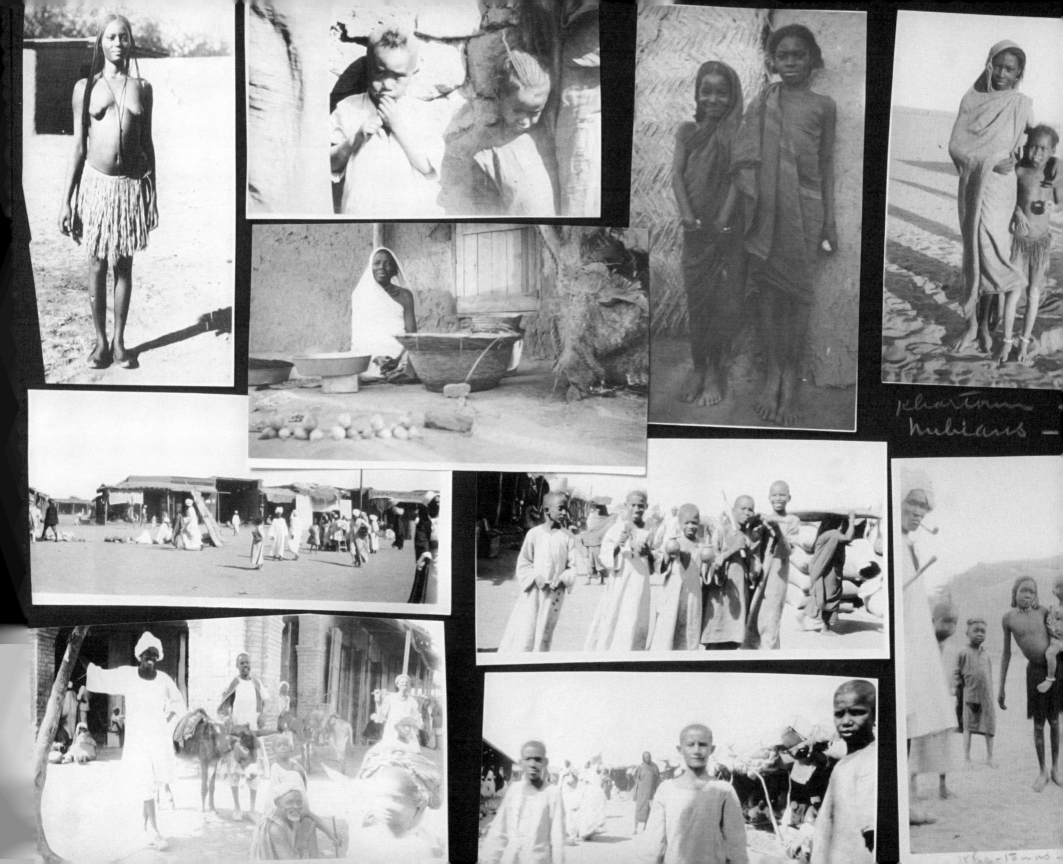

Khartoum
Nubians —

Find the baby!

Omdurman.

a Sakkia for lifting water.

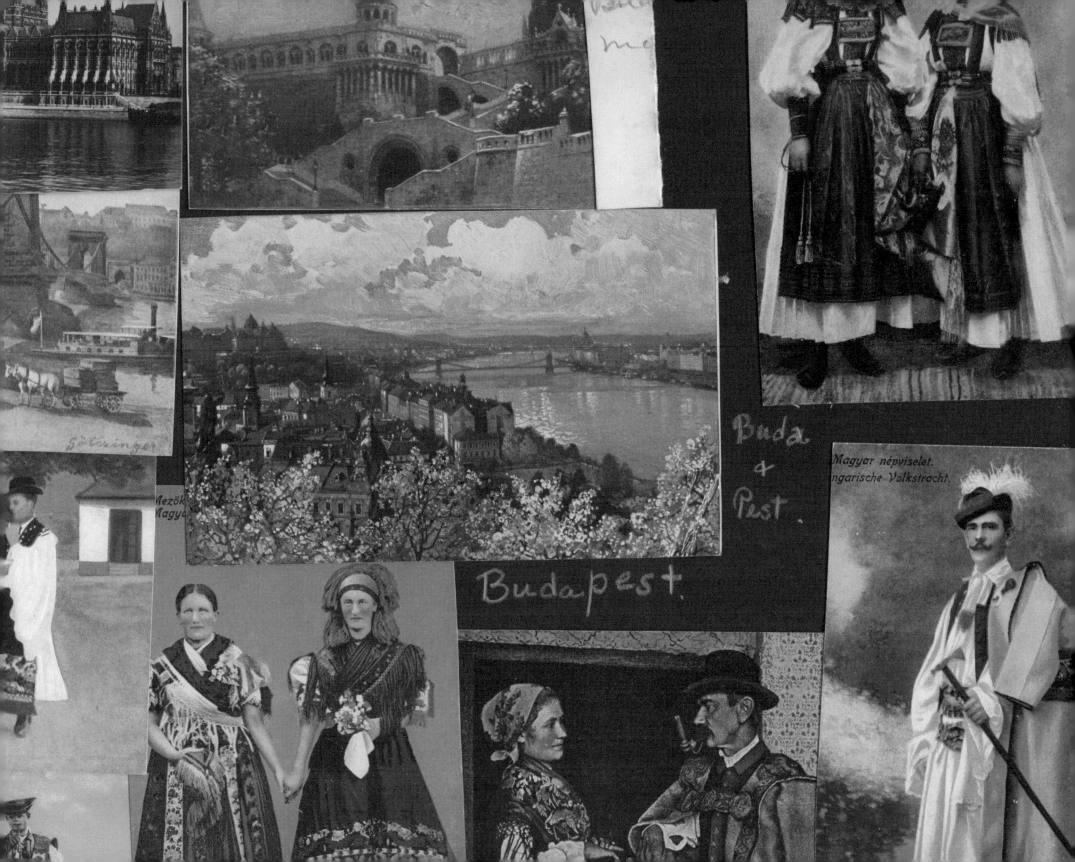

Buda
&
Pest

Budapest.

Magyar népviselet.
Ungarische Volkstracht.

In striking contrast to the rest of the album, Vera devotes only two pages to the last stage of her journey, her time in Europe. There are no personal snapshots, only souvenir postcards, arranged in her hallmark layered jumble. But these do not tell the same animated story or convey the same energy as the rest of the album. The arrangement suggests a kind of dismissive insouciance to the familiar sites and monuments of Rome, Vienna, and Paris. Compared with exotic Bangkok, Cairo, and the Sudan, Europe probably seemed "old hat." After all, anyone in her social circle could see what she saw in Paris or Budapest, but few were likely to replicate her out-of-the ordinary experiences in Asia. Perhaps Vera was tired in the homestretch of her two year journey, or perhaps she simply ran out of film.

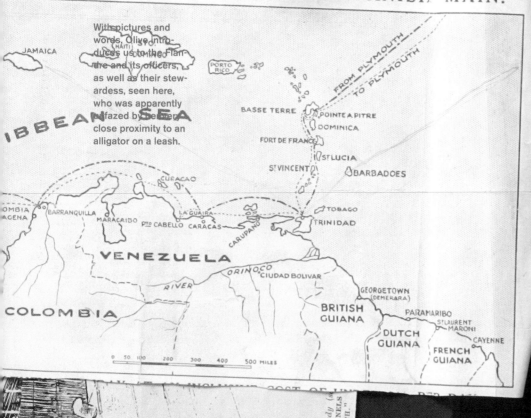

YAGES TO WEST INDIES AND SPANISH MAIN.

With pictures and words, Olive intro-duces us to the Flan-dre and its officers, as well as their stew-ardess, seen here, who was apparently unfazed by her own close proximity to an alligator on a leash.

Old Lady (a...) BOTH FUNNELS COOK LUNCH."

Paquebot "FLANDRE". - Longueur 146 mètres, 9.500 tonneaux, 10.500 HP.

"FLANDRE" Displacement 11,420 tons, Gross Reg. 8,503 tons. Quad. Screw.

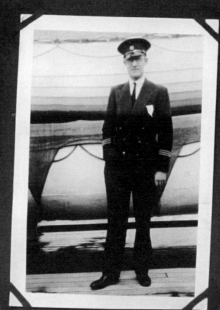

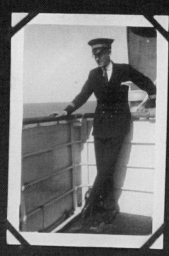

Le Commissaire

Armand
Limnander de Nieu
von Hiilo

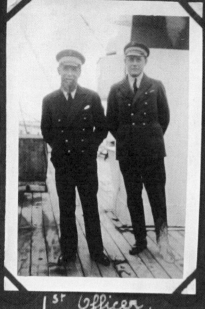

The Captain &

1st Officer.

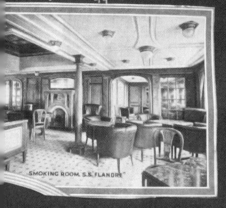

SMOKING ROOM, S.S. FLANDRE

Our Steward ess

A Caribbean Pleasure Cruise

P

ERHAPS inspired by this French Line brochure, with its pleasing beach scene advertising a "pleasure voyage to escape the rigors of an English winter," in February 1929 Olive Jubb packed up her family, including her mother and young son, Alistair, and off they went on a trip to the West Indies. Leaving the winter chill of England behind, they boarded the *Flandre* in Plymouth and in 44 days sailed over 10,600 nautical miles. Their package tour itinerary was highly structured, with stops of only a day or two in such cities and ports as Martinique, Trinidad, and Curacao. If this is Tuesday, as the saying goes, this must be Tobago. The album reads like a geography lesson on the region, replete with texts cut out from brochures provided by the French Line travel company citing populations, natural resources, and agricultural facts, along with collected postcards, photographs, and ship memorabilia. It is easy to imagine mother and son's delight in recalling their trip while they assembled their scraps and images into the album.

WINTER VOYAGES TO SUNNY SEAS

HARRY WEINCAP

The WEST INDIES & Romantic SPANISH MAIN

French Line

Cⁱᵉ Gᵗ Transatlantique

French Line

S.S. Flandre on the Atlantic

Drawn by Alistair.

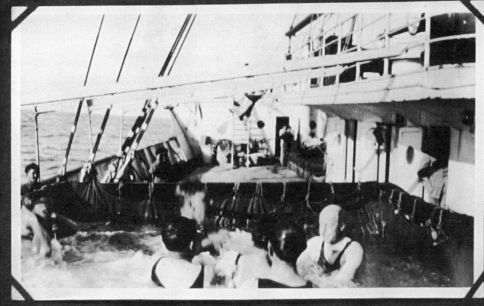

Water Polo.

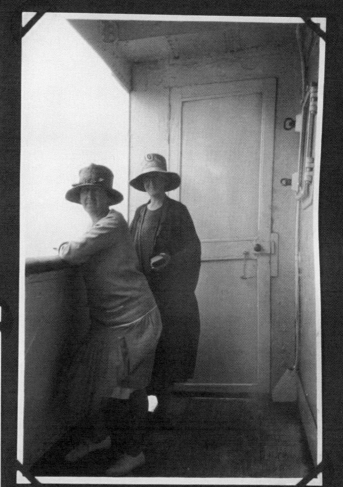

Mrs Annan & Miss Urie.

Life on board the ship was never dull; there were many things to do—group activities and events sponsored by the crew, such as water polo and concerts, as well as other, more individualized activities like sketching, perhaps introduced by Olive to counteract Alistair's boredom during their long and monotonous journey across the ocean.

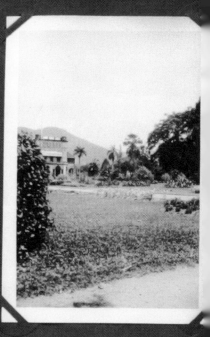

The Governor's Residence

On March 13th the ship arrived in Martinque, where Olive probably purchased these postcards of native women. For Olive and her companions, the local women's colorful dress—which she couldn't capture on black and white film—and their daily life in the French colony was incredibly exotic and, quite literally, worlds away from their city life in London.

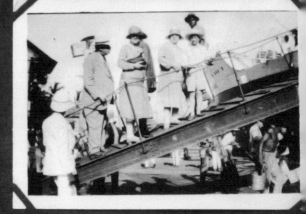

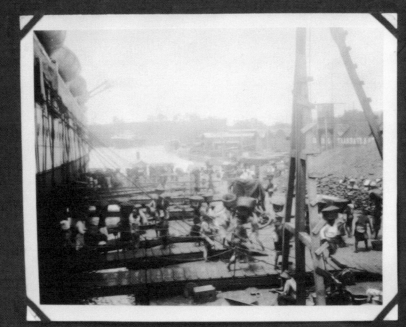

Coaling.

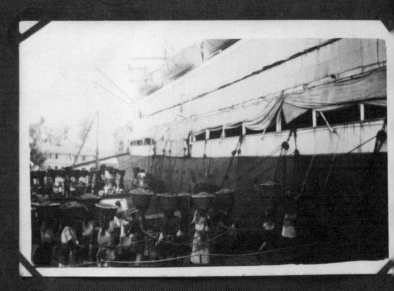

March 13th
Martinique

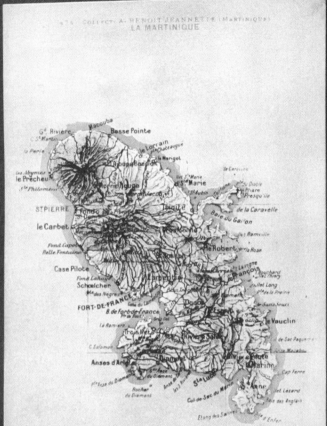

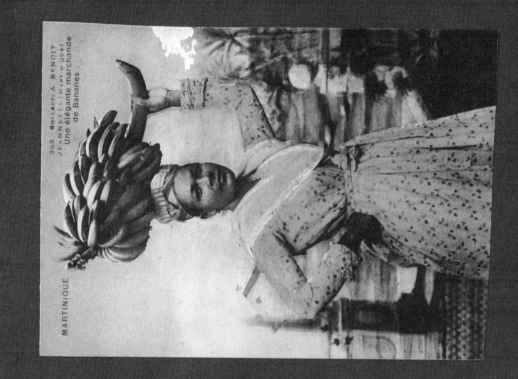

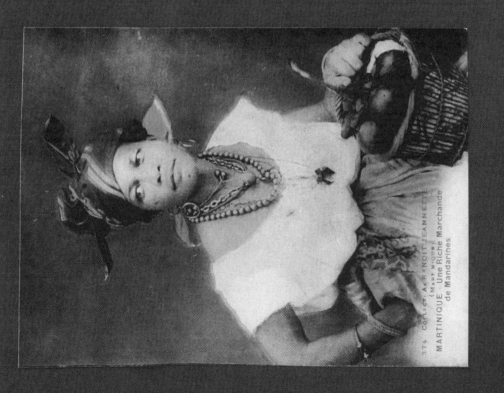

Young Cocoanut trees

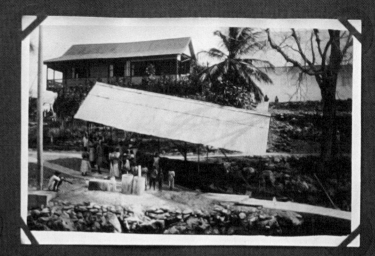

Cocoanut Palms

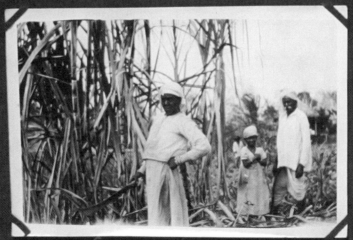

Sugar Cane

Drying Cocoa Beans

In Trinidad, Olivia took these candid snapshots showing the daily life of the island's men, women, and children. She also affixed a photographic postcard showing children being bathed in a washtub. One cannot help wonder about her son Alistair's reaction to seeing children his same age whose lives were so different from his own.

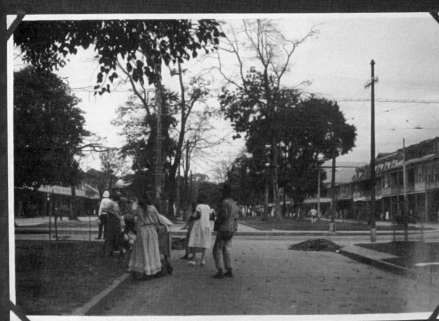

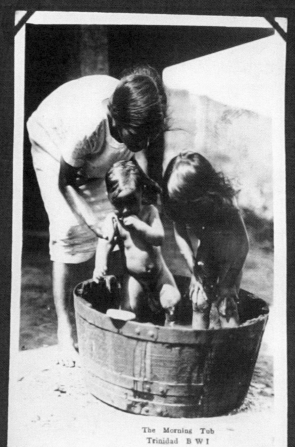

The Morning Tub
Trinidad B W I

172

CRISTOBAL—COLON

Panama

THE principal thing to interest here is of course a visit to that stupendous achievement—the Panama Canal. There is no need here to describe the Canal as the details are familiar to most people. It suffices to say that the Canal is over 40 miles long, from shore to shore, and has a minimum depth of 41 feet and so can easily admit the largest vessels at present built. There are six gigantic locks to be passed before the Pacific is seen.

The whole undertaking is so spectacular that there is no need for the slightest technical knowledge for one to appreciate the magnitude of the builders' task.

To the uninitiated the word "Canal" spells monotony, but in this case never would a greater mistake be made, for the trip takes one through entrancing scenery, great lakes studded with wooded islands, bordered by verdure clad hills running sheer down to the water. No words do justice to the ever-changing scenery. The Culebra Cut driven right through the mountains, represents one of Man's greatest achievements.

There is so much to be seen that, without some organized effort, visitors would waste much of the valuable time that is available. The Company's General Agent has therefore come to an understanding with a leading firm, greatly experienced in such work, for an excursion right through the Canal. This tour shews to visitors all the more interesting places. Motor cars, launches and railway observation cars are used.

PANAMA CANAL—THE GAILLARD CUTTING

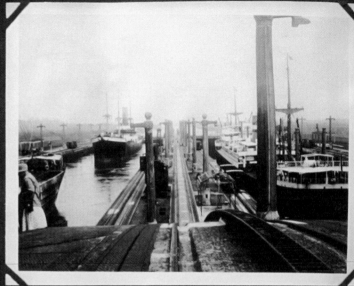

The Gatun Locks.

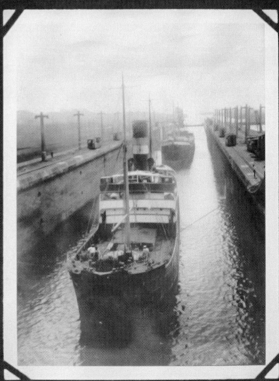

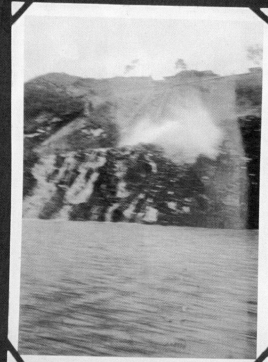

Taking off a
corner of the Culebra
Cut by water
pressure.

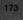

March 20th The Caribbean Sea.

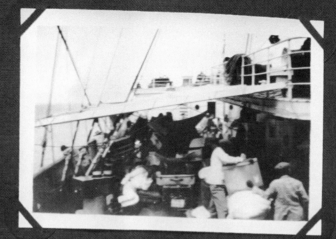

The Steerage

As the Jubb family's itinerary suggests, the distances between destinations meant they spent a lot of time on the ship—first the long voyage, then a series of brief stops between islands, countries, and cities. Olive apparently ranged all over the ship, perhaps in an effort to avoid cabin fever. Here, we glimpse her behind-the-scenes photos of the ship's activities and one of its more unusual passengers, an elephant that was traveling in the steerage compartment as part of a circus—perhaps to entertain guests—that, Olive elsewhere called "the menagerie."

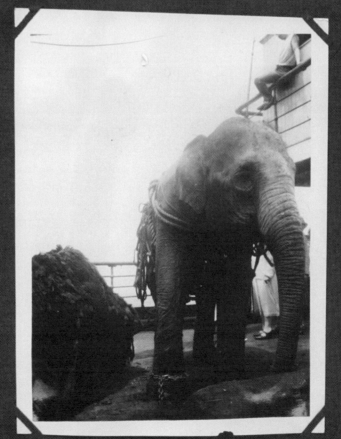

Jumbo

Gazette

THE LINER'S LEXICON.

By a Diffident Traveller.

Aft.— Anything that isn't forrard. Passengers new to the sea call it "back" or "behind."

Band.—As on shore, a large part of the duty of the band is to distract attention from the food and thus prevent criticism. At other times it assists the dancers, but the tunes are the same.

Barber.—A glib fellow who, in the intervals of selling knick-knacks and dressing the hair of women, now and then finds a hurried moment for shaving.

Baths.—Always few and mostly engaged.

Belaying-pin.—Since this article is of invaluable use during a mutiny, passengers should, immediately on coming aboard, find out where it is kept.

Belle.—There is one on every ship, but the other men are there first.

Below.—See *Downstairs.*

Billiard-Room.—You will ask in vain for this, even on the Pink Star Line.

Boat-Drill.—A ceremony which, being devised for the safety of the passengers, is avoided by most of them. See *Life-belt.*

Boots.—You will know at the end of the voyage who has been cleaning these.

Bridge.—The most popular antidote to the monotony of the ocean. But for this game the sea would be full of suicides.

Bugle.—The call to food (See *Food*). None the less, if music means the food we need, play on.

Cabin.—A minute apartment, inconveniently arranged, which, even when you have it to yourself, is a prison-cell without the ordinary prison-cell's stability.

Cabin Companions.—Persons of impregnable selfishness, disagreeable habits and no consideration for others.

Captain.—An elusive and saturnine figure who at meal-times is chatty with peers.

Chief Engineer.—A reserved Scotsman who is incapable of extracting from the propeller as many revolutions as, if the Captain were Chief Engineer, the Captain could.

Chief Officer.—The man who runs the ship.

Chief Steward.—The controller of the dining-saloon, and, as such, a man to have on your side.

Concert.—One at least of these entertainments is given on each trip, when the most unlikely people sing the most likely songs. If no one else gets any benefit out of them, the admirable Seamen's Charities do.

Crew.—A well-disciplined body of otherwise useful and capable men who are bound together in the delusion that perfectly clean decks are dirty and in the decision that no passenger shall sleep after six A.M.

Divine Service.—Should there be no clergyman on board, this ceremony affords an opportunity of hearing the Captain's voice and at last definitely making sure that he is neither the Purser nor the Chief Officer.

Doctor.—A confirmed bridge-player whose potential patients on shore preferred to eat the diurnal apple.

Deck Chairs.—Reclining seats, more or less comfortable, which could be set up in favoured spots were it not that other people had pre-empted them.

Deck Quoits.—A game which takes up more room than those who don't play it can spare.

Deck Steward.—The man who mistakes exposure for shelter.

Downstairs.—A word which is definitely shelved for "Below" only on the last day of the voyage.

Field-Glasses.—Optical instruments which enable their user to confute the statement that that boat over there is one of the Purple Funnel Line. Also useful for the purpose of repudiation when alleged whales are sighted.

Food.—This is notoriously better on other lines.

Gentle Motion.—The Chief Officer's term with which to describe a venomous disturbance of the surface of the sea.

Gramophones.—These are carried and played by the people in the next cabins.

Horizon.—The line in the far distance which, as you sit in a deck-chair on a rough day, goes up and down until you can't endure it another second. It is also of service as marking every afternoon the final disappearance of the sun and ushering in the watcher's reward.

Island.—Most voyagers have thought wistfully of MARK TWAIN's heart-felt wish, expressed to his millionaire host on a yachting trip, who, as the humourist was groaning in his cabin, asked him if there was anything he could do for him. "Yes," was the reply, "get me a small island."

(To be continued.)

THE LINER'S LEXICON.

By a Diffident Traveller.

(Concluded.)

Library.—A series of bookcases containing all the novels you have read—except one which is never returned.

Life Jackets.—An unsightly article of emergency clothing which, should you be projected into the sea, will keep you afloat long enough to ensure your death from a chill. In every cabin is a picture of the way to put these jackets on. The gentleman who poses for these photographs is, owing to the highly specialised character of the industry, one of the most liberally paid of all public officials.

Marline-spike.—See *Belaying-pin.*

Mile.—A distance measured on the decks for the benefit of passengers who must, by Jove! keep fit. On land, should they be dominated by the same passion, they gratify it in silence; but at sea they walk only at the top of their voices.

Mill-pond.—A small sheet of water on the outskirts of low-lying English villages with which the ocean on a calm day is invariably compared.

Partner.—The so-called ally who at all ship's games prevents you from winning.

Passengers.—Fellow-voyagers who say, "Good-morning," "It's not so rough to-day," "Isn't that a whale?" "The Pink Star is a much more comfortable line than this," and "Are you going across?"

Porpoises.—Large and frolicsome fish whose gambols are always completed a few seconds before you can reach the side.

Purser.—An official who, like the Chief Steward, it is well to have on your side. Everything that is not done by the Chief Officer and the Chief Steward is done by him. No one else can break the Company's rule against cashing cheques.

Sea.—The untrustworthy element which buoys ships up, and which between embarcation and disembarcation there is no real need even to glance at.

Sea-Sickness.—A degrading malady from which many very common people are exempt.

Second Class.—A part of the ship reserved for inferior creatures who, when seen beyond their barrier, are often found to be behaving uncomfortably like ourselves.

Steamer Acquaintances.—Passengers who have been admitted to a certain degree of intimacy, but whom there is no reason to continue to know, or more than barely acknowledge, on dry land.

Steward.—No sooner does the ship leave port than your steward becomes your father and mother. See to it that you are not an orphan.

Stewardess.—Ditto.

E. V. L.

Ship Lore/ Liners Lexicon

The Jubbs' boat, the *Flandre*, like most ships of its size, had a printing press on board that produced daily tidbits of practical information such as the ship's position, temperature, and wind reports; the number of miles the captain intended to cover that day; the ship's speed; and notations about the relative calmness of the sea. The information was provided to the passengers on small pieces of paper titled "Point de Midi." Olive kept most of these and pasted them into her album.

The ship's staff also produced *The Liner's Lexicon*, a dictionary of ship terminology by a "Diffident Traveler," which offered passengers humorous definitions for both arcane and familiar terms used on board. The wry entry for "ship's bridge" read: "The most popular antidote to the monotony of the ocean. If it were not for this game the sea would be full of suicides," making reference to the popular card game rather than the ship's control center, as well as the frequent boredom of passengers. Other entries poked fun at the passenger experience on board, noting that food was something "notoriously better on other lines" and the game of deck quoits (horseshoe pitching), "a game which takes up more room than those who don't play it can spare." Olive did not take any pictures of passengers playing quoits or bridge, but like water polo and "the menagerie," these pastimes were probably welcome distractions during long stretches at sea.

POINT DE MIDI

Mercredi 3 Avril 1929

Latitude : 23.11 N.

Longitude : 51.58 W.

Milles parcourus : 282

en 23h.46 VITESSE : 11n.84

VENTS ET TEMPS

Jolie brise d'alisés.

Mer houleuse.

POINT DE MIDI

Jeudi 4 Avril 1929

Latitude : 26.47 N.

Longitude : 51.02 W.

Milles parcourus : 303

en 23h.14 VITESSE : 12n.76

VENTS ET TEMPS

Jolie brise du N.E.

Mer houleuse.

POINT DE MIDI

Vendredi 5 Avril 1929

Latitude : 30.29 N.

Longitude : 46.48 W.

Milles parcourus : 315

en 23h.43 VITESSE : 13n.26

VENTS ET TEMPS

Jolie brise du N.N.E.

Houle de Nord.

POINT DE MIDI

Samedi 6 Avril 1929

Latitude : 33.46 N.

Longitude : 42.30 W.

Milles parcourus : 294

en 23h.42 VITESSE : 12n.38

VENTS ET TEMPS

Jolie brise de N.E.

Mer houleuse.

Gazette

The Jubbs' Caribbean vacation covered the West Indies and Spanish Main. They left from *London* and traveled to Martinique, Trinidad, and Curacao.

FRENCH LINE
COMPAGNIE
GÉNÉRALE TRANSATLANTIQUE

Head Office: 6, Rue Auber, PARIS.
Agents for British Isles: Cie. Gle. Transatlantique, Ltd.
22, Pall Mall, London, S.W.1.

PLYMOUTH

TO

COLON.

Steamer......FLANDRE......Date....Feb. 25

Mr......E. Jubb......

5000/5465/8/24.

"FLANDRE"
..............
Horse N° 2
Race N°_____

FLANDRE

N° 517-2.
(Déc. 1921.)
—Sp. 646c.
RÉCÉPISSÉ
à
remettre au déposant

5,70

Nom et adresse du destinataire

t Kilner
Sold Head Mirfield
à York England

IDÉAL-BOULE
POUR
RAVIVER LES COULEURS

TEIGNEZ VOUS-MÊME
LA TEINTURE
IDÉALE
TOUS TISSUS EN TOUTES NUANCES
L.GONNET, 55 Pl.de la République, LYON.

Cie Gle TRANSATLANTIQUE
VAPORES CORREOS FRANCESES

PLYMOUTH

M
PAQUEBOT FLANDRE DATE

CABINE N°

IMPORTANT.

This card is to be presented to the Aliens' Officer at the port of arrival in the U.K., together with such papers as will establish the nationality and identity of the bearer.

In order to expedite their landing, passengers are requested, upon arrival, to hold themselves in readiness to assemble as directed by the Company's servants, for examination by the Government Officers.

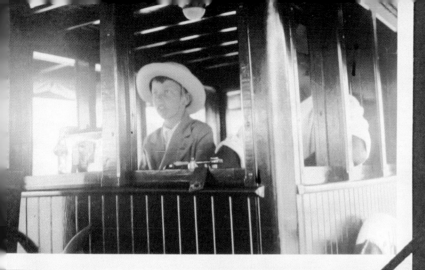

Pilot Alistair Kilner

Passing Gold Hill.

Alligators.

Our drinking Cup.

Like Martinique, many of
the islands in the Caribbean
that the Jubbs visited were
European colonies. Late
in March they found them-
selves on the Dutch island
of Curacao, off the coast
of Venezuela. Perhaps they
were witness to local unrest
with Dutch rule while they
were there, because Olive
took the trouble to paste
into her album a newspaper
clipping that recorded an
event that occurred nearly
four months after their
visit—the kidnapping of the
island's Dutch governor
in June by "outlaws" from
Venezuela seeking indepen-
dence for the island.

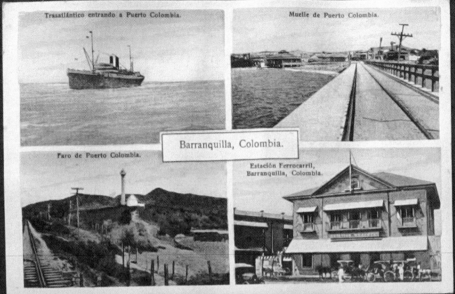

Trasatlántico entrando a Puerto Colombia.

Muelle de Puerto Colombia.

Barranquilla, Colombia.

Faro de Puerto Colombia.

Estación Ferrocarril,
Barranquilla, Colombia.

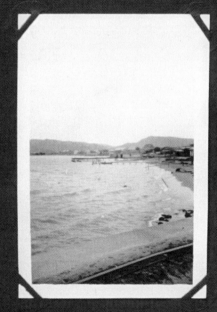

Puerto Colombia

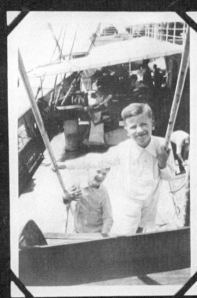

March 24th
The
Caribbean
Sea

Alistair
&
Georgie.

March 25ᵗʰ Curaçao

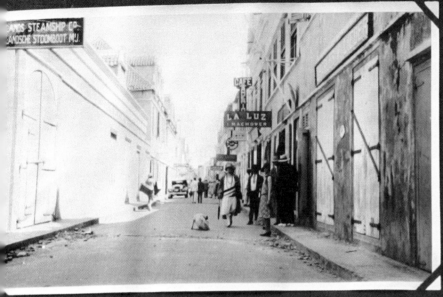

Willemstad

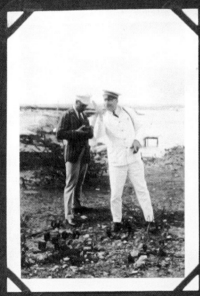

M. Angosse
&
M. Dupont.

Edie Olive
Doris Elsie.
M. Dupont

June 11ᵗʰ
1929

GOVERNOR SEIZED IN A RAID.

HOSTAGE OF REBELS.

Dutch Warships Rushing to West Indies.

The spacious days of the Spanish main are recalled by the raid of a party of Venezuelan rebels upon the Dutch Island of Curacao, and the capture of the Governor and Commander-in-Chief of the forces.

The outlaws, who had come from the mainland, stole arms and ammunition, and returned to the mainland in a borrowed American steamer with their distinguished hostages.

On reaching Velado Goro Bay they released their hostages, and continued their pillaging way, but the latest reports suggest that they have encountered sterner opposition than they anticipated, and that they have suffered a reverse.

A strict censorship has been imposed, and this has given rise to wild rumours, but the peaceful inhabitants are reassured by the knowledge that Dutch warships are hastening to their protection.

CARACAS (Venezuela), Tuesday.

The Venezuelan revolutionaries who enjoyed a brief success in a week-end raid on the Dutch possession of Curacao have now returned to the Mainland, and are in flight before Venezuelan troops.

According to official despatches reaching here, they have not enjoyed an equal success since their return to their native land. Immediately upon landing at Vela De Goro Bay, the insurgents attacked a small garrison, but according to despatches from that post this garrison "repulsed them with many killed and some taken prisoners."—British United Press.

Calm has been restored in Willemstad (Curacao) says another British United Press message, and the apprehensions of the populace have been allayed by the news that Dutch warships are on their way to Curacao.

Since Saturday night the populace has been disturbed by fears that the modern freebooters of the Spanish main might return from Venezuela to attack this island, or might be followed by another raiding party.

Fort Amsterdam, the military stronghold here, which was the object of the raiders' attack, has been reinforced, and

Fort Amsterdam, the military stronghold here, which was the object of the raiders' attack, has been reinforced, and certain Venezuelan exiles living here are being carefully watched.

Following a strict censorship introduced by the Dutch authorities at Curacao, wild rumours are circulating in New York of an outbreak of revolution in that island. These rumours, which are attributed to private wireless advices, are discredited by the authorities who contend that they are the natural outcome of the strict censorship imposed on all Press messages to or from the Dutch possession.

DUTCH INTERPELLATIONS.

THE HAGUE, Monday.

M. Colyn, a member of the First Chamber, has addressed the following questions to the Minister for the Colonies in reference to the raid by an armed band of 500 Venezuelans on Willemstaad (Curacao) on Saturday last:—

1. Will the Government obtain at the earliest moment full information regarding the events in the Isle of Curacao which are so damaging to our international reputation?

2. Will the Government make it clear how it came about that a band of 500 Venezuelans could be so strongly armed that they were able to overcome the military police force?

3. Will the Government give an assurance that it will take measures of a permanent nature with a view to preventing a repetition of events so humiliating to our Colonial authority and our international reputation?

The Foreign Minister, Jonkheer van Blokland, stated to-day that he did not consider the incident likely to cause any conflict between Venezuela and Holland, because it was only a question of a "putsch" by irresponsible people.—Reuter.

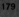

Puerto Cabello.

Revolutionists marching to prison

An Easter Sunday Ceremony

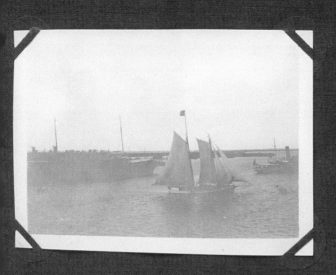

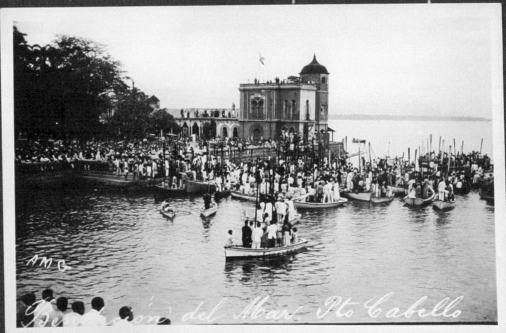

Bendición del Mar. Pto Cabello

The Priest blessing the Port

Paisaje Venezolano.

AMG

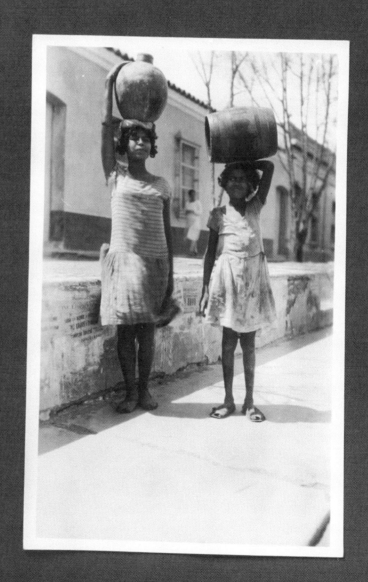

Cocoanuts

After fourty-four days on board, with an itinerary that barely seemed to have allowed for lengthy exploration of the many ports they visited, it is perhaps not surprising that Olive would ask her fellow travelers—strangers made into friends by virtue of their close quarters—to sign her program as a souvenir of their time together.

Paquebot " FLANDRE "

Mercredi 3 Avril 1929

a 21 heures 15 précises

SOIRÉE DE GALA

organisée par le groupe Artistique des

" FLAMANTS ROSES "

au profit de la Caisse de Secours des Agents du Service Général à bord

sous la présidence d'Honneur

du Commandant LE MÉDEC et son Etat Major

Régisseur général : C. Chermat

Directeur Artistique : R. Bigot

Les travaux électriques et la machinerie sont exécutés par M. P. OLIVIER.

The last glimpse of land before crossing the Atlantic

Mardi 2 Avril 1929

Latitude : 19.10 N.

Longitude : 58.17 W.

Milles parcourus : 232

en 24h.26 VITESSE : 11n.95

VENTS ET TEMPS

Forte brise de N. E.

Mer assez grosse.

POINT de MIDI

Mercredi 3 Avril 1929

...tude : 23.11 N.

...tude : 54.58 W.

Milles parcourus : 282

...3h.16 VITESSE : 1m.8

VENTS ET TEMPS

...rise d'alisés.

...uleuse.

Olive A. Jubb

Edmond Doubin

B. Lockerbie Doubin Edgar Fitton

Alice M. Kilner Emily Jubb

Doris. J. Fitton.

Albert Kilner

Mr Ladye Board

Alistair J. Monro

Cie Gle Transatlantique H. Board

Day Blomberg

French Line J. Goodine

Alsooding Pdelalalle

AimeeBerg John Auray

The Gooding E. Gessey

J A Kburgham A. Bergis Nemesis Guin Navaji

M. L. Franville W. E. Gessey Edith Gooding

George Sam ac Pole

Pollard Bangore E. Maud A. Millrie

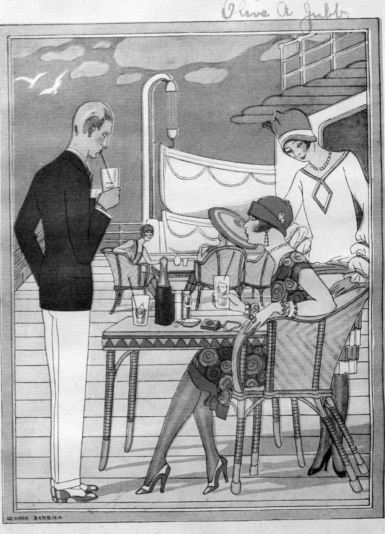

GEORGE BARBIER

1927
On board French Line Steamers
Voyageurs d'aujourd'hui

The Grand Tour

IN 1929 a group of young Canadian women embarked from Montreal on a Grand Tour of Europe that began with England and culminated two months later in Paris. Chaperoned by an older couple named Claude and Kit, these young women were on an educational tour; they were going abroad to see and experience what accomplished women of their class were expected to see and experience, and Europe was their finishing school. In England, they visited Stratford-upon-Avon, Windsor Castle, the Lake District, Wordsworth's grave, and they listened dutifully to a guide at the ruins of Kenilworth Castle. They went to Belgium, Holland, Germany, through the Alps to Italy, doubled back to Switzerland, and then headed to Paris. They left no stone unturned, no monument unvisited.

We do not know, exactly, who the creator of the album was, although photographs taken before and after the trip seem to indicate that it might have been Kit. Whoever it was, she used an expensive, tooled leather-bound album measuring 11 1/2 x 14 1/2 inches. She took an incredible number of snapshots, and supplemented these with sets of souvenir photographs.

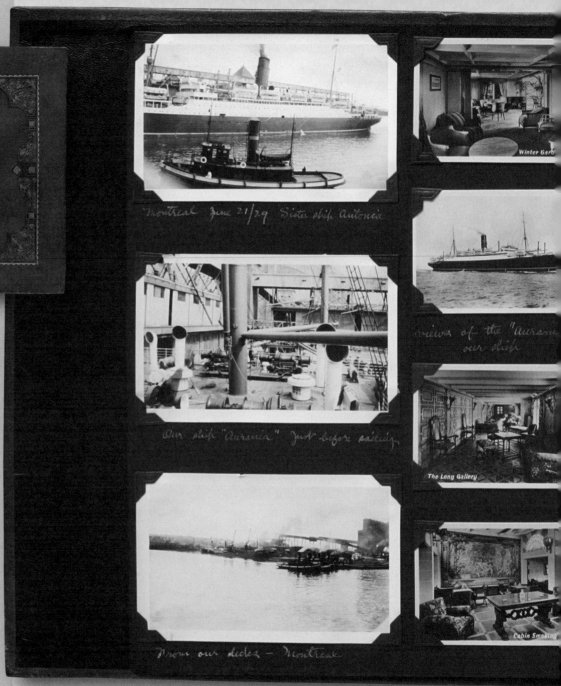

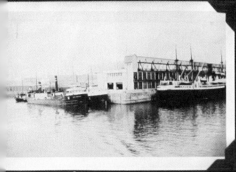

Montreal

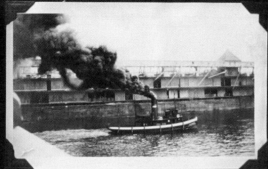

Tugs pulling our ship Aurania away
from dock at Montreal June 21/29

Dining Saloon.

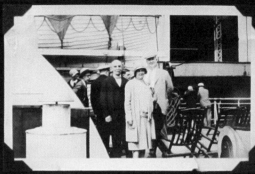

just
'rarin'
to go!

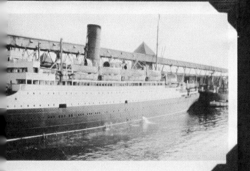

"Antonia"

Before Kit got seasick!

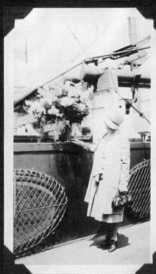

Flowers from Mr & Mrs Mosher

Aurania
at the
dock
at
Montreal

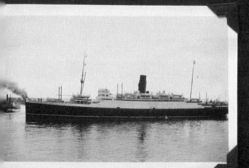

"Antonia"

Claude, Mr Geo. Schorr & Geo Davis

The Children's Room

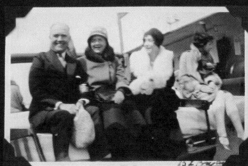

Claude, Kit & Dorothy, & Margaret Eury

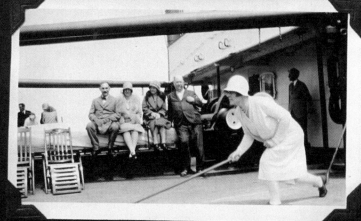

Shuffleboard on the Aurania

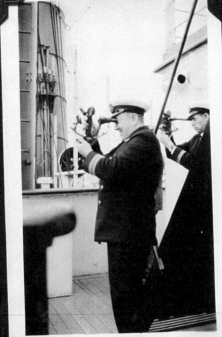

Navigating officers

A fine day on the Aurania
Lower halves of Doc & "Toodles" Eng

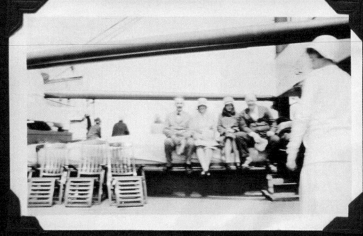

The Shuffleboard audience

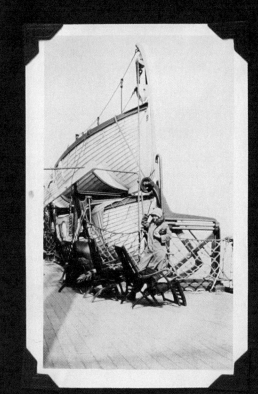

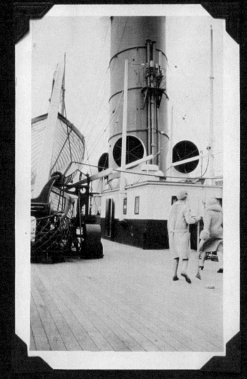

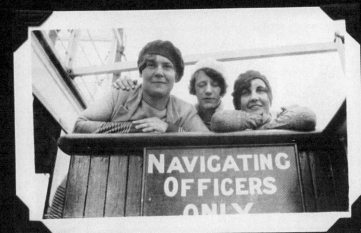

Eleanor Hauck, Eleanor Vogeler & Christine Schorr

Jean Stanley at
Shuffleboard
on the Aurania
June 1929

A windy day in
mid Atlantic

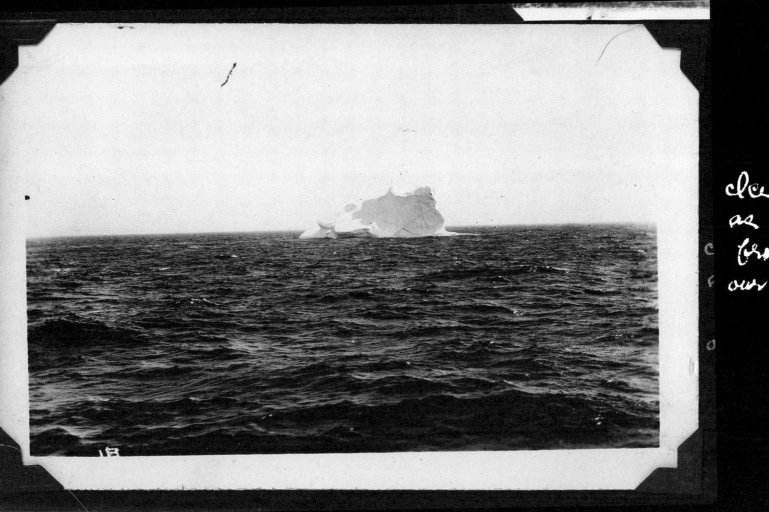

iceberg
as seen
from
our ship

WALES

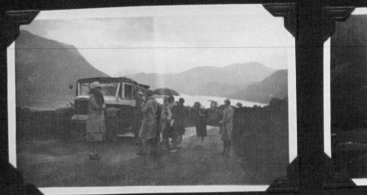

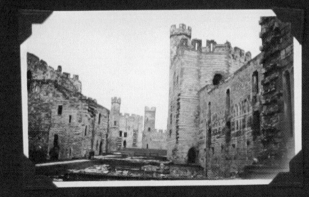

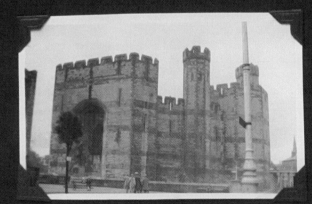

Carnarvon Castle, Wales

Wales

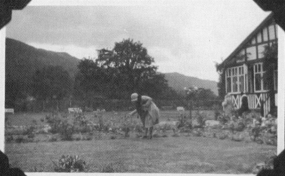

Bettws-y-coed - Wales ⌐ at lunch

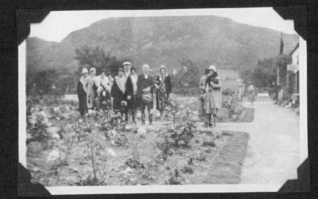

garden at Bettws-y-Coed

Despite the youthful enthusiasm in the album's photographs, and the kind of spur-of-the-moment whimsicality that we can imagine characterized this trip, the author of the album arranged it in a highly structured way. The photographs—placed in a series of grids, implying a linear telling of the trip's story—are arranged in vertical and horizontal rows of repeating patterns, alternating three rows of horizontal and vertical photographs on one page, and then reversing the pattern on the opposite page, or on the next. The photographs almost seem to march across the page as we might imagine the girls themselves marching from monument to monument in the company of their chaperones. Yet, there is some creativity here, just as there are candid and humorous photographs and captions.

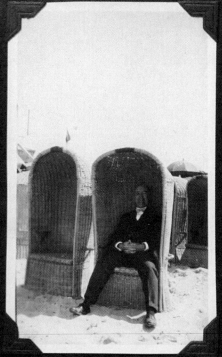

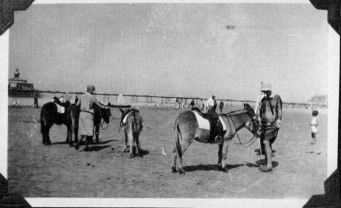

At the beach

Oh for a week of this!

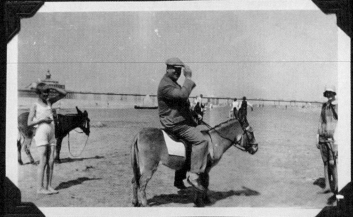

Amsterdam

George Davis — to the poor donkey!

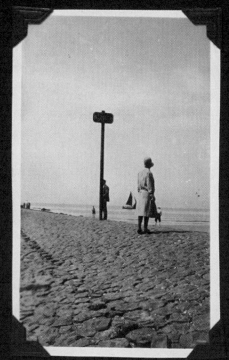

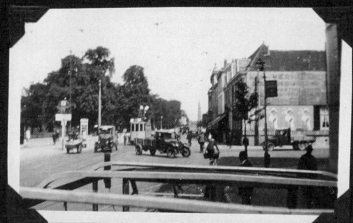

At the beach
Scheveningen

The Hague

A Dutch lady

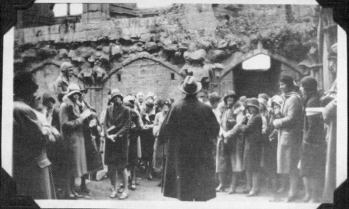

Listening to guide at Kenilworth

Kenilworth

Mrs. Schorr at Shakespeare's burial place

Ann Hathaway cottage

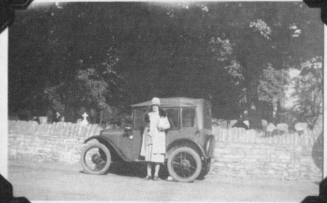

Kit and a "Baby Austin" auto near where Shakespeare was buried

Shakespeare's birth place Stratford on Avon

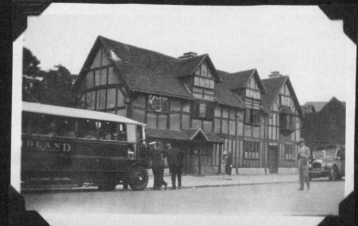

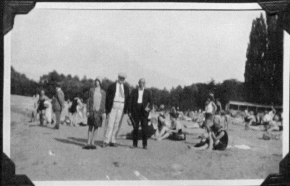

Beach at Weisbaden, Germany, on the Rhine

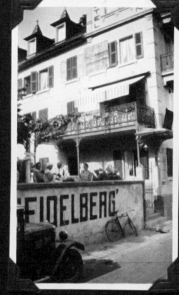

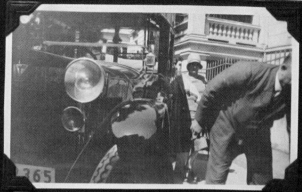

Scene, or locale, of the opera "Student Prince" in Heidelberg

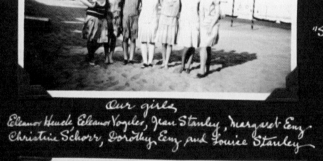

Our girls
Eleanor Heuck, Eleanor Vogeler, Jean Stanley, Margaret Enz,
Christine Schorr, Dorothy Enz and Louise Stanley

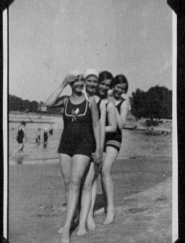
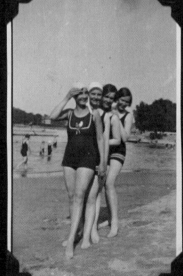

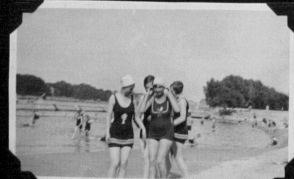

Our girls at the beach

Our bathing beauties

To right — our room at Heidelberg
notice the "puffs" on bed

Heidelberg

Weisbaden

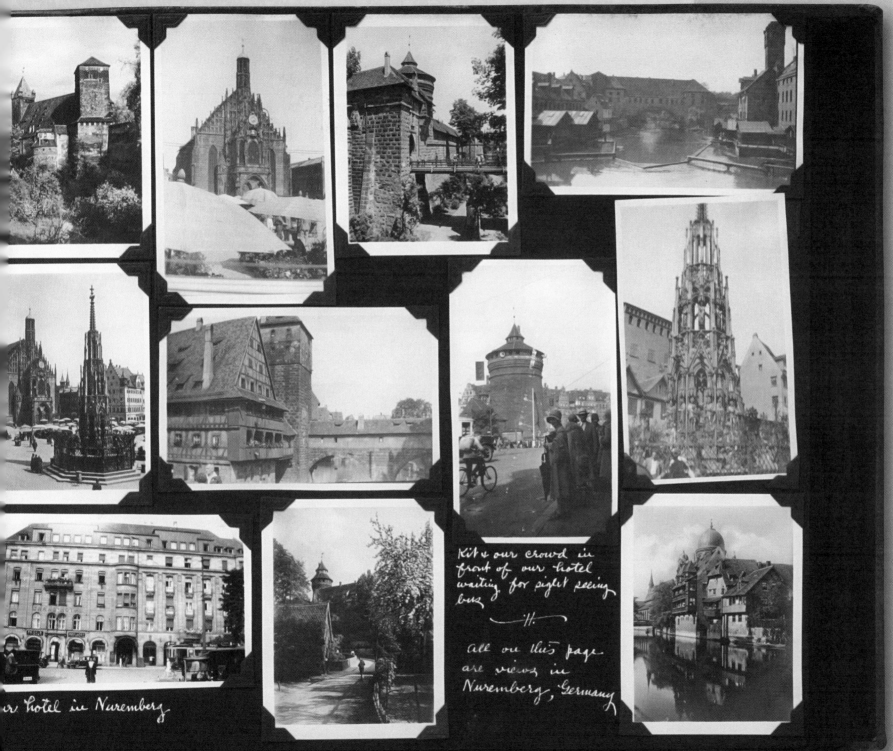

Kit & our crowd in front of our hotel waiting for sight seeing bus

—H.

all on this page are views in Nuremberg, Germany

r hotel in Nuremberg

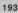
193

Intriguingly, the author of this album chose to rely on tourist photographs when it came to the important monuments of cities such as Nürmberg, Florence, Luzerne, and Paris, and probably purchased sets of pre-selected views. Perhaps she did not trust herself or her skills as a photographer to capture Florence's Santa Croce or sculptor Bertel Thorvaldsen's *Lion of Luzerne* in just the "right" way. Or perhaps, she was making her own comment about these historical monuments: it is easy to pass right by them in the album, as the author herself may have done, because she "knew" them already from guidebooks. What seems to have been interesting to her was the *experience* of Europe, and it is this sense that comes across most strongly when looking at her album.

The Dolomites

In the Dolomites, Italy

The Dolomites - from our hotel near Cortina d'Ampezzo

Dolomites

Dolomites

The Dolomites

Dolomites

Dolomites

194

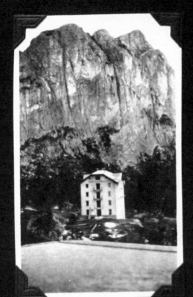

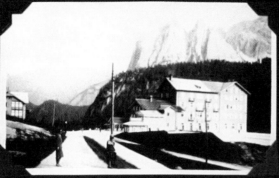

Tre Croci Hotel near Cortina d'Ampezzo

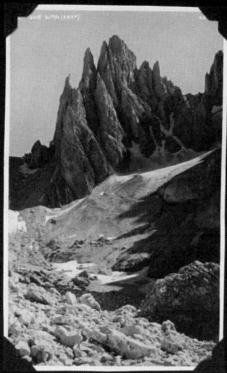

The annex to Tre Croci

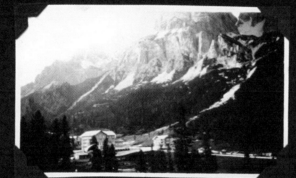

The Dolomites

Tre Croci (Three Crosses) our hotel

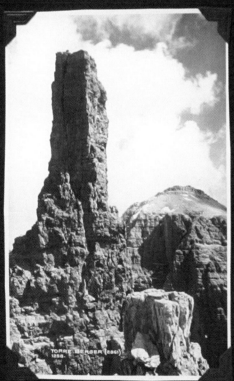

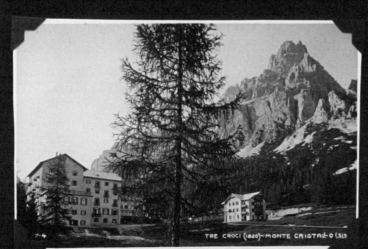

TRE CROCI (1820) - MONTE CRISTALLO (315)

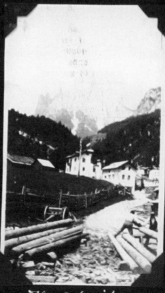

Dolomites, Italy

Olsar hotel - we stayed at the building at the right

The Dolomites

Looking from our hotel room in Rome

Rome

Adrian's Villa Tivoli

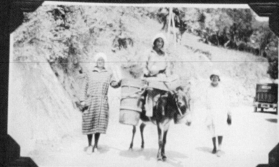

Tivoli roadside

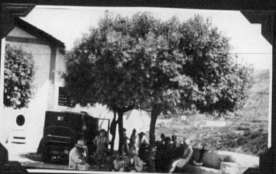

Our lunch at Tivoli

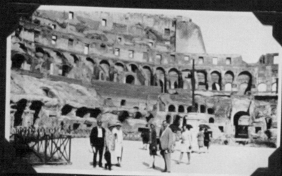

Coliseum at Rome

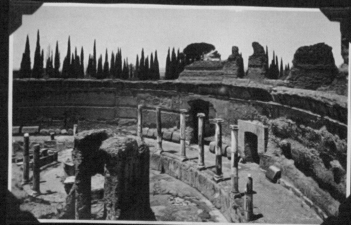

Adrians villa ~ Tivoli

On the Appian way
This statue more than
2000 years old

ke Nemi being drained

near Tivoli

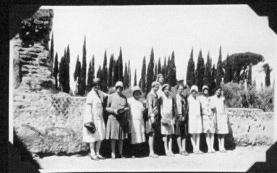

Adrians Villa - Poor Adrian, he
died too soon and so missed our girls!

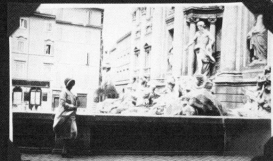

Throwing a coin into this fountain
in Rome - Evidently Kit wants to
return

Ruins in Adrian's villa

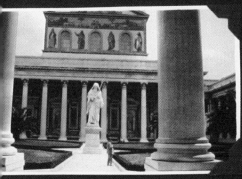

Paul's outside the walls - Rome

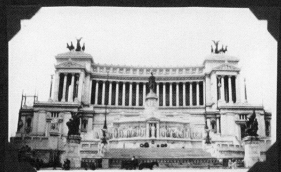

King Victor Emmanuel's tomb

Tivoli, Italy

After leaving Italy
the group goes to
France and takes
in the Eiffel Tower,
the Louvre, and
Versailles.

197

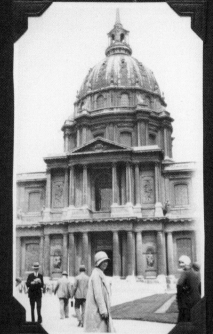

Napoleon's Tomb

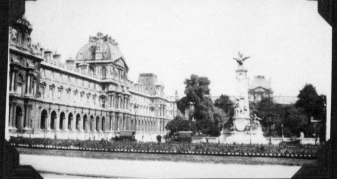

The Louvre

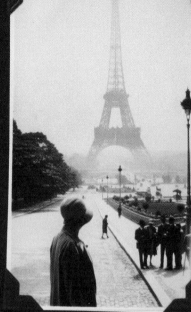

Eiffel Tower

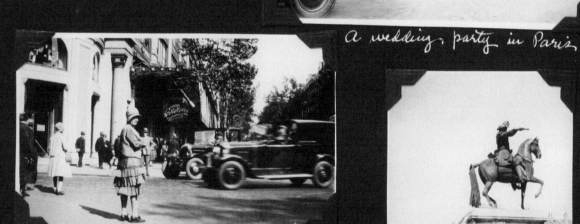

A wedding party in Paris

Versailles

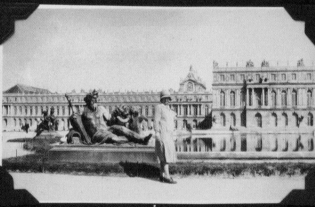

Versailles

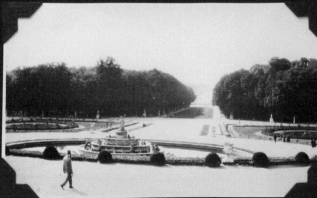

Versailles

Shopping in Paris!

Our guide Benjamin telling us to hurry

War &
Monuments

The students who made their Grand Tour of Europe during the summer of 1929 did so during a unique period of history—ten years from the conclusion of the First World War and almost as many before the beginning of the second, in 1938. Teenagers at the time of this trip, most of the group would have been six to eight years old during World War I, and most of the album is not concerned with any kind of introspection on war and its destruction, which might have appeared in the albums of older travelers. On the last few pages, however, as the group made its way from Italy to France before returning home, the group visited the Hindenburg Line and the American cemetery in Belleau Wood. In these photographs, placed in the album next to photographs of Versailles and Rheims, the vast and crumbling complex of the German defense network—bunkers, tunnels, and command posts—and the regimented white crosses at Belleau Wood similarly become tourist sites to wander through, play in, and take photographs.

Because we know what has shortly to occur on these sites once more, we cannot view this album without eyes colored by our knowledge of those future events—the charming and delightful innocence of these girls as they tramp about Europe would soon be shattered by World War II. In the album's pages are sites, monuments, and buildings that, while untouched by the First World War, would be reduced to ruins a decade later: Nüremberg, Cologne, Rheims. Nor can we escape the knowledge that barely two months after their return home, on August 25th, 1929, the carefree girls in the album's many photographs would be experiencing an entirely different reality, a world away from their summer tour: the world after October 19th, the Great Depression.

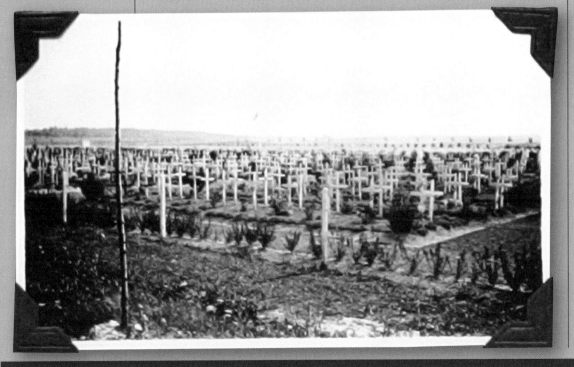

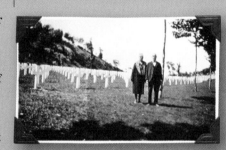

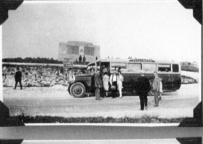

Gazette

The students' two month Grand Tour included stops in England, Belgium, Holland, Germany, Italy, Switzerland, and *Paris*.

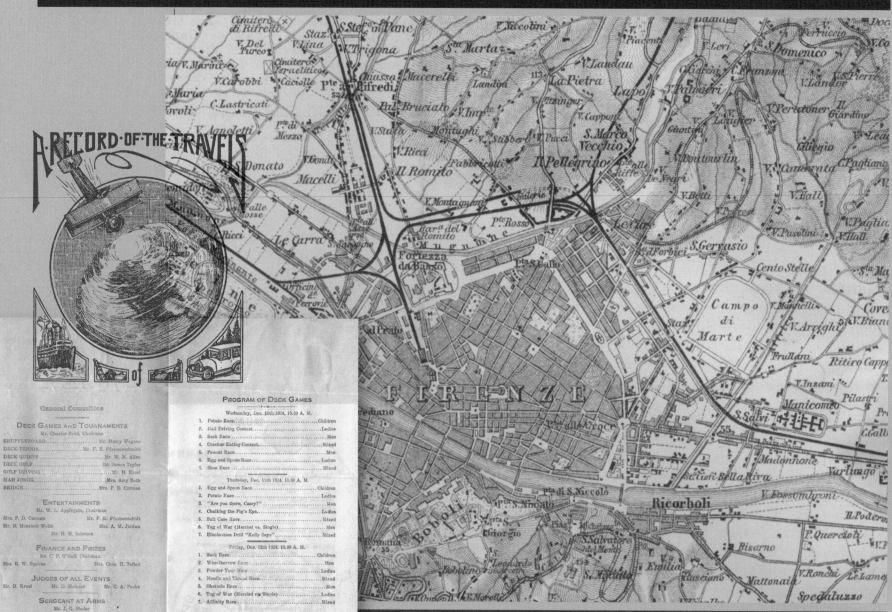

A RECORD OF THE TRAVELS

of

General Committee

DECK GAMES AND TOURNAMENTS
Mr. Chester Fritz, Chairman

SHUFFLEBOARD..................Mr. Henry Wagner
DECK TENNIS.................Mr. F. E. Pfannenschmidt
DECK QUOITS.....................Mr. W. N. Allen
DECK GOLF.....................Mr. James Taylor
GOLF DRIVING.....................Mr. H. Krusi
MAH JONGG.....................Mrs. Amy Roth
BRIDGE.....................Mrs. P. D. Carman

ENTERTAINMENTS
Mr. W. L. Applegate, Chairman

Mrs. P. D. Carman Mr. F. E. Pfannenschmidt
Mr. S. Montieth Webb Mrs. A. M. Jordan
 Mr. H. H. Solomon

FINANCE AND PRIZES
Mr. C. F. O'Neil, Chairman

Mrs. R. W. Squires Mrs. Chas. H. Talbot

JUDGES OF ALL EVENTS
Mr. H. Krusi Mr. D. Mainzer Mr. C. A. Pooke

SERGEANT AT ARMS
Mr. J. G. Shaler

PROGRAM OF DECK GAMES

Wednesday, Dec. 10th, 1924, 10.30 A. M.

1. Potato Race.....................Children
2. Nail Driving Contest.....................Ladies
3. Sack Race.....................Men
4. Cracker Eating Contest.....................Mixed
5. Peanut Race.....................Men
6. Egg and Spoon Race.....................Ladies
7. Shoe Race.....................Mixed

Thursday, Dec. 11th, 1924, 10.30 A. M.

1. Egg and Spoon Race.....................Children
2. Potato Race.....................Ladies
3. "Are you there, Casey?".....................Men
4. Chalking the Pig's Eye.....................Ladies
5. Suit Case Race.....................Mixed
6. Tug of War (Married vs. Single).....................Men
7. Elimination Drill "Kelly Says".....................Mixed

Friday, Dec. 12th, 1924, 10.30 A. M.

1. Sack Race.....................Children
2. Wheelbarrow Race.....................Men
3. Powder Your Nose.....................Ladies
4. Needle and Thread Race.....................Mixed
5. Obstacle Race.....................Men
6. Tug of War (Married vs Single).....................Ladies
7. Affinity Race.....................Mixed

House in the woods - Versailles

Nearest approach of German troops to Paris

On the Hindenburg line
High officers' headquarters

What a mark to shoot at! On the Hindenburg line

In woods at Versailles

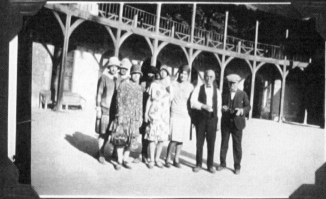

Versailles

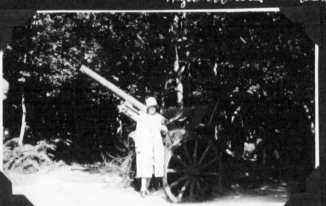

Belleau Wood

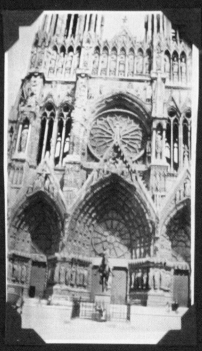

Rheims cathedral

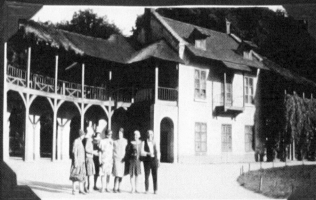

The "little house" at Versailles

American Cemetery Belleau Wood

Homeward bound on The Carmania

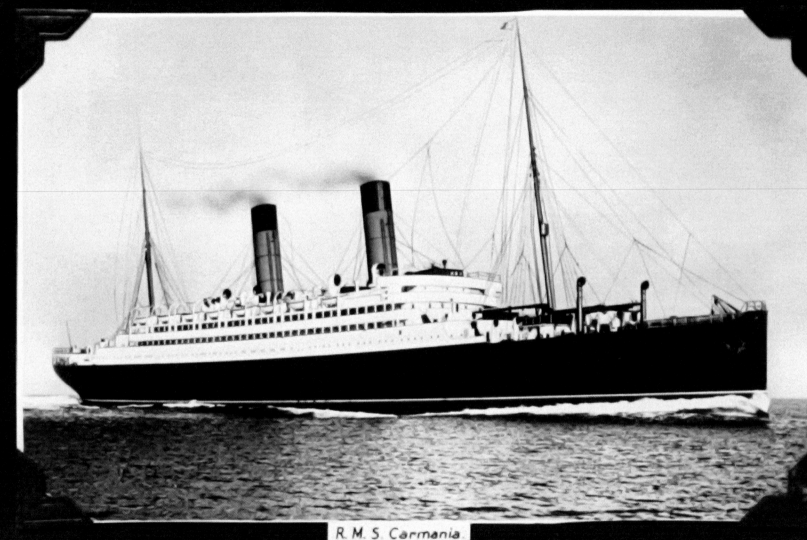

R. M. S. Carmania.

The ship that brought us home

Our crowd — completely worn out

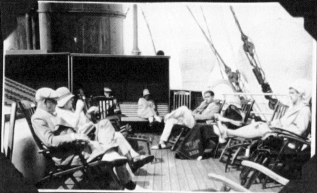

Taking it easy on upper deck

e Stanleys, Jean & Mrs. S. & Louise

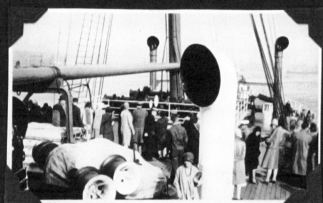

Statue of Liberty in sight!

Our baggage ready to go ashore
t New York. August 25th 1929

Home! monday August 26th 1929

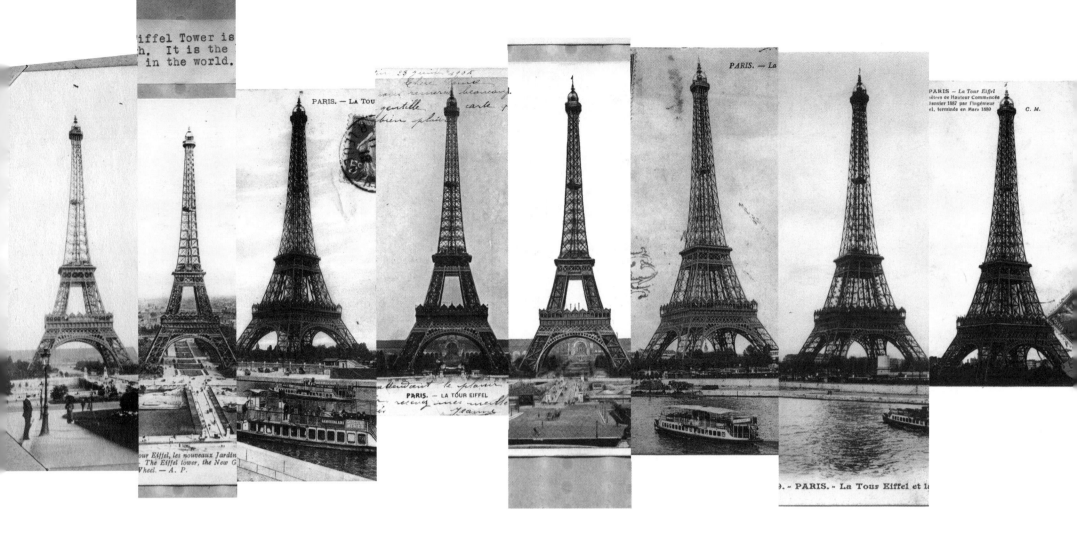

PARIS. — LA TOUR

PARIS. — La

PARIS — La Tour Eiffel
ètres de Hauteur Commencée
anvier 1887 par l'Ingénieur
el, terminée en Mars 1889 C. M.

PARIS. — LA TOUR EIFFEL

our Eiffel, les nouveaux Jardin
— The Eiffel tower, the New G
Wheel. — A. P.

9. — PARIS. — La Tour Eiffel et la

ASOCIACION MEXICANA DE TURISMO MEXICAN TOURIST ASSOCIATION

PRINTED IN MEXICO OFFSET GALAS

your Mr. Reyes is muy guapo y muy amable tambien!

Postscript

Wish You Were Here

Barbara Levine

For many years I traveled through the lens of anonymous vintage travel albums. The evocative photographs, the colorful bits and pieces pasted on the pages to animate the story, and the captivating messages on personal postcards stuffed into the album, conspired to take me on mesmerizing armchair journeys (figs. 1 & 2). Through all those years, I received countless postcards and emails from friends, exuberantly describing the delights and peculiarities of their far-flung travels. The food! The colors! The balmy air and scorching sun! The gypsy caravan, the full moon over Stonehenge, the handsome stranger met at a concert, etc. have all shouted out to me—*this* is the best place!

I used to roll my eyes at the sun-drenched postcards and the lush multimedia albums my friends would produce to narrate their travel adventures. Not that I didn't believe they had a good time or that the place they visited was truly incredible. It was more that I felt a responsiblity to respond with appropriate and sufficient enthusiasm to their need to immediately recount their experiences and latest geographic conquests. I was more comfortable using my imagination and looking at travel pictures in albums created by total strangers nearly a hundred years ago.

It seems, however, that years of vicarious travel have had a subconscious effect—all those old photo albums stuffed with colorful brochures and beautiful photographs and the exuberant postcards, e-cards, and travelogues have gotten under my skin. The day came, not so long ago, when I got up from my armchair and moved to Mexico.

Now, ironically, I am the one who can hardly contain myself about the delights and differences of being in another country. I am the one compulsively emailing photos from my cell phone at the internet cafe. I am compiling an album (the old-fashioned kind you can hold in your hands!), cramming in everything from menus, maps, and flowers to product labels and, of course scads of photographs. Don't get me wrong; I still avidly collect vintage travel albums and now have an even deeper appreciation for the timeless stories they tell. It's just that now I'm the one mailing the colorful, shiny postcards that say: *I wish you were here.*

Acknowledgments

Greetings,

Just a note to let you know that we've had a wonderful time working with the incomparable Jennifer Thompson and all the staff at Princeton Architectural Press. Graphic designer Martin Venezky gave our book the five star luxury treatment and Dana Davis's photography is first-class all the way.

Kirsten is grateful to Geoffrey Batchen and Kris Belden-Adams for their willingness to read successive drafts of her essay and for the insightful comments and suggestions that helped shape it. She also wishes to acknowledge Rachel Snow, who shared her research on travel books and photography. Thanks to Lars Pedersen, the perfect traveling companion, who provided constant support and willingly tolerated the proliferation of travel albums and papers that littered the dining room for months.

Barbara sends thank yous to friend and editor extraordinaire, Lulu Torbet, for responding to her S.O.S. during the writing of her essay, and to Jessica Helfand for her invaluable support early on in this project. And, so many thanks to Paige Ramey, for the journey of many lifetimes.

We've both enjoyed working together along the way and hope you enjoy this memento of our voyage.

All best to you—

Barbara Levine and Kirsten M. Jensen